VISIONS

STAR WARS ART

VISIONS

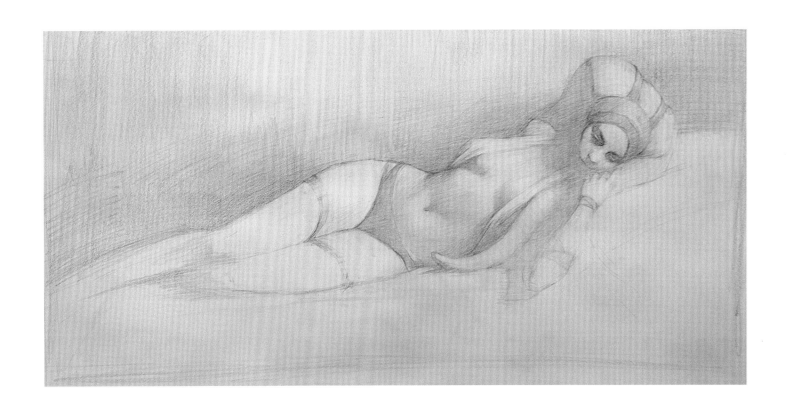

FOREWORD BY **GEORGE LUCAS**
INTRODUCTION BY **J.W. RINZLER**

ABRAMS, NEW YORK

TO BERNIE FUCHS AND SERGE MICHAELS

CONTENTS

PAGE 3:
JEREMY LIPKING
Preliminary sketch for *Yobana*

Pencil on paper
14 × 30 ˝

RIGHT:
JON DEMARTIN
Magic Hour

Oil on canvas
20½ × 50 ˝

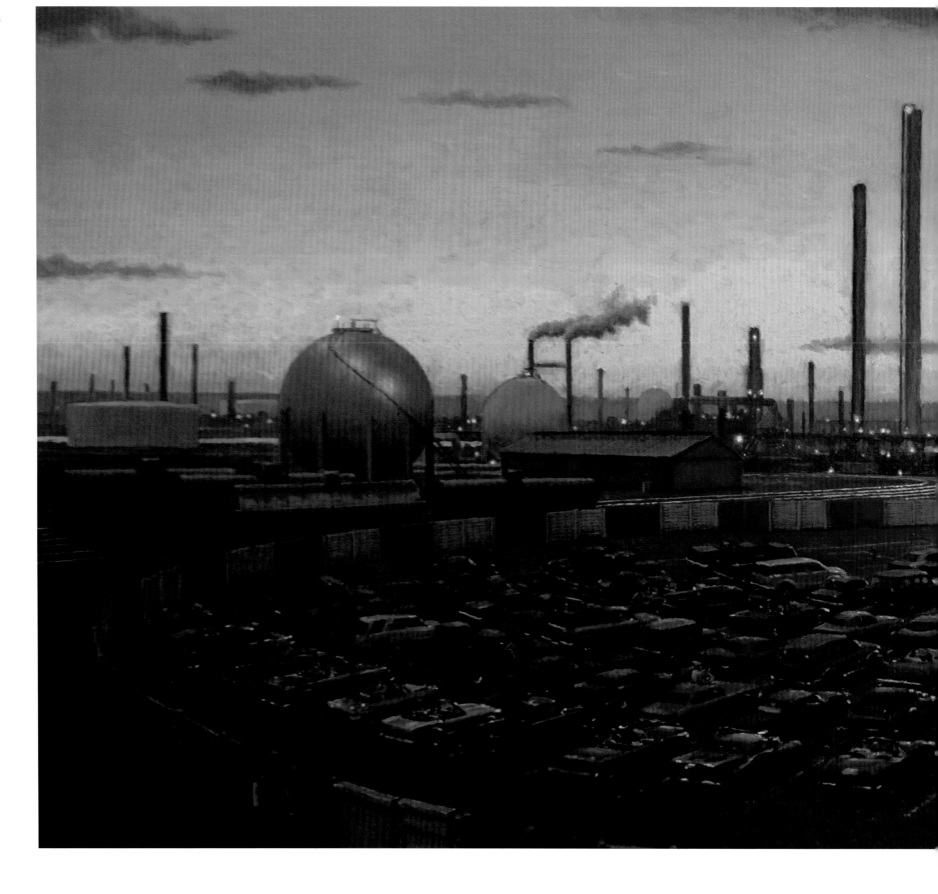

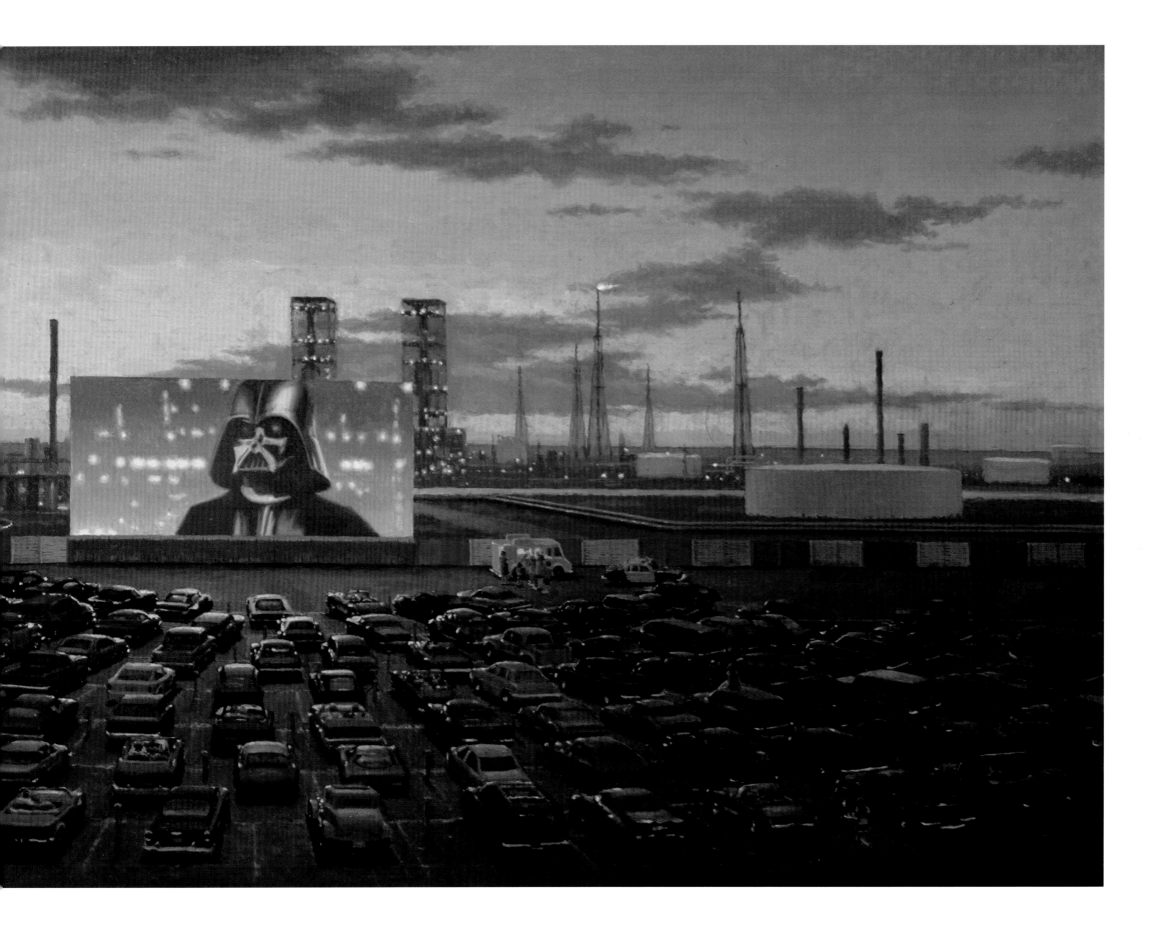

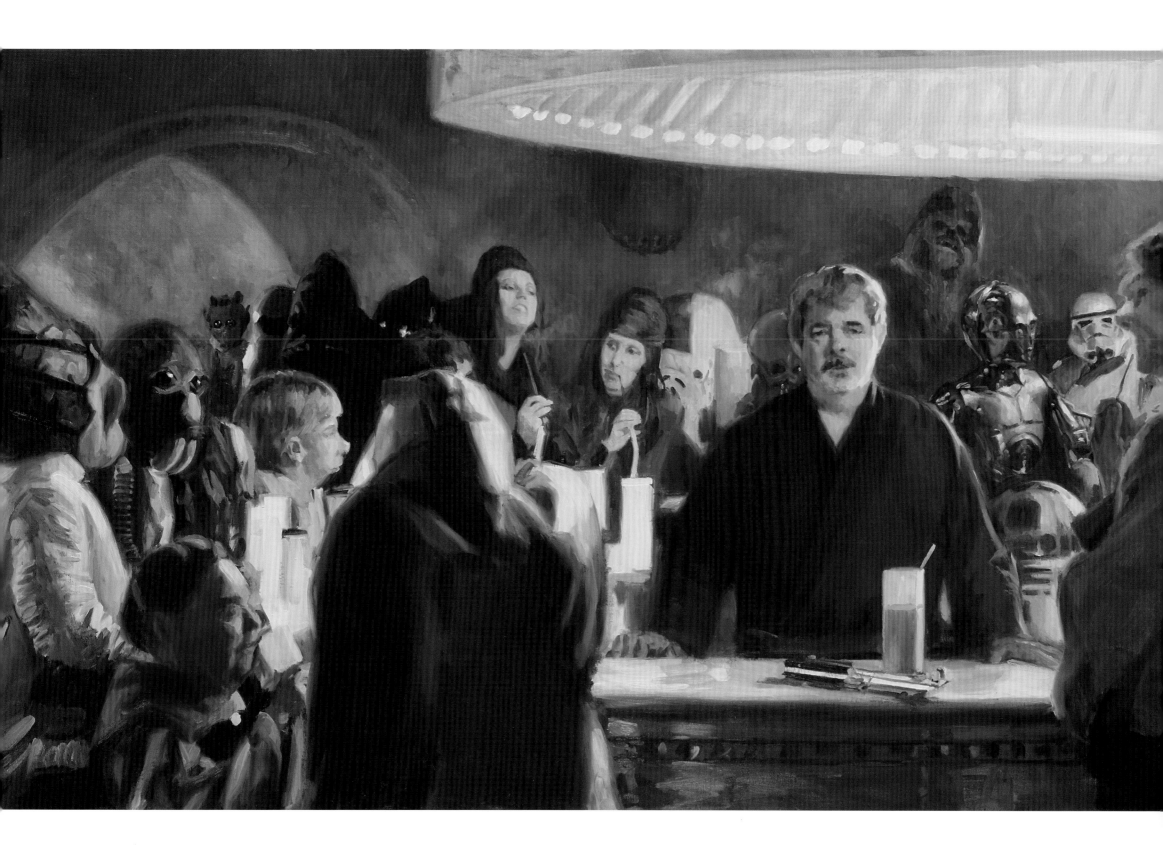

FOREWORD

Throughout my life, art has captivated and inspired me. When I was a kid, I was a big fan of the *Flash Gordon* comic strips by Alex Raymond and the science-fiction fantasy tales in EC comics illustrated by Wally Wood and others. I was also an admirer of artists such as Frank Frazetta and Al Williamson. Later I discovered the paintings of J. C. Leyendecker, Norman Rockwell, Maxfield Parrish, and the Italian Renaissance. Of course, there are many additional artists whose work has greatly influenced me—such as the unprecedented creative output from the teams guided by the genius of Walt Disney.

Thanks to my work making movies, I've had the good fortune of collaborating with some of the most talented contemporary artists, production designers, and visual effects masters in the industry—people like John Barry, Ralph McQuarrie, Norman Reynolds, Joe Johnston, Jim Steranko, and so many others. I even got to work with some of the people I admired as a kid, such as Williamson, Moebius, Philippe Druillet, and Mort Drucker—the legendary *MAD* magazine artist who drew the poster art for my second feature film, *American Graffiti*.

In one way or another, every artist that I've admired has inspired me in the creation of my films. They each bring a unique perspective to the works they create, and they enable us to see things—real or imagined—from a different point of view. And each has contributed, either directly or indirectly, to shaping the vision that I have expressed in the six films of the *Star Wars* Saga.

As *Star Wars* began to take on a life of its own, it was especially gratifying to see so many new artists expand on the Saga through our licensing program and elsewhere. And that led to the thought that was really the impetus for this project: Asking a select group of great contemporary artists, of many different genres and styles, to create interpretations of *Star Wars*.

The results have exceeded my expectations, in terms of both the quality and the breadth of the visions expressed in each of these unique artworks. I am grateful to each of the enormously talented artists who contributed to *Star Wars Art: Visions*, and hope that you enjoy their works as much as I have.

George Lucas
Skywalker Ranch

LEFT:
PAUL G. OXBOROUGH
The Mos Eisley Cantina with George Lucas as the Bartender

Oil on linen on stretchers
36 × 72 ″

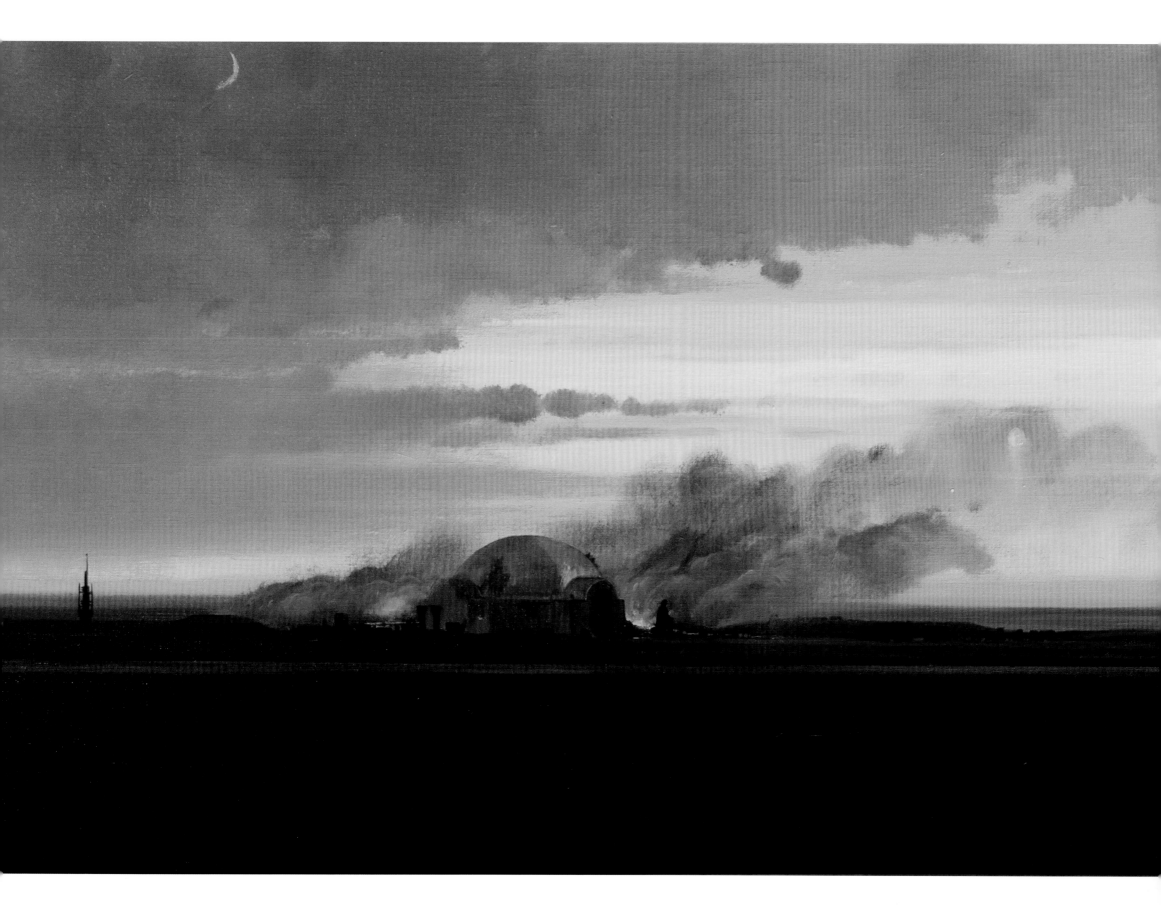

PREFACE

SINCE THE ADVENT of filmed entertainment, it seems every generation has had a film or films that captured its collective consciousness. For my grandparents it was *Gone With the Wind* and *The Wizard of Oz*. For my parents it was *2001: A Space Odyssey* and *Psycho.* For me it was, undeniably, *Star Wars.* The emotion of the story, the trip to distant worlds, and a whole new universe of possibilities reached right out from the screen on a summer day in 1976 and captured my imagination. It was inspiring. It was visionary.

No other picture in our entertainment history has generated so much fan involvement, what with all the conventions and celebrations (even Disney World has *Star Wars* weekends), licensed products, clubs and fan organizations, online forums, collectors, gamers . . . I could go on all day! *Star Wars* has truly become ingrained in our popular culture. I feel fortunate to have been in the theater when it all started, and through the years I have been amazed at the variety of fans from all over the world. I've talked to *Star Wars* fans who include politicians, movie directors, a professional football coach, models, a Japanese diplomat, astronauts, doctors, writers, actors, attorneys, teachers, a theology professor, a group of naval architects, several fighter pilots, engineers, a fishing guide, authors, Olympians, a NASA administrator, famous photographers, and scores of artists.

Some fans have been inspired to invest untold thousands on exacting costume replications. Some become members of various fan organizations; others fill entire rooms (and in a few cases warehouses . . . yes, actual industrial storage spaces) devoted to their *Star Wars* Collections. (Lest I appear to cast stones, let me disclose that visitors to my office will find a dense collection of prop replicas, art, and books.) The point I'm trying to make is that people (including me, if not my very accommodating wife) the world over have been inspired to the point of expressing their inspiration in so many ways. For this book, George Lucas has sought out fine artists, illustrators, comic book gods, and other artists and asked them the question, "What is your vision for *Star Wars*?" The overwhelming response from this group of artists was truly astonishing. Setting aside very busy schedules, events, commissions, and personal commitments, these artists have stepped up to the challenge and brought forth exciting, provoking, fun, and fanciful "visions" of *Star Wars.* The results range from the literal to the abstract and comprise a unique collection of art created by artists who have all shared in the inspiration that is *Star Wars.*

Sean McLain
Acme Archives

LEFT:
NICHOLAS COLEMAN
To Be a Jedi

Oil on board
18 × 32 ″

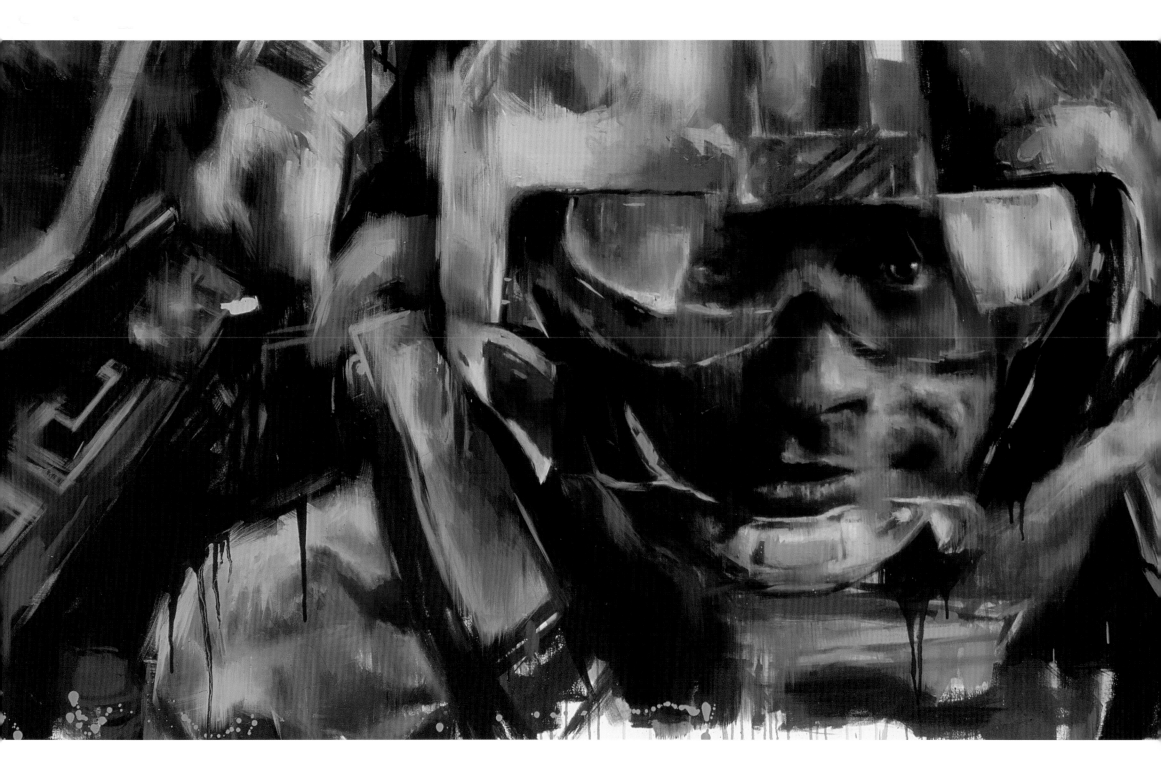

INTRODUCTION

For more than a year on Fridays, I often met with George Lucas in the Main House of Skywalker Ranch to work on a special book. On November 4, 2005, George turned to me and said that he'd like to start on another big idea, an interpretative art project. We could turn it into a book that brought together a variety of artists from different disciplines, all of whom would do their vision of *Star Wars*. They would be free to create whatever they wanted—landscape, portrait, still-life, new scenes, new characters, satire, allegory—as long as the artwork was in the spirit of the movies.

"Take a look at the artists in *Heavy Metal* magazine, manga, and the top illustrators," George said. "We could do something a little different. We could ask comic book artists to participate, the most exotic and interesting people—we could do something unexpected."

The first artist mentioned by name was Jamie Wyeth. "These guys will be among the best, not easy to recruit," he added. "We'll need a really broad range, with women illustrators and a few from the avant-garde."

George's ideas, like this one, often require new systems to be put into place, new ways of thinking. We had to find a creative publisher—Abrams stepped up—and we had to find the artists. Lists were drawn up, additional lists, and more lists—it was an ongoing four-year search. Acme Archives was enlisted to help. The Internet was a key exploration-and-discovery tool. Gallery curators helped in a few key instances. Friends offered a name. And not every artist approached signed on—though I believe we batted above .500.

Initial conversations with a candidate usually involved a brief mention of the parameters followed by, "I'm in!" Sometimes, it was a longer conversation, followed by a few days or weeks to think about it and then—"My kids say I *have* to do it!" In a few cases, grandkids came to our rescue.

Ultimately, *Star Wars Art: Visions* has succeeded in bringing together painters from several diverse art genres: Western; fantasy; science fiction; comic book; military aviation; historical; automobile racing; film production; abstract; parody; and the figurative fine arts (which are seeing a great resurgence in the United States thanks to many of the men and women in this book). We have been extremely fortunate to count among our visionaries a few of the foremost in all of these disciplines, including those who stand at the very pinnacle of their careers and those who have only recently begun.

It has been a once-in-a-lifetime opportunity and I feel that I've been most fortunate in meeting with many unforgettable artists—Paul Oxborough, Harley Brown, Dan Thompson, Noah Buchanan, Evan Wilson, Nelson Boren, Ciruelo Cabral, Robert Bailey, and others—who either made the trip to Skywalker Ranch or with whom the collaboration on *Visions* became more than a quick telephone call.

What brought everyone together of course was the common denominator of George Lucas and *Star Wars*. The interpretative artworks, as expected, offer a great variety, from Americana to the style of the Italian Renaissance, from portraits to futurism, landscapes, and caricature; from many visions of Darth Vader, Princess Leia, and the Cantina scene to singular versions of the sandcrawler and Twi'leks.

Our hope is that anyone who picks up this book will be surprised, delighted, and transported; perhaps even inspired to take up a pencil or paintbrush. Perhaps the next volume will include their artwork.

J. W. Rinzler
Executive Editor
Lucasfilm

LEFT:
JÉRÔME LAGARRIGUE
Untitled

Oil on canvas
42 × 82 ˝

THE PLATES

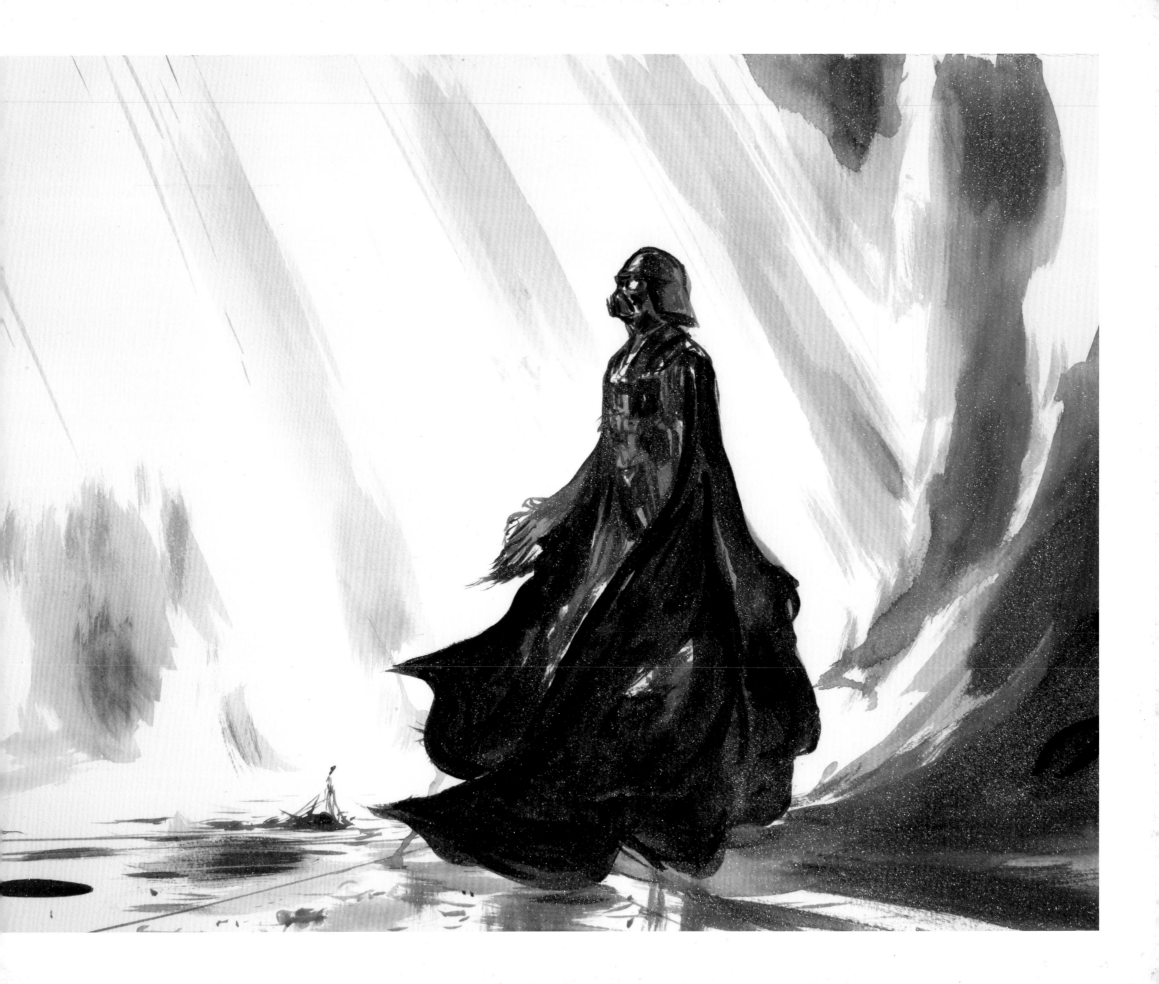

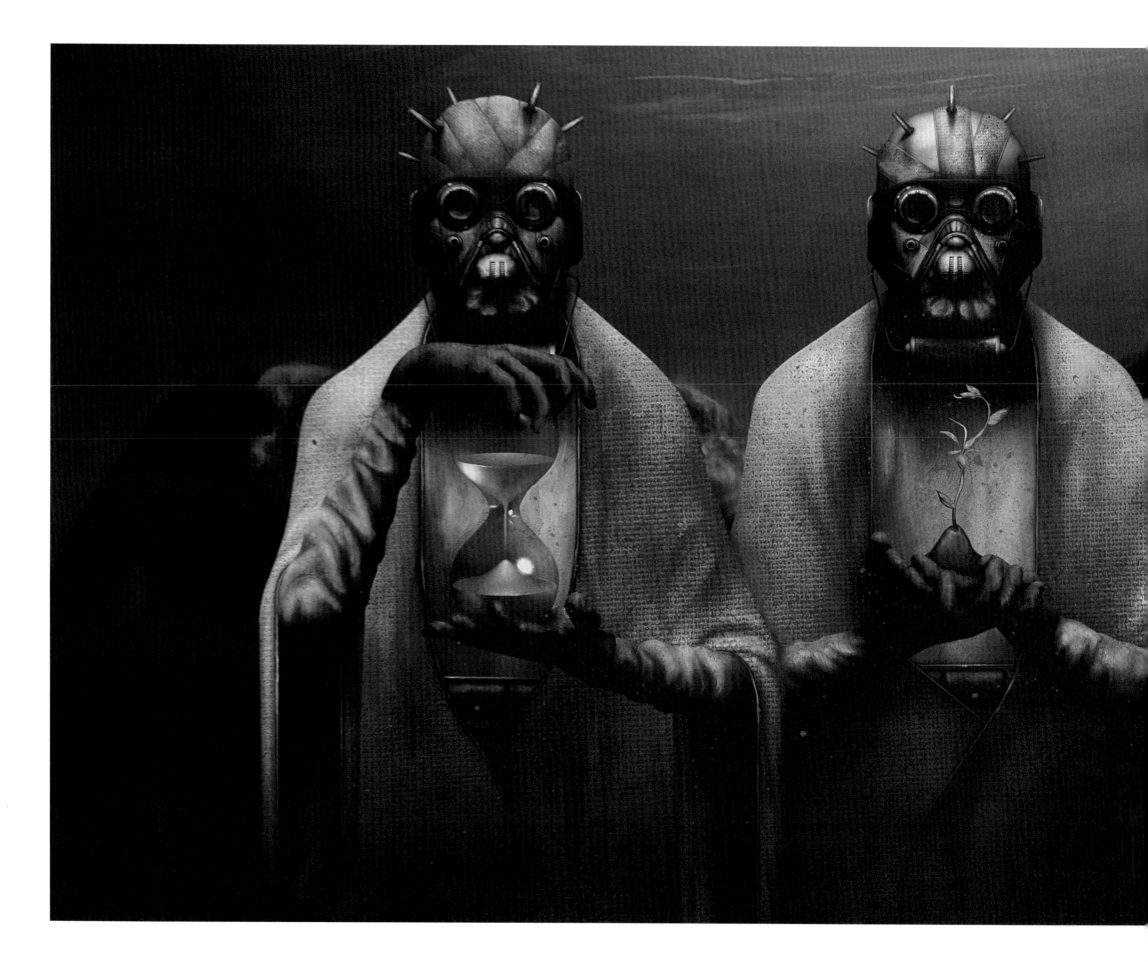

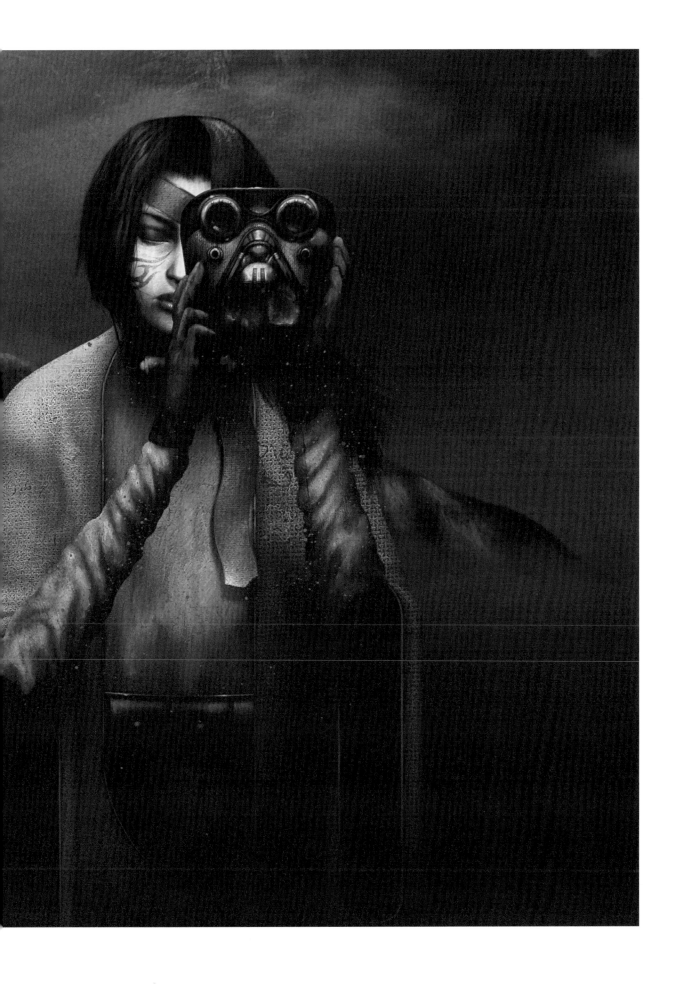

LEFT:
DAVID HO
The Sacrifice

Digital/mixed media
18 × 32 "

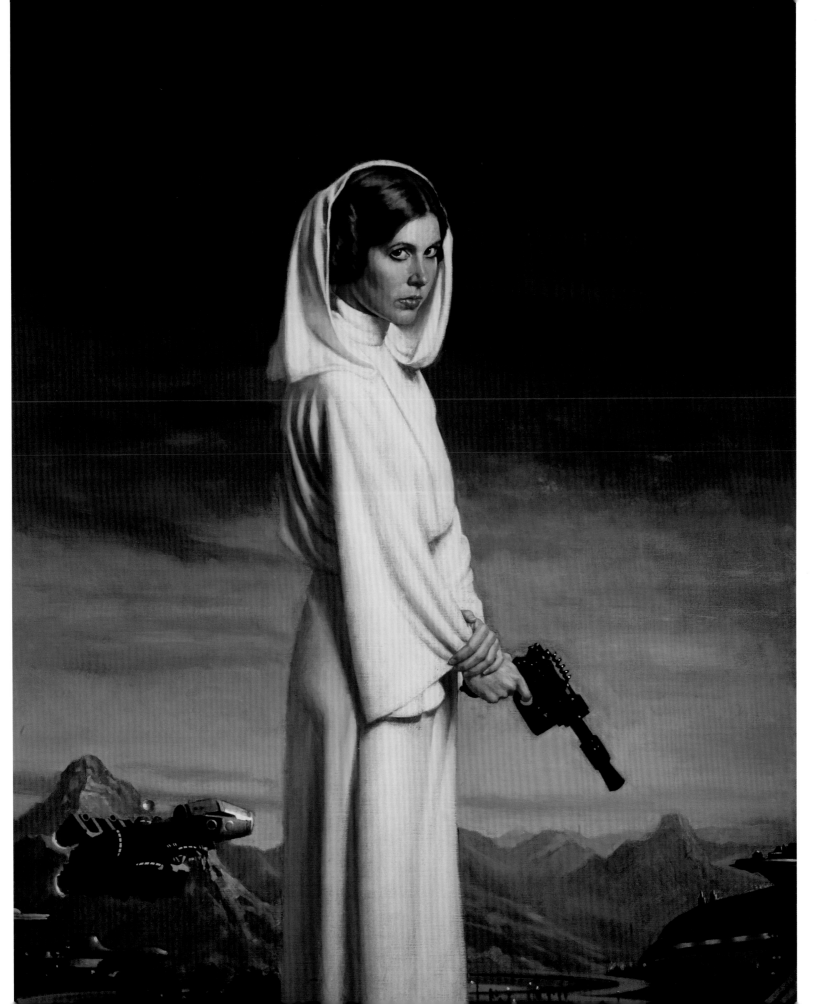

LEFT:
DANIEL E. GREENE, N.A.
Princess Leia

Oil on linen
50 × 32 ″

RIGHT:
RAYMOND SWANLAND
Shadows of Tatooine

Digital/mixed media
30 × 20 ″

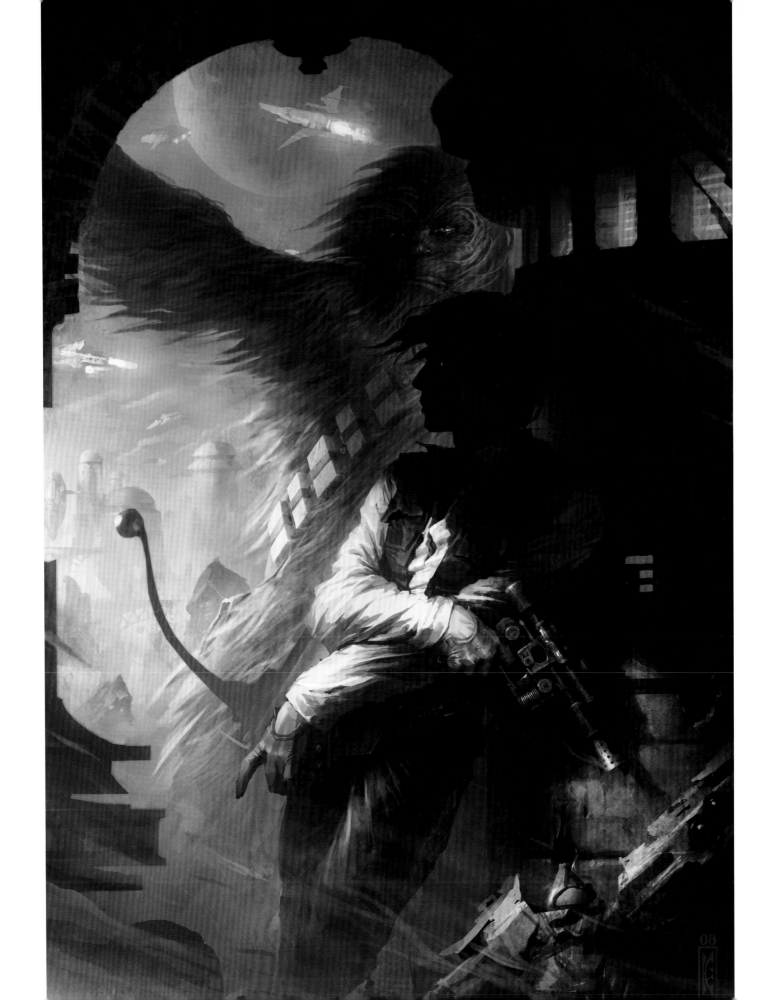

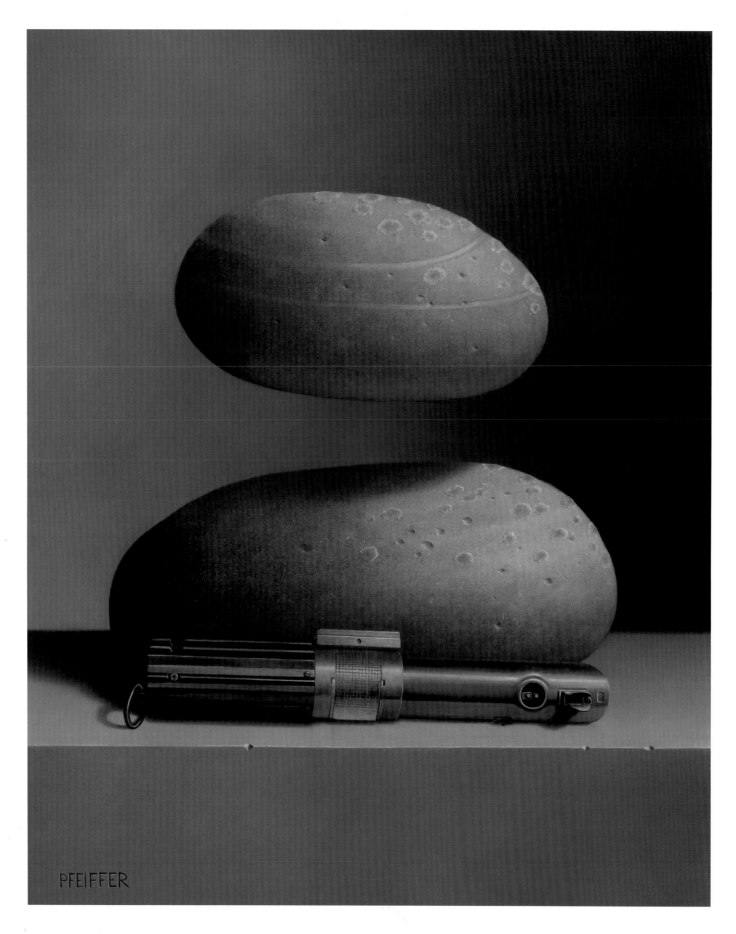

PFEIFFER

LEFT:
JACOB A. PFEIFFER
Luke's Lesson

Oil on panel
18 × 14 ˝

RIGHT:
ALEX ROSS
Empire of Style

Gouache/airbrush
36 × 19 ˝

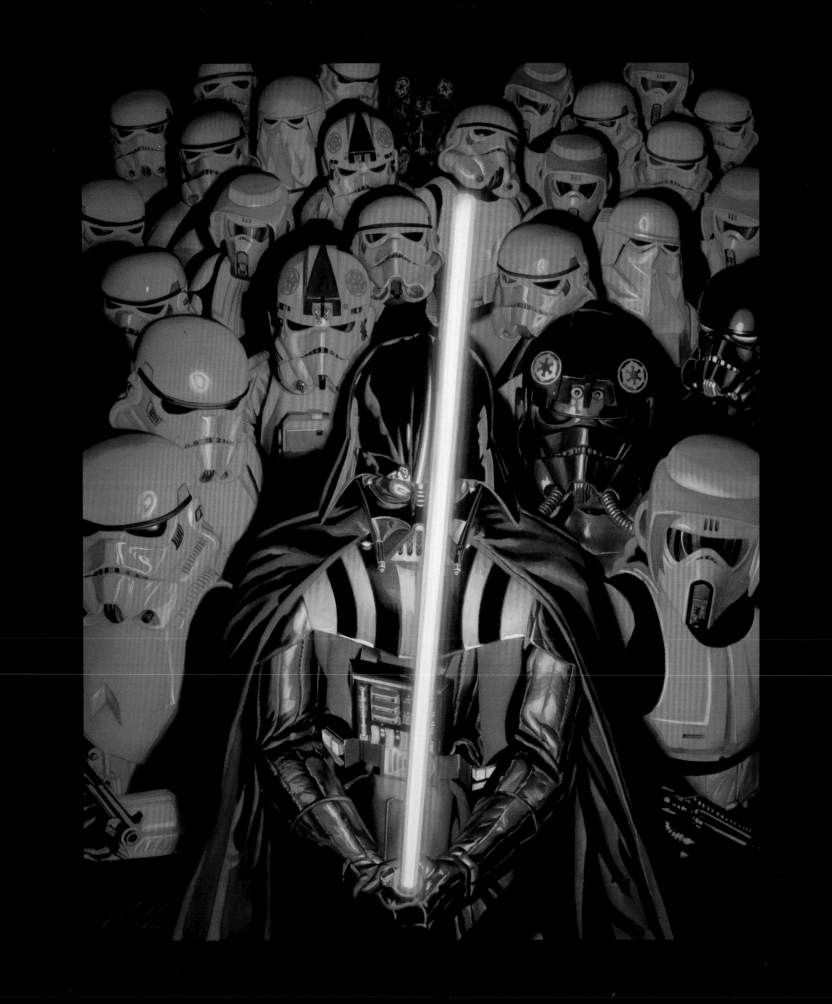

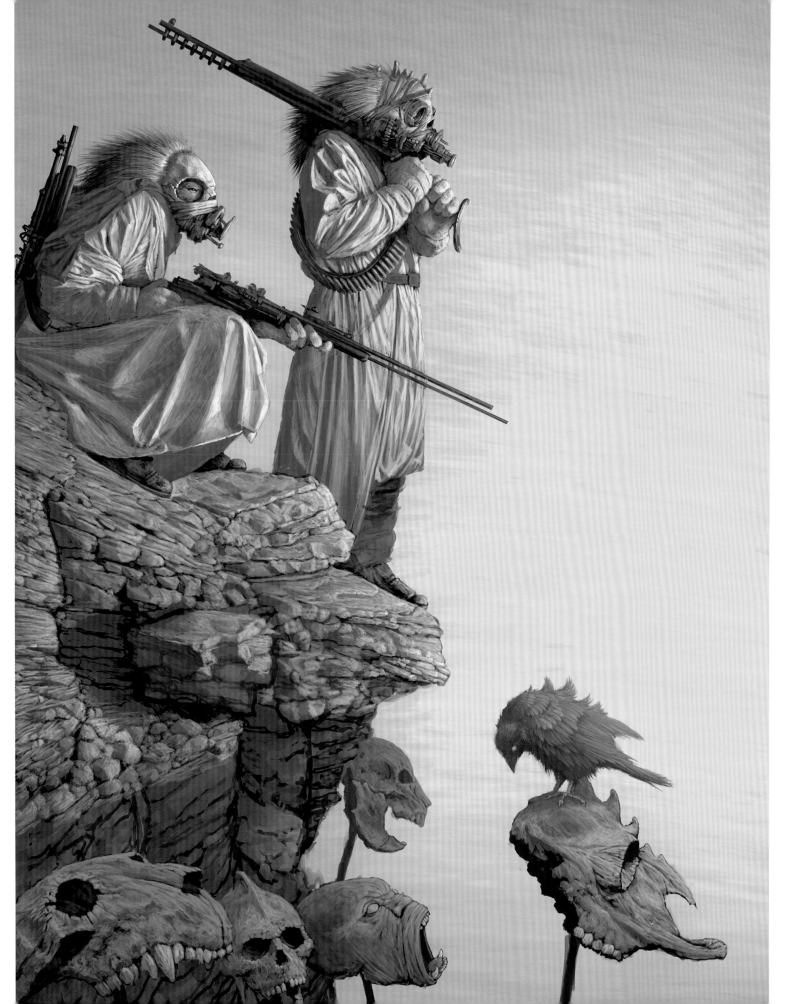

LEFT:
ED BINKLEY
Tusken Sentries

Mixed media
40 × 30 ˝

RIGHT:
TONY CURANAJ
*A Good Find: Portrait of a
Tusken Raider*

Oil on canvas
18 × 13 ˝

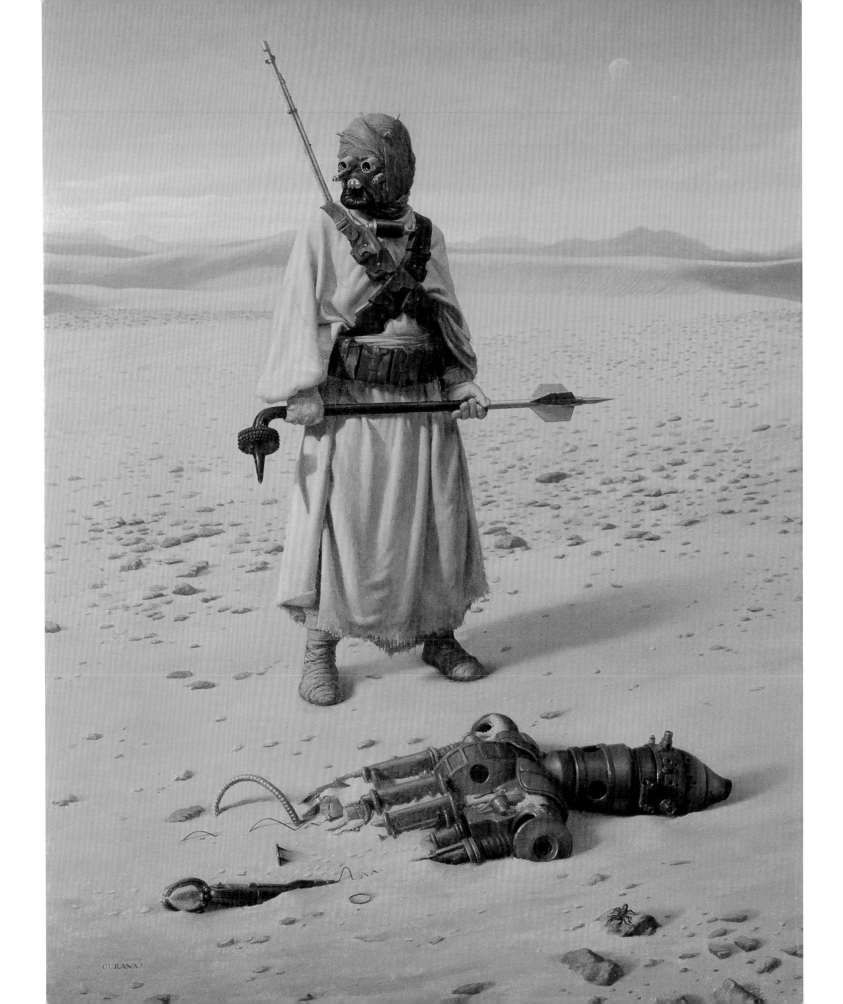

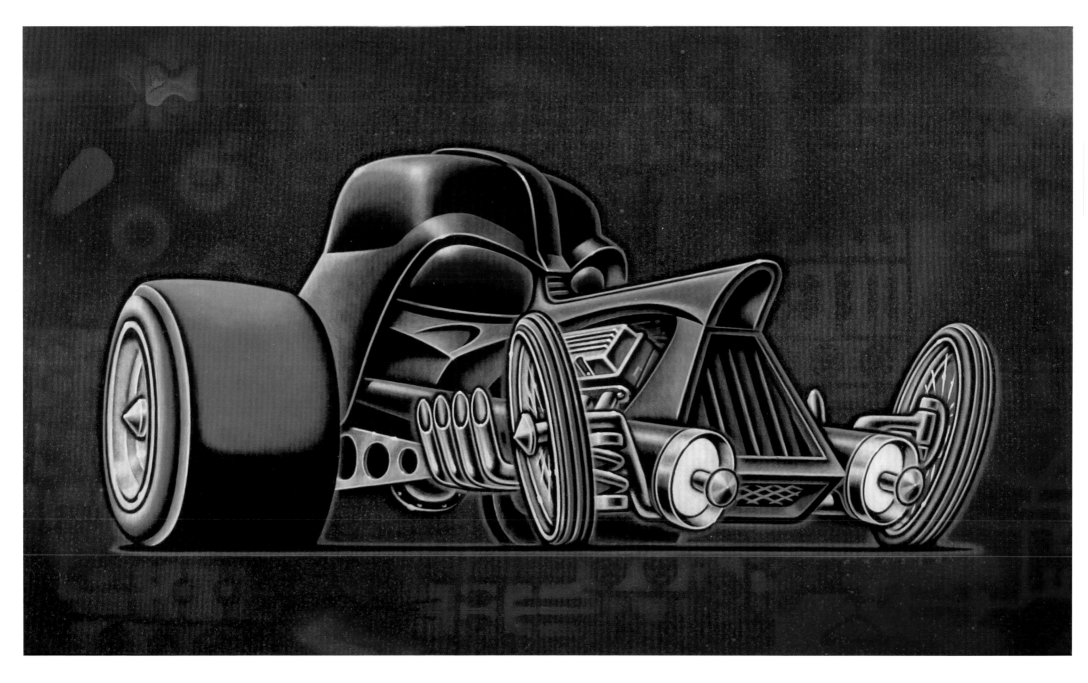

LEFT:
DORIAN CLEAVENGER
Darth Simi

Acrylic on illustration board
20 × 30 ˝

ABOVE:
DOUGLAS FRASER
¹⁄₂₄th Scale

Alkyd (oils) and Testors spray
model paint on masonite hardboard
12 × 20 ˝

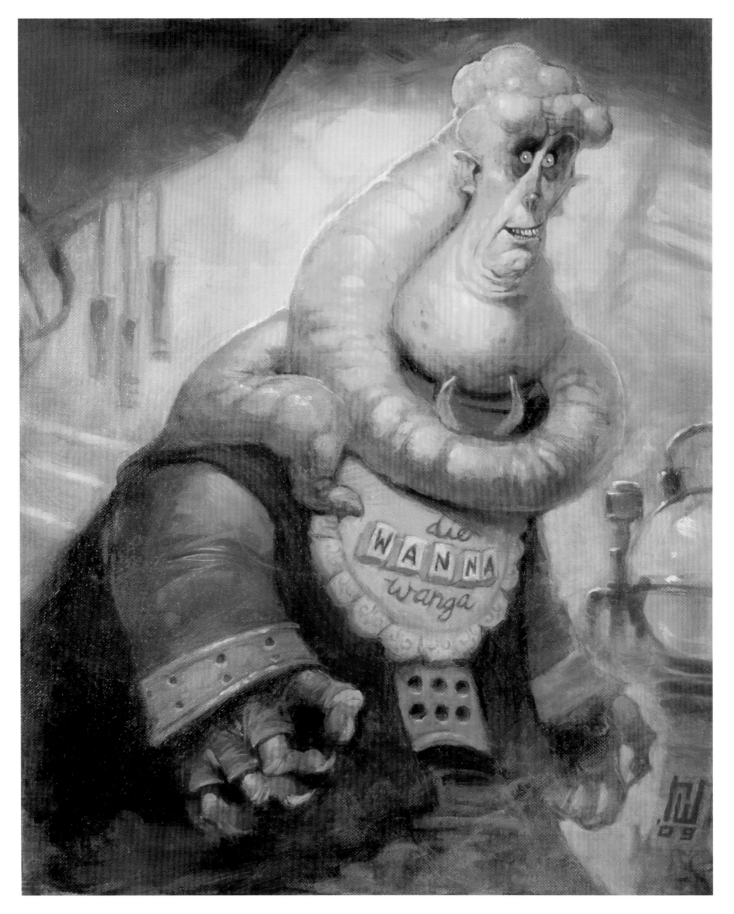

LEFT:
RYAN WOOD
Die Wanna Wanga

Oil on canvas
30 × 20 ″

RIGHT:
MAYA GOHILL
Wookiee Family Portrait

Oil on canvas
29 × 23 ″

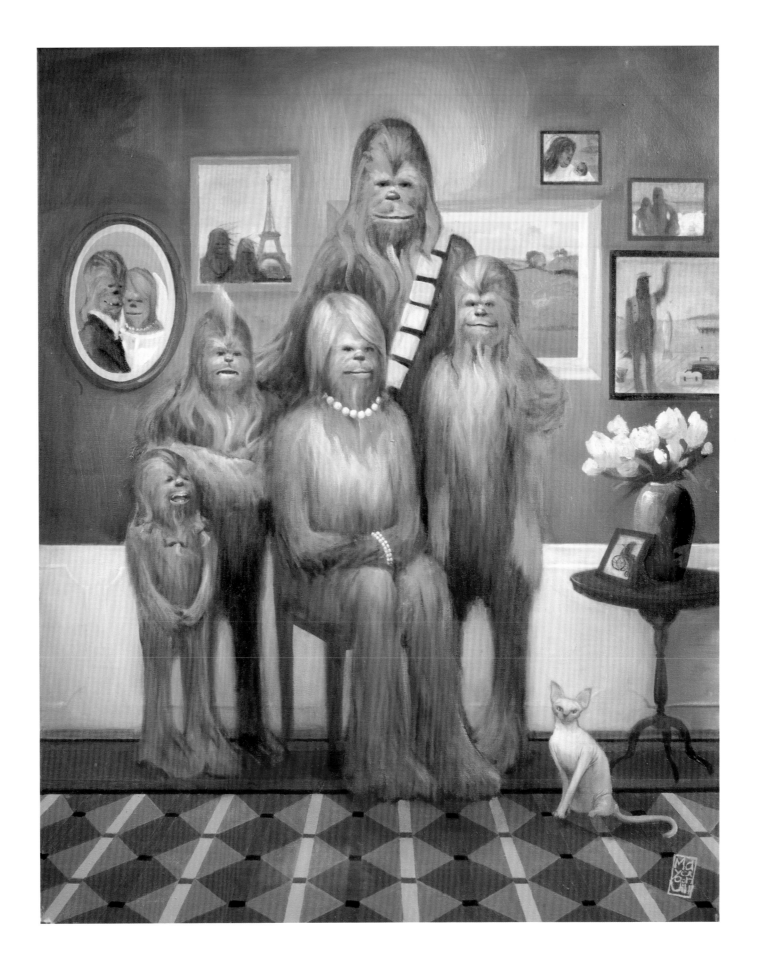

RIGHT:
RANDALL WILSON
Star Destroyer in for Repairs

Oil on canvas
26 × 38 ″

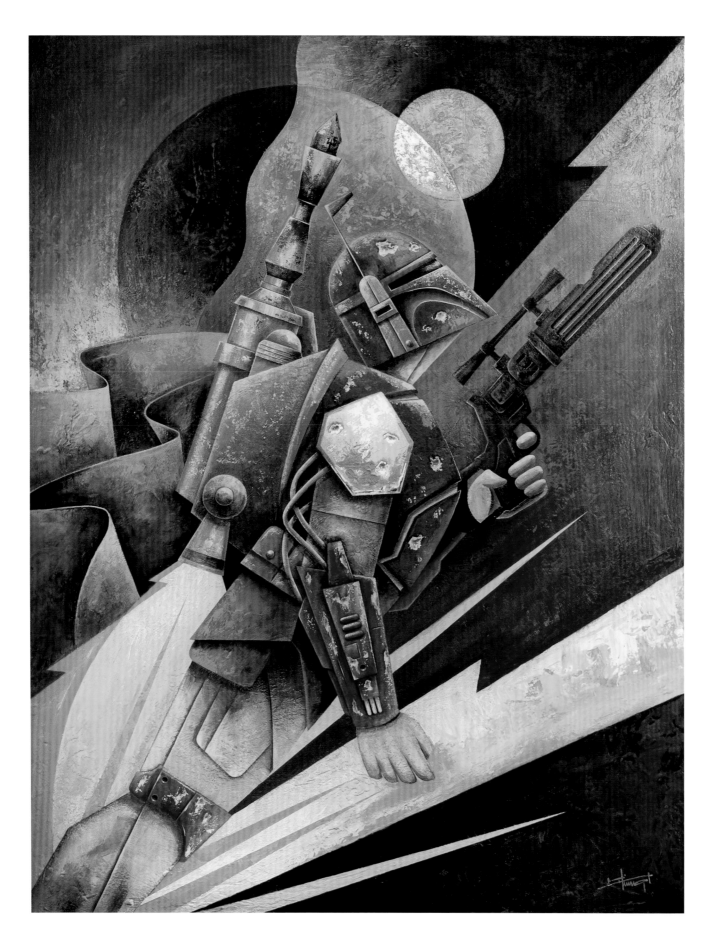

LEFT:
M. KUNGL
Boba Fett, "The Hunter"

Mixed textured media on canvas
40 × 30 ˝

RIGHT:
RUDY GUTIERREZ
The Exorcism of Darth Vader

Acrylic painting
40 × 30 ˝

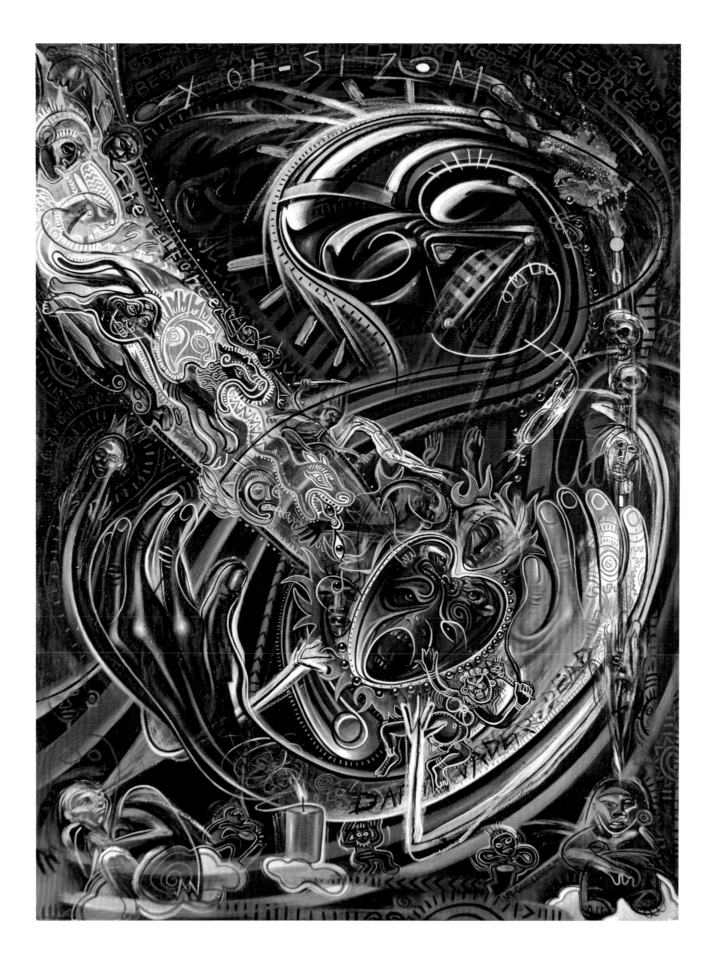

RIGHT:
IVAN BERRYMAN
Hot Pursuit

Oil on canvas
20 × 30 ″

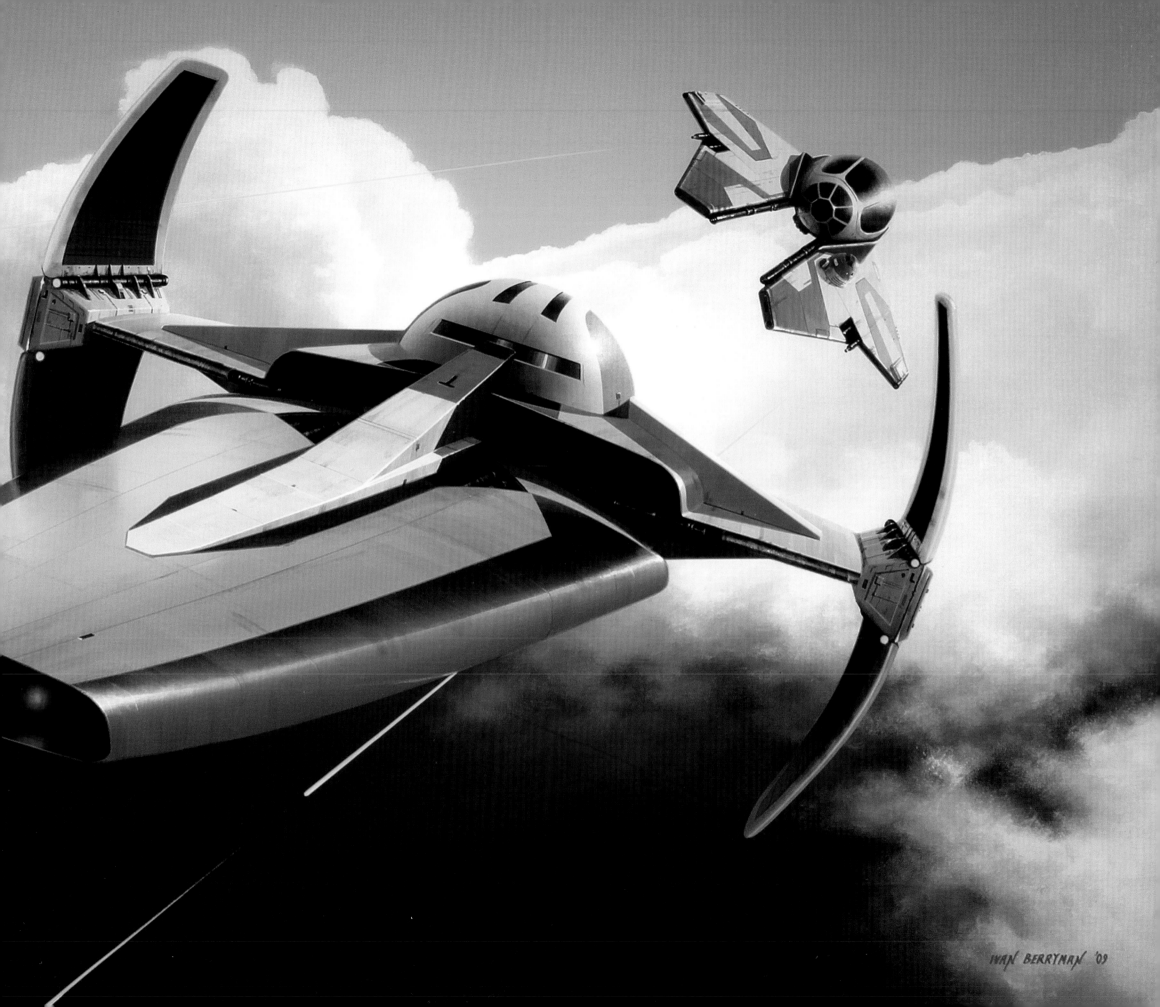

IVAN BERRYMAN '09

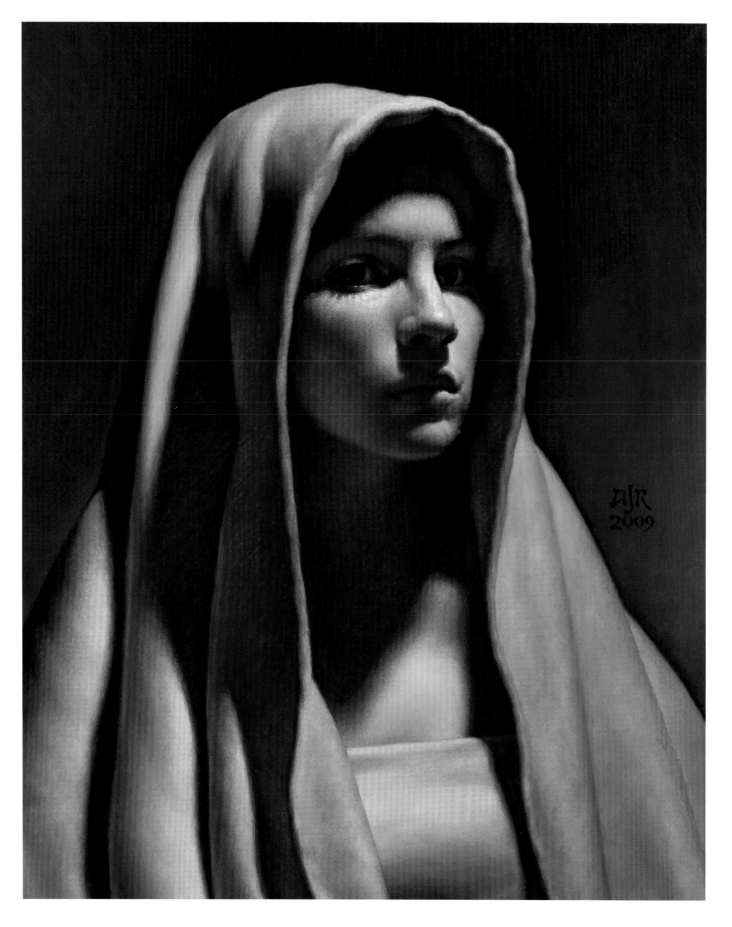

LEFT:
ANTHONY J. RYDER
Pia

Oil on linen
18 × 14 ″

RIGHT:
SCOTT M. FISCHER
Fem Trooper

Oil on canvas
24 × 18 ″

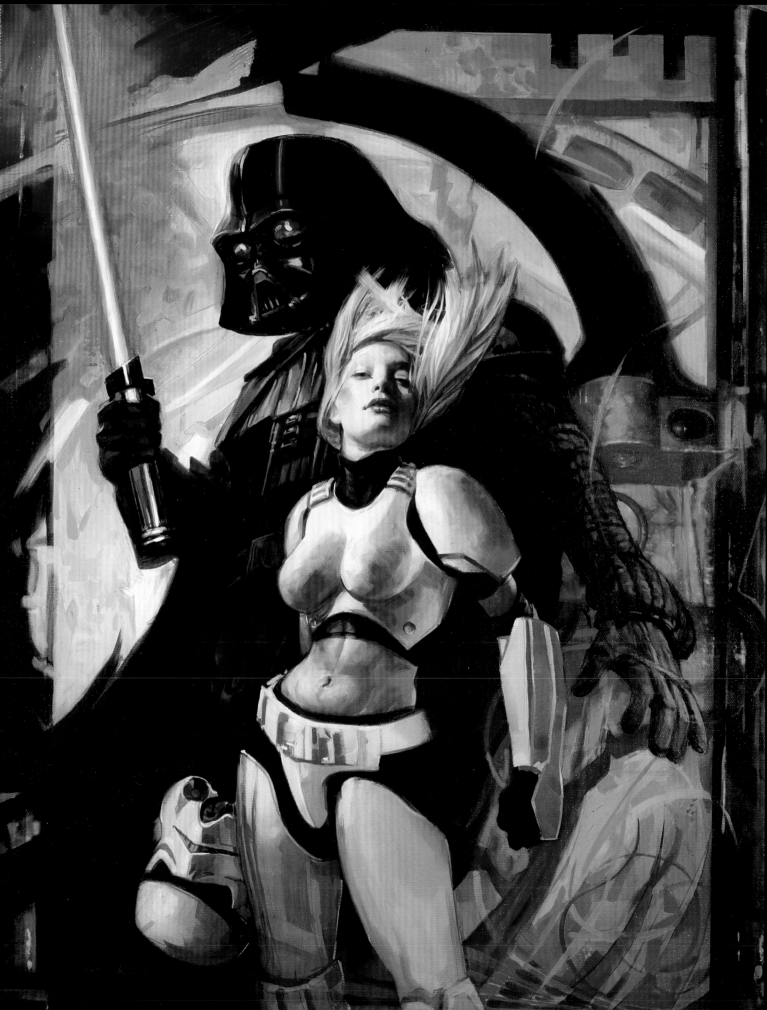

041

Lots o'Luck ♡ J.D. Yuma Re...

BA D. TIURE

"J. D."

DRAMA CLUB

C.L.C. 2-3

HONOR ROLL 4

Watch your back!!

Ree-Yees

REEDO JONS

GLEE CLUB 1-4

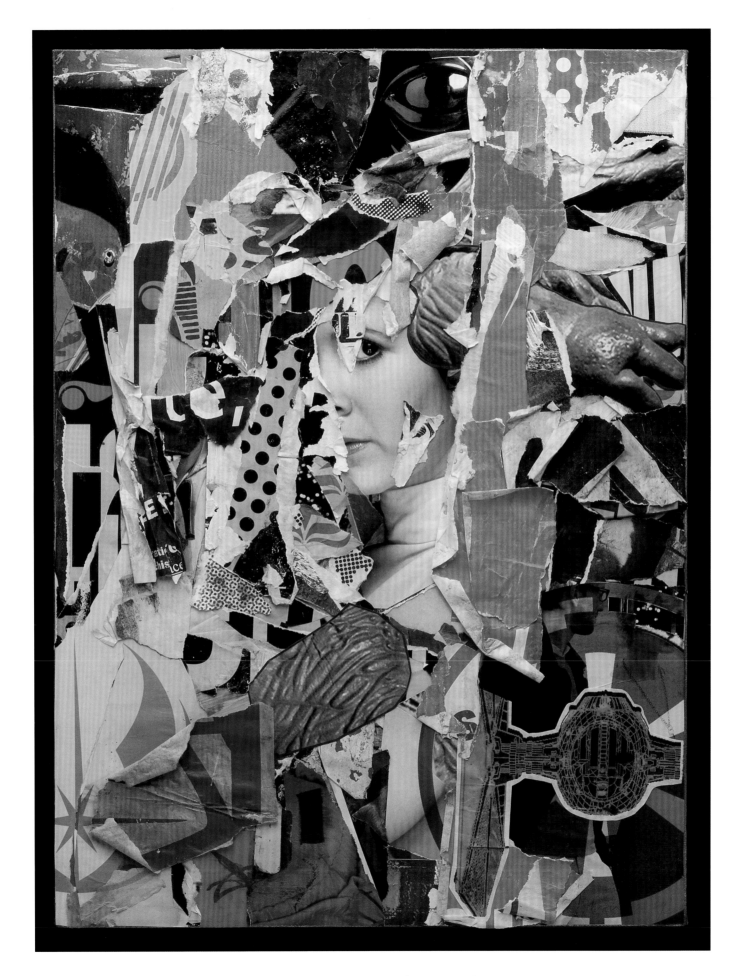

LEFT:
C. F. PAYNE
Jabba the Hutt: High School Reunion

Mixed media on board
17 × 11 ˝

RIGHT:
STEPHEN JOHNSON
LEIAPOP!

Collage on canvas
22⅛ × 16 ˝

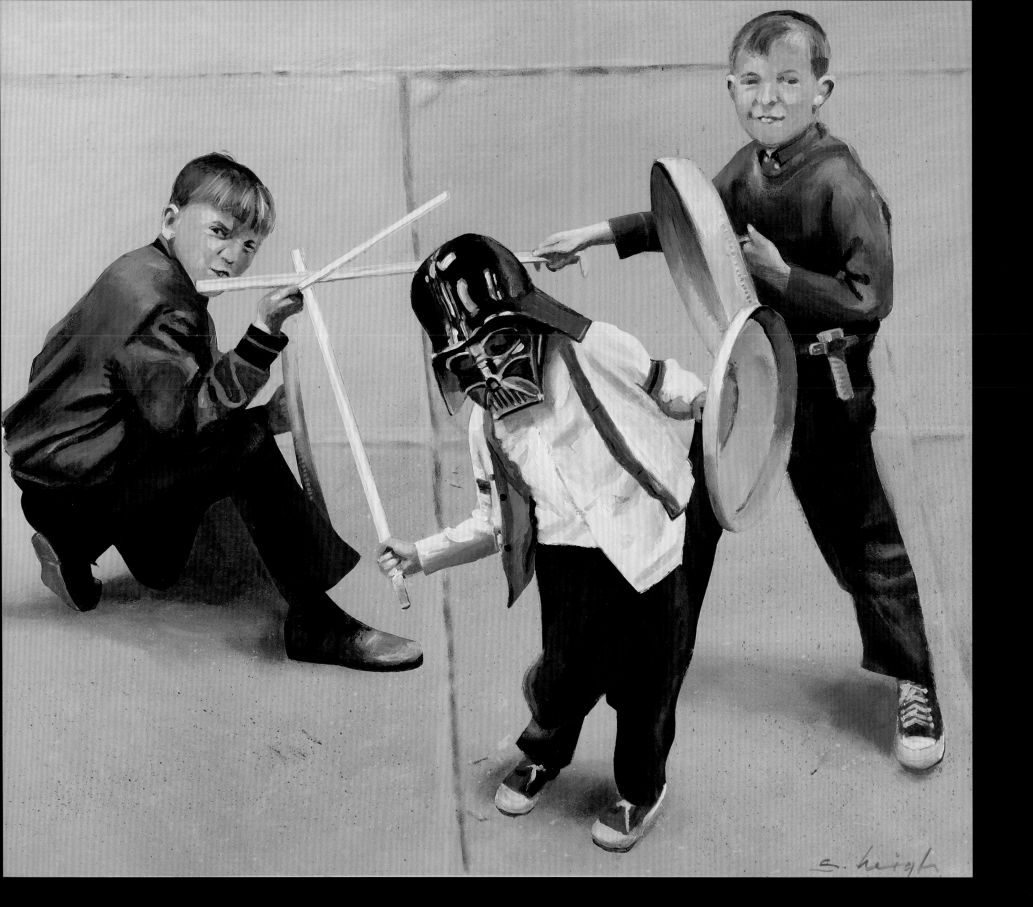

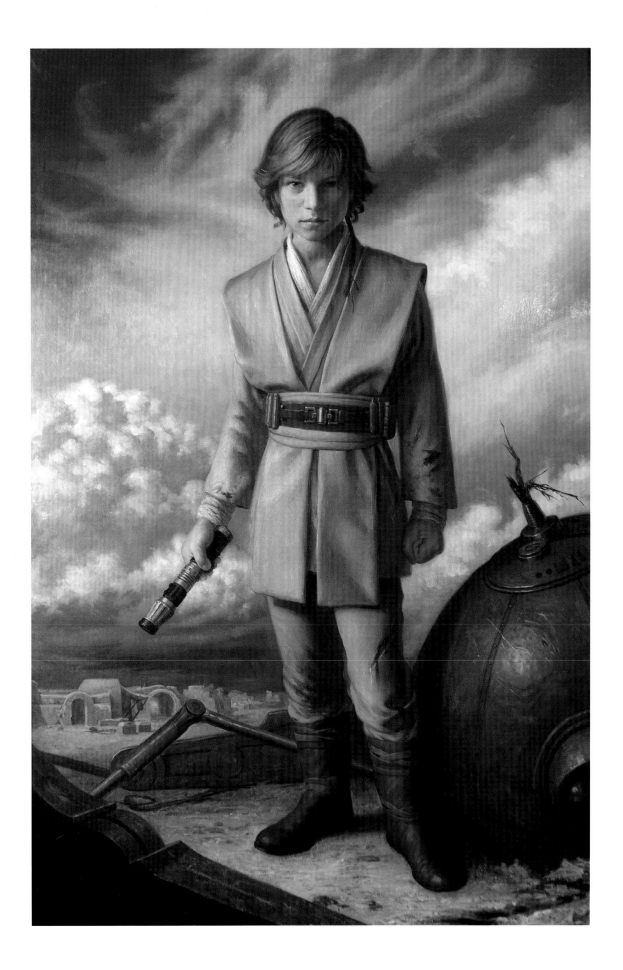

41

LEFT:
STEPHEN HEIGH
Backyard Jedi

Acrylic on museum board
13½ × 15˝

RIGHT:
PATRICIA WATWOOD
Anakin, Padawan

Oil on canvas
44 × 28˝

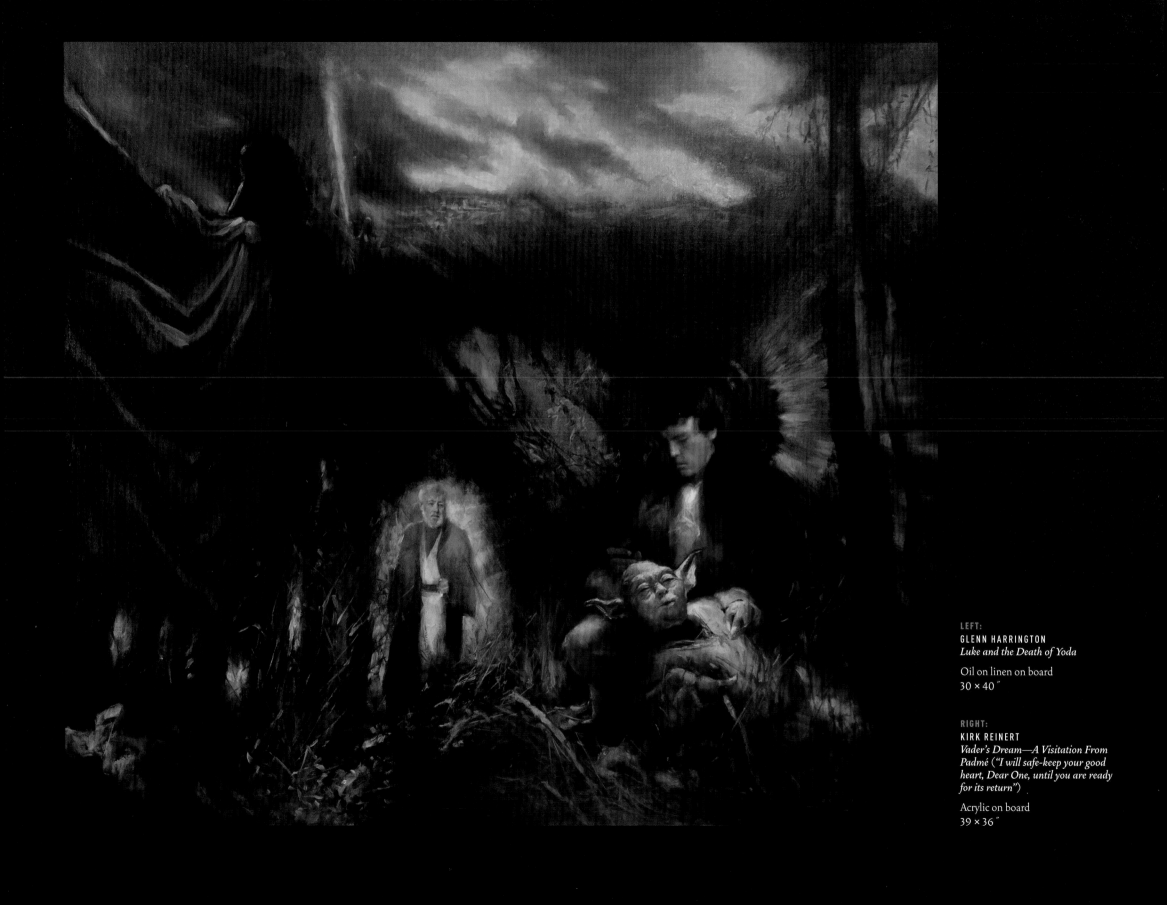

LEFT:
GLENN HARRINGTON
Luke and the Death of Yoda

Oil on linen on board
30 × 40 ˝

RIGHT:
KIRK REINERT
Vader's Dream—A Visitation From Padmé ("I will safe-keep your good heart, Dear One, until you are ready for its return")

Acrylic on board
39 × 36 ˝

44

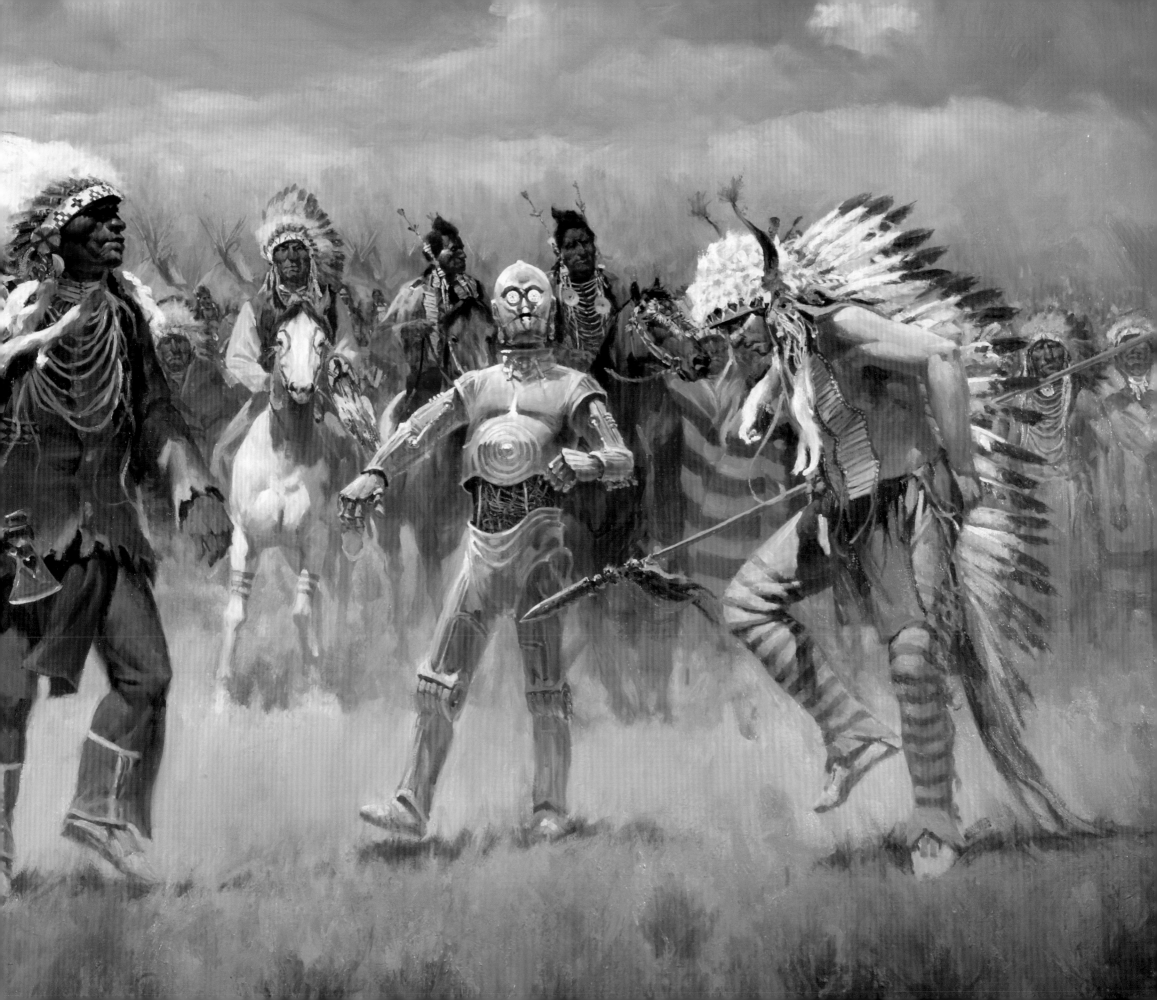

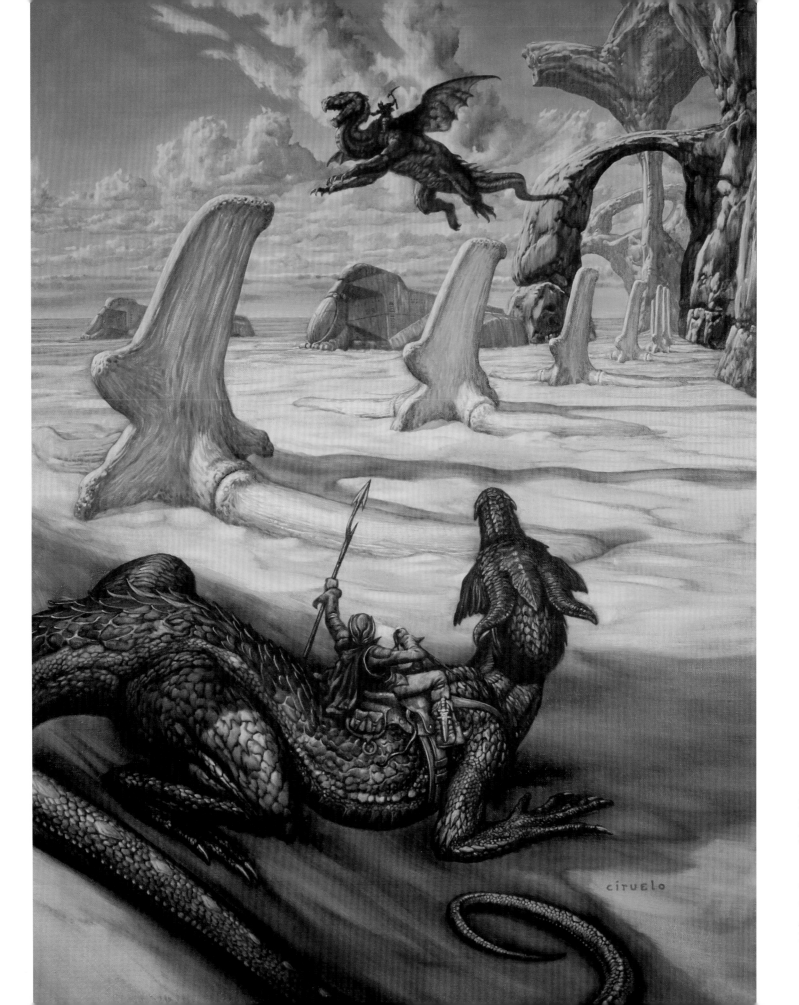

46

CIRUELO

LEFT:
CIRUELO CABRAL
Tatooine

Oil on canvas
28 × 20″

RIGHT:
TOM ALTENBURG
Use the Force

Acrylic on panel
17½ × 19½″

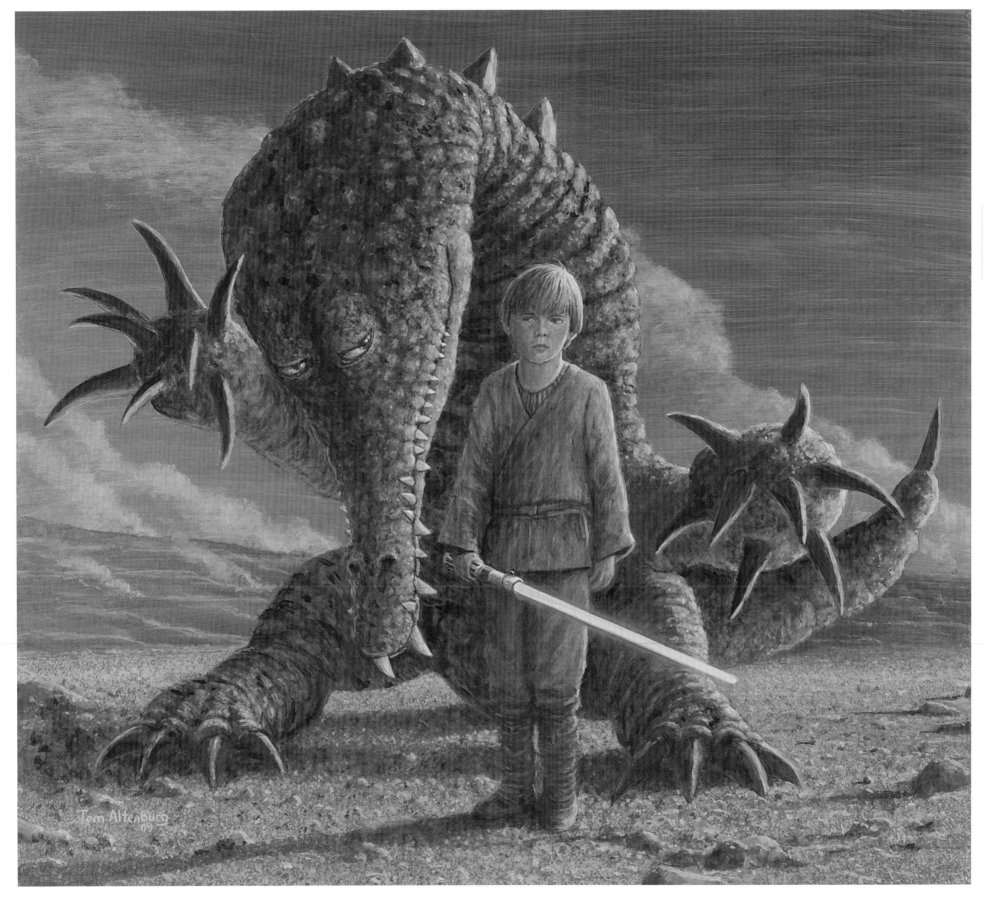

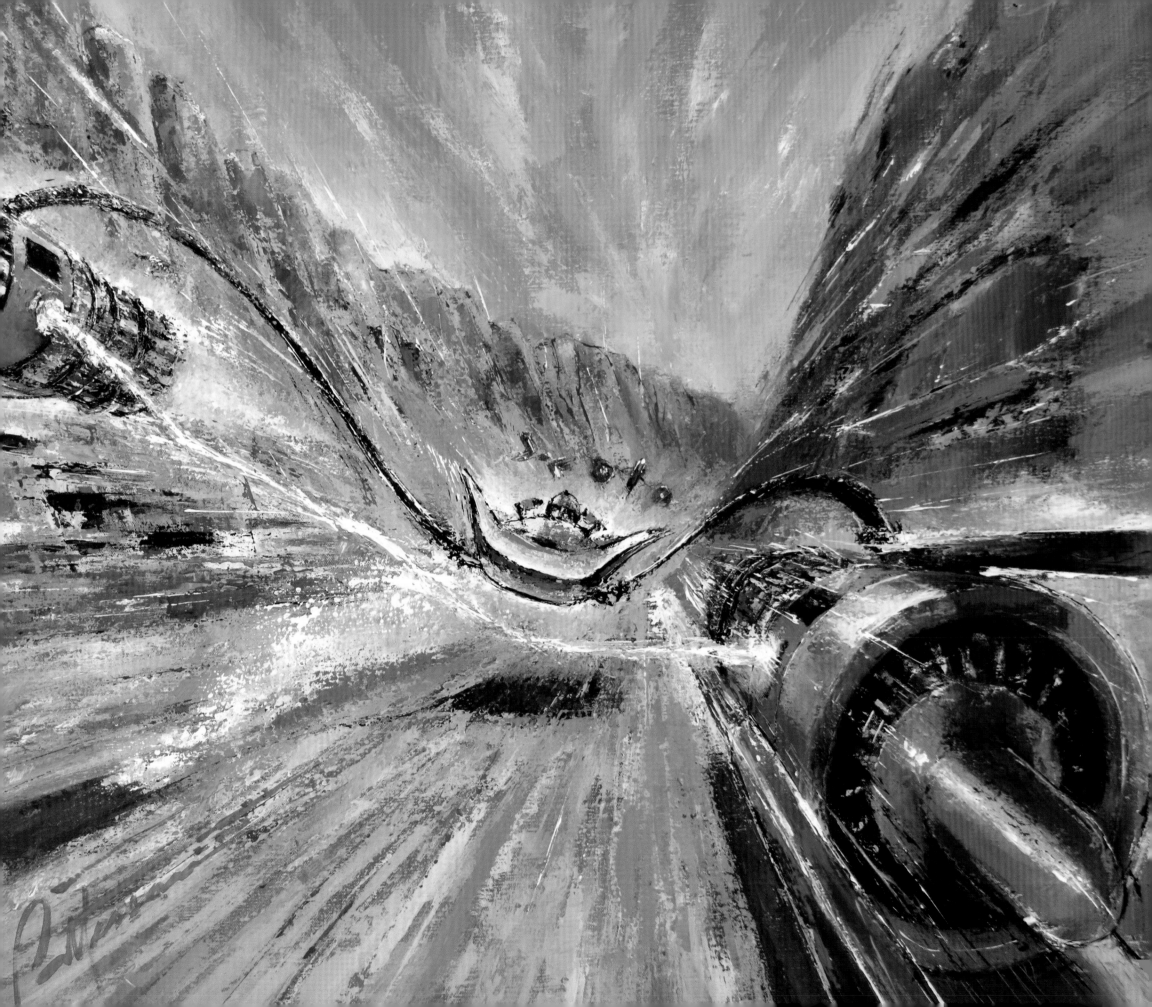

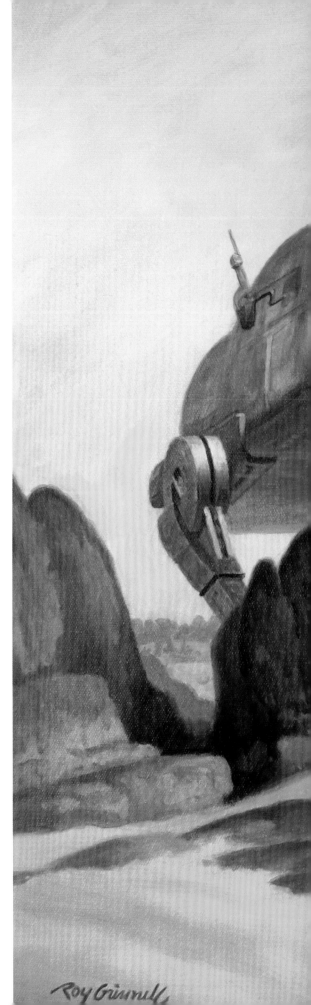

RIGHT:
ROY GRINNELL
*"Wait . . . The Droid Just Wants To
Say Hello!"*

Oil on canvas
20 × 30 ˝

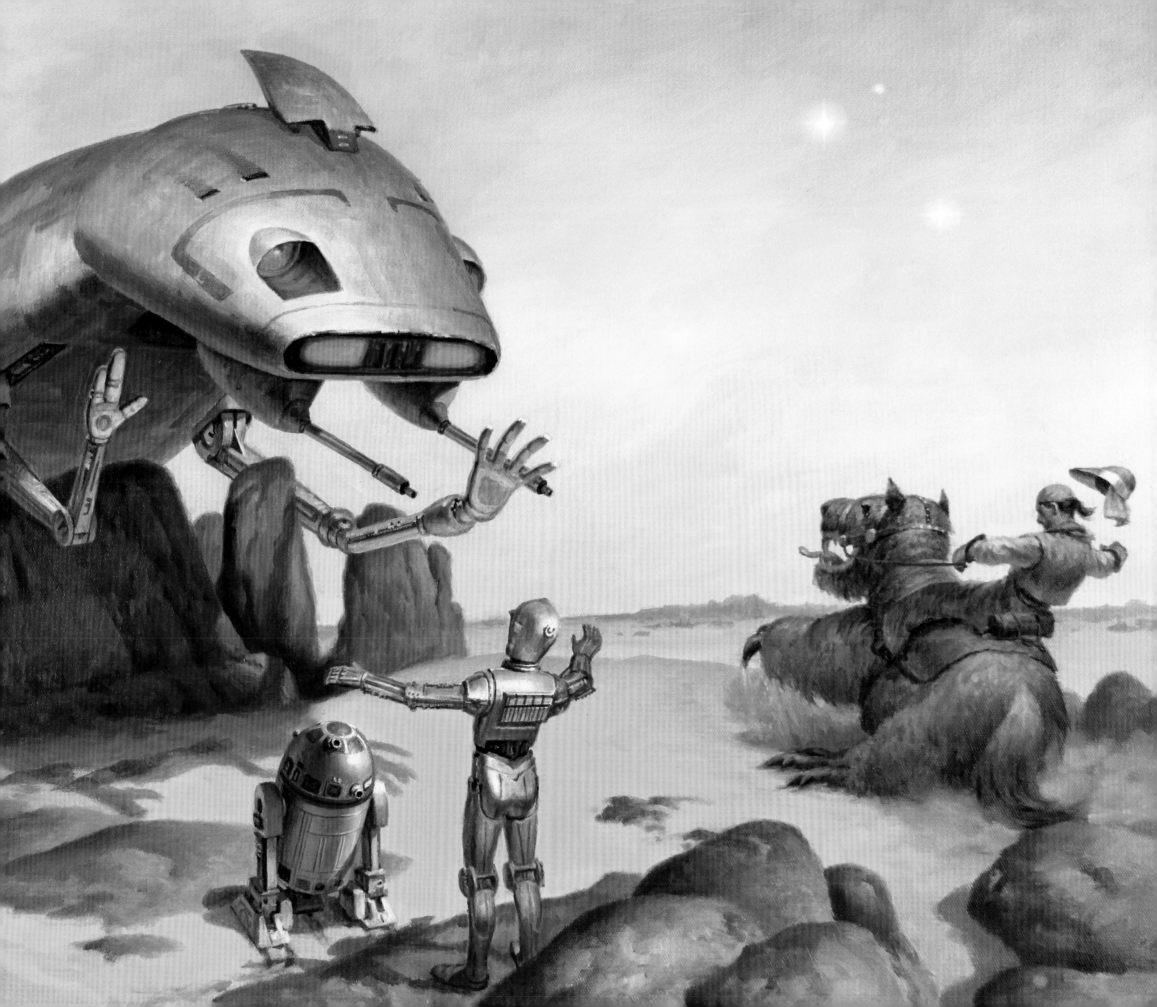

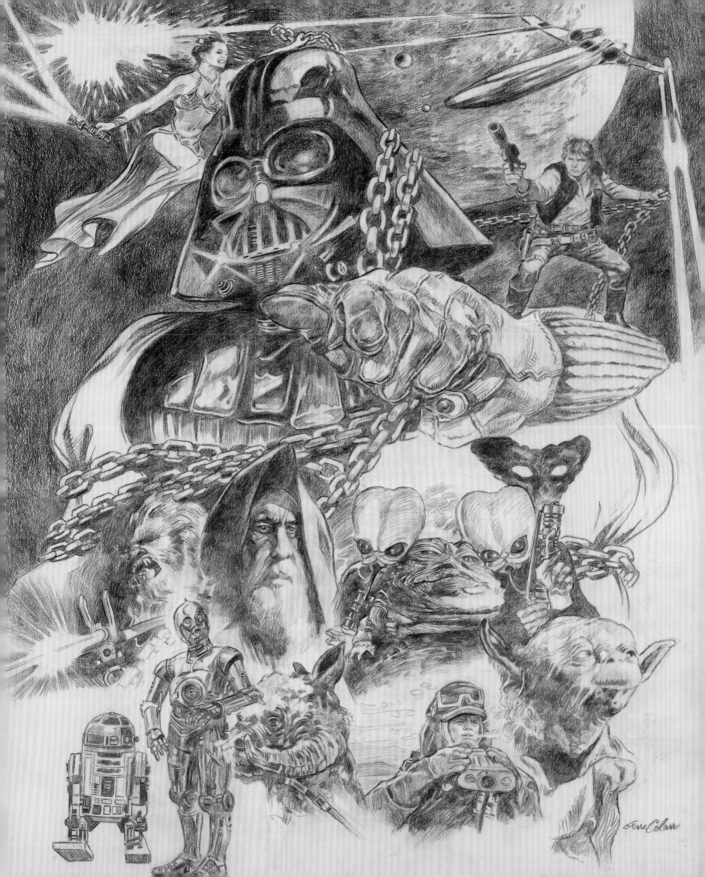

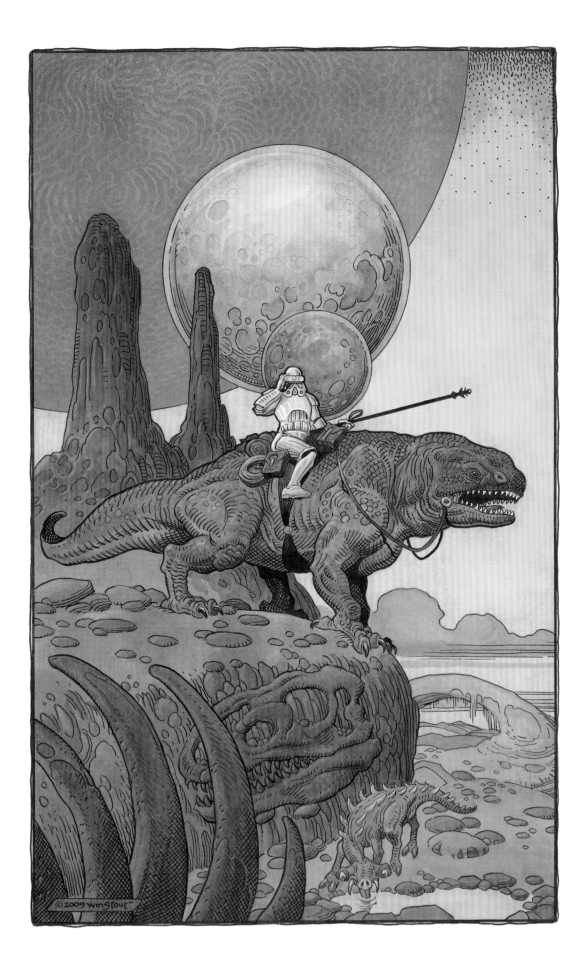

LEFT:
GENE COLAN
Star Wars Montage

Graphite
3 × 2´

RIGHT:
WILLIAM STOUT
*Searching for Anomalies (Storm-
trooper and Dewback)*

Ink, watercolor, and colored pencils
on illustration board
18 × 11˝

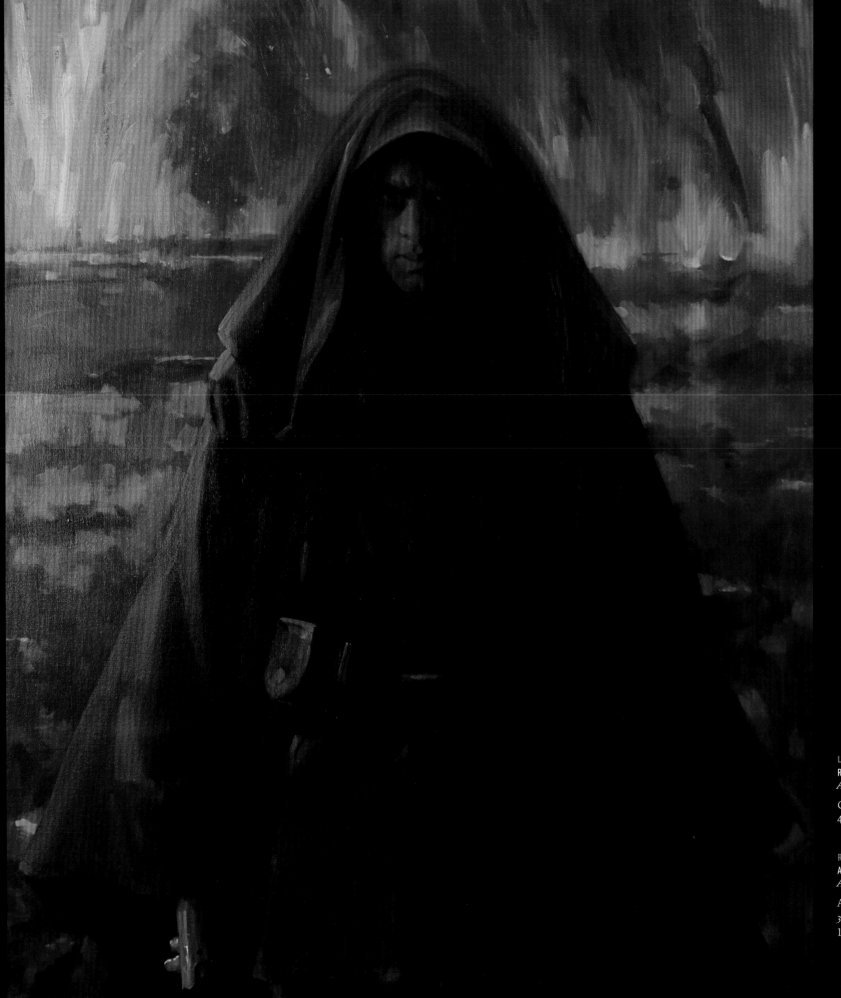

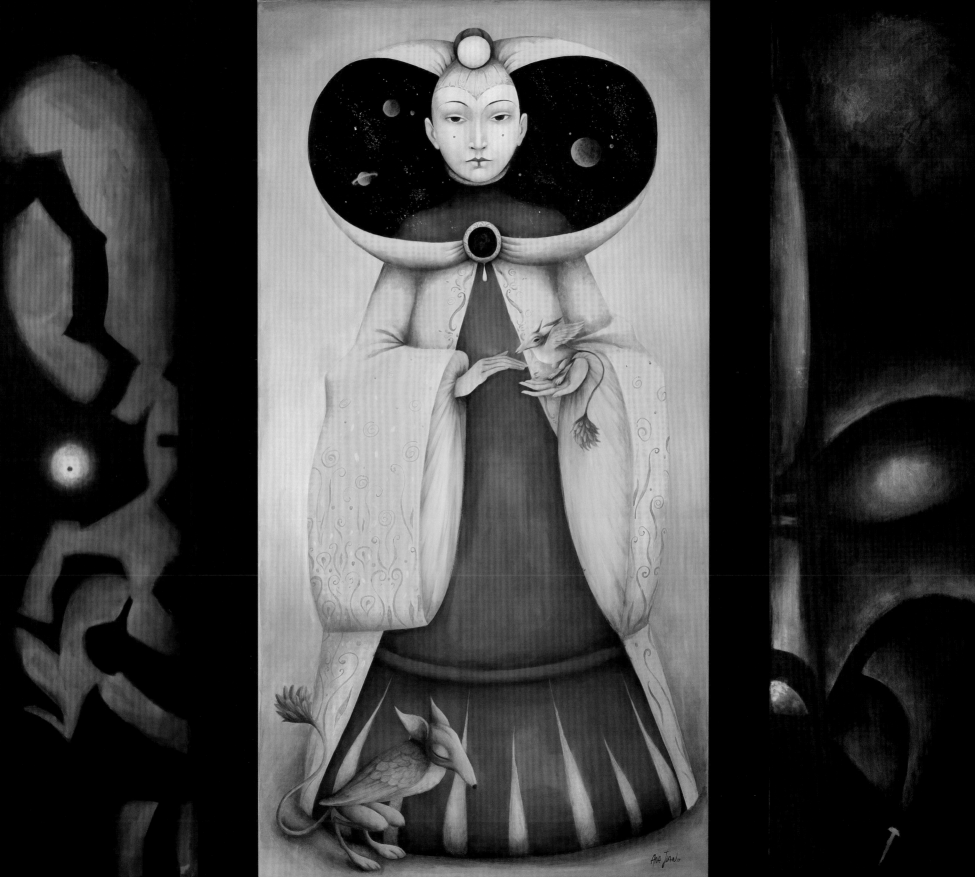

RIGHT AND OVERLEAF (DETAIL):
JASON ASKEW
Hoth Snow Battle (*The Empire
Strikes the Rebel Stronghold*)

Mixed media/oil and acrylic on
canvas
30 × 50 ˝

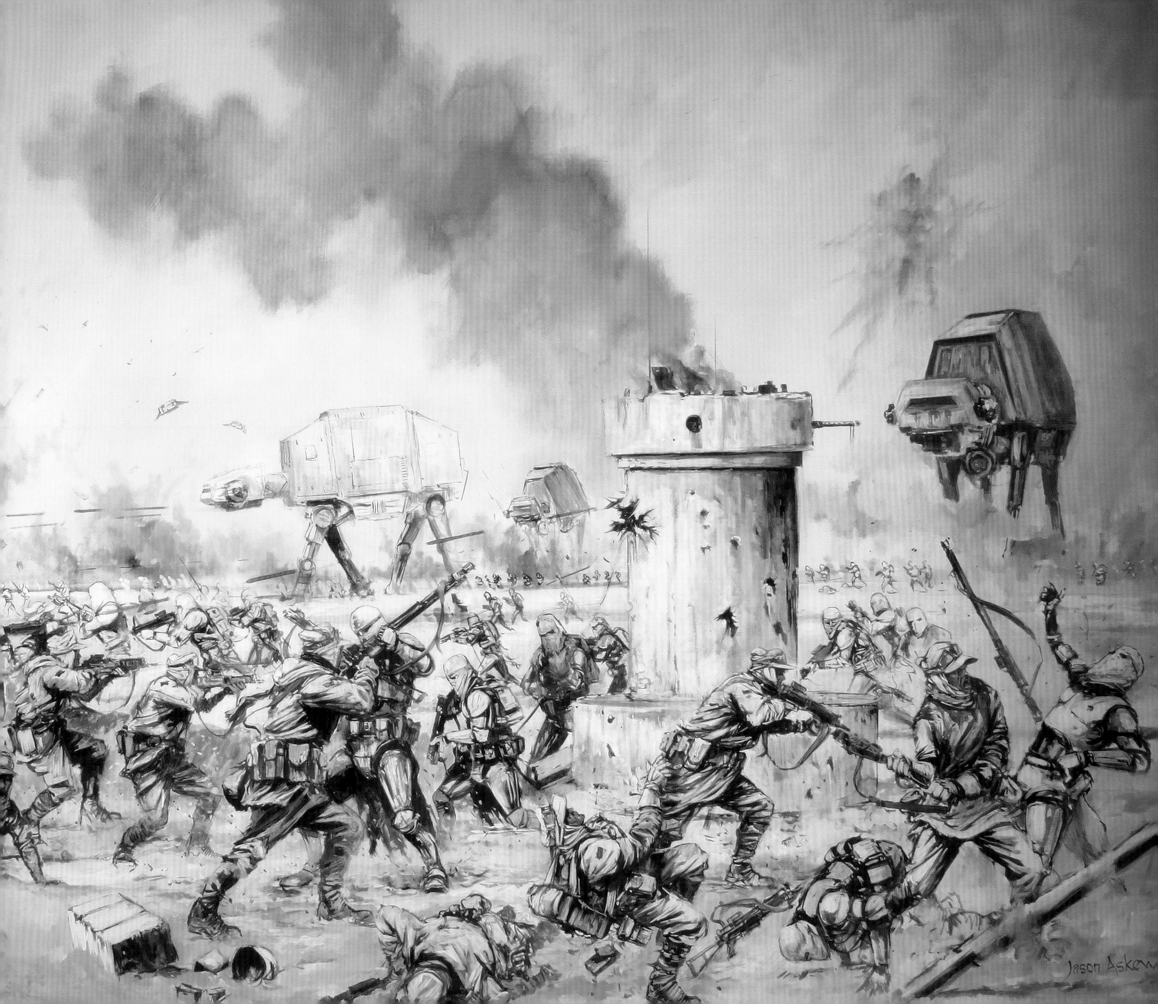

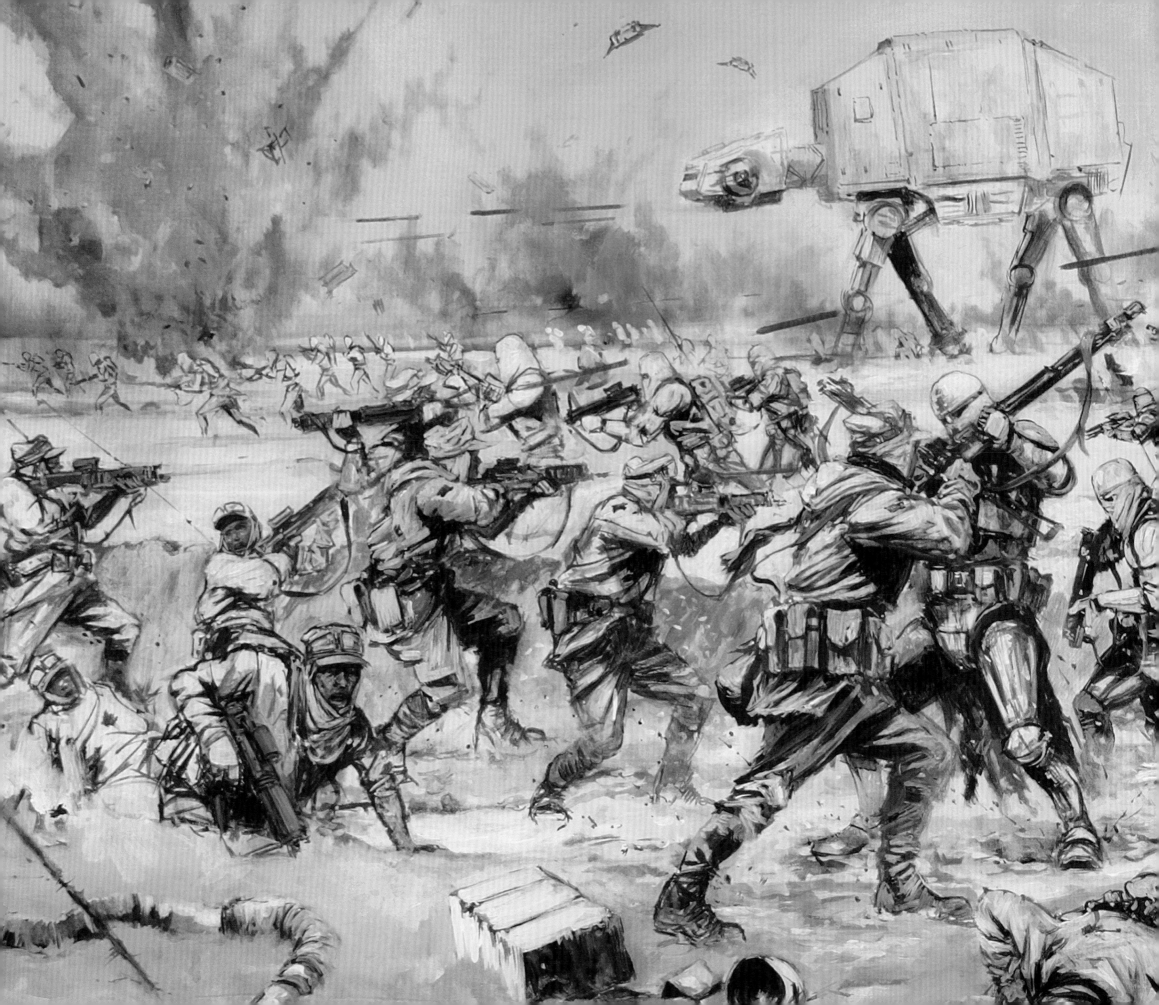

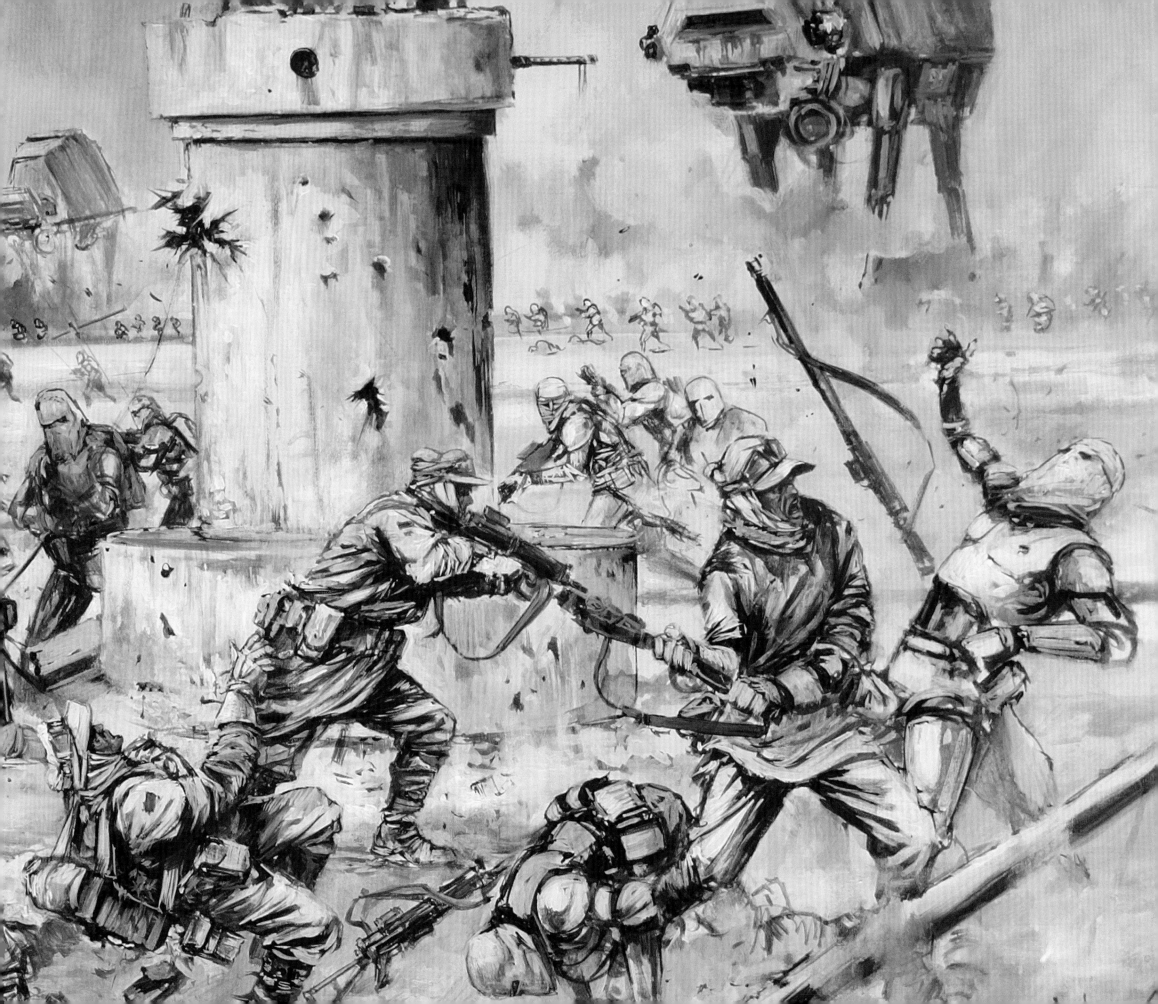

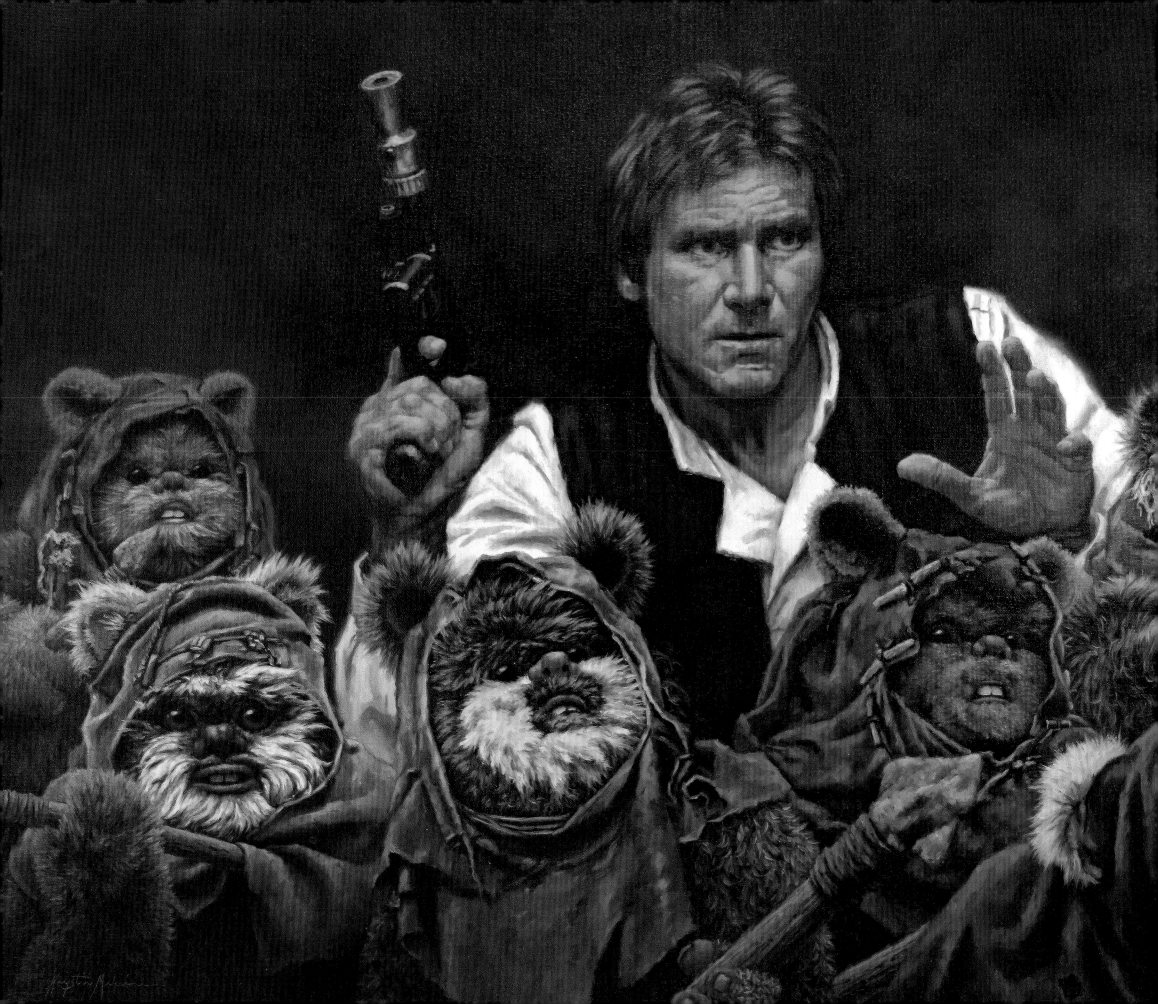

LEFT:
KRYSTII MELAINE
Fur Balls

Oil on canvas on board
24 × 36 ˝

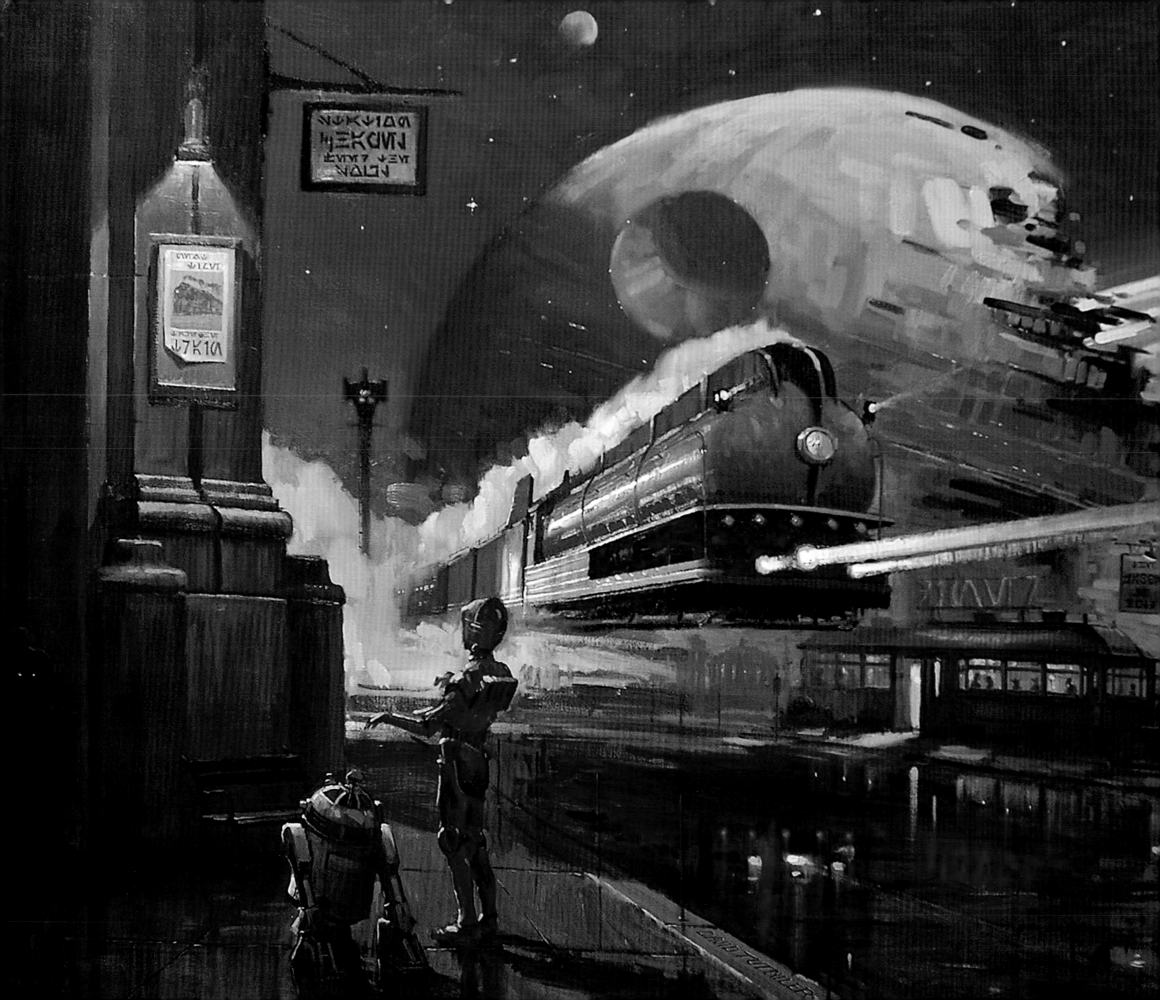

LEFT:
DAVID TUTWILER, OPA
Droids

Oil on linen
40 × 50 ″

ABOVE:
MOEBIUS
Untitled

Pen, ink, and watercolor on paper
12 × 16 ″

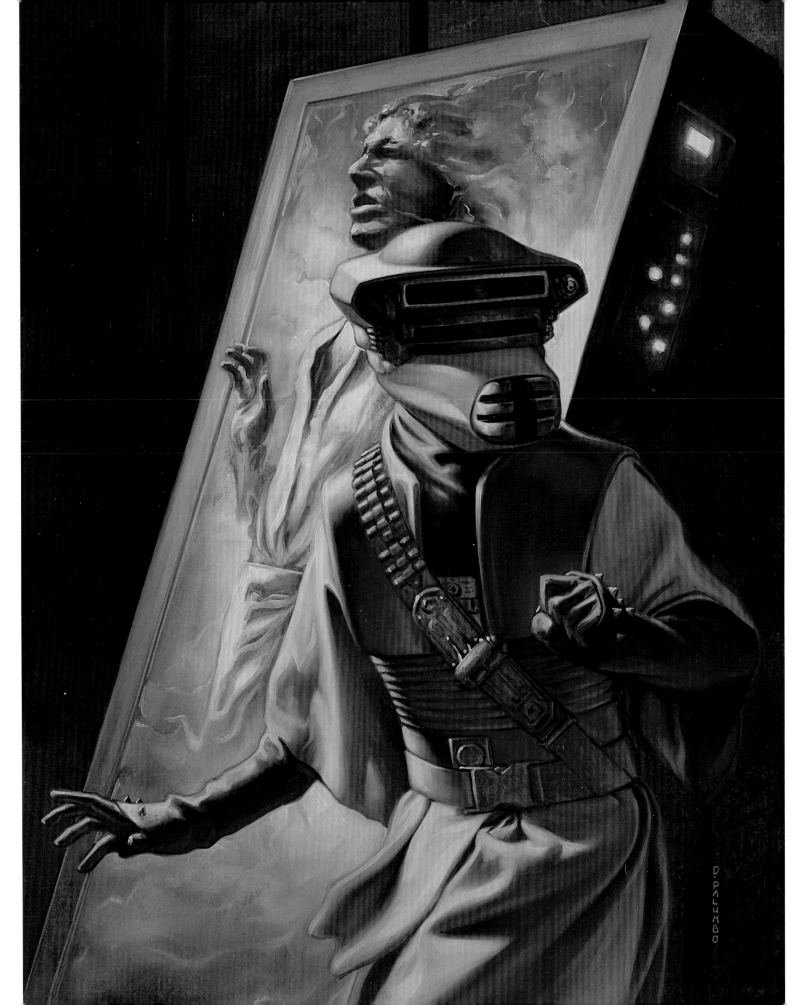

LEFT:
DAVID PALUMBO
Escape

Oil on illustration board
18 × 13½ ″

RIGHT:
SEAN CHEETHAM
Untitled (Luke Skywalker on Hoth)

Oil on linen
48 × 72 ″

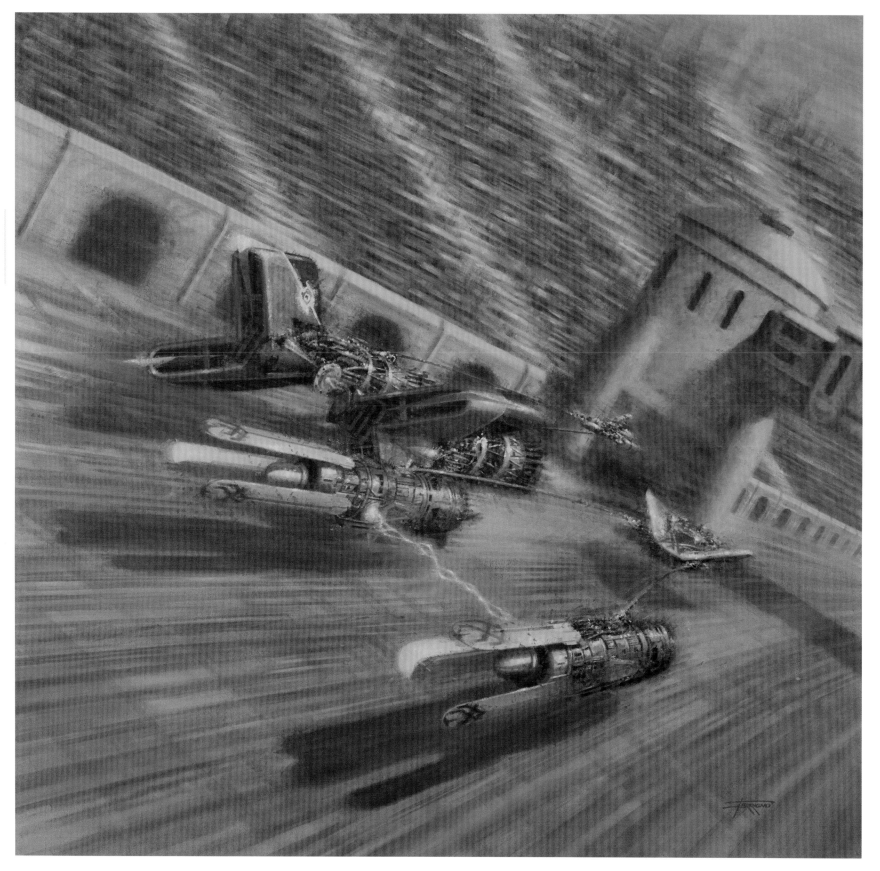

LEFT:
JUAN CARLOS FERRIGNO
Podracers

Acrylic on canvas
40 × 30 ˝

RIGHT:
DAVE NESTLER
Double Cheeseburger with a
Side of Crumb

Acrylic on cold-press illustration
board
24 × 30 ˝

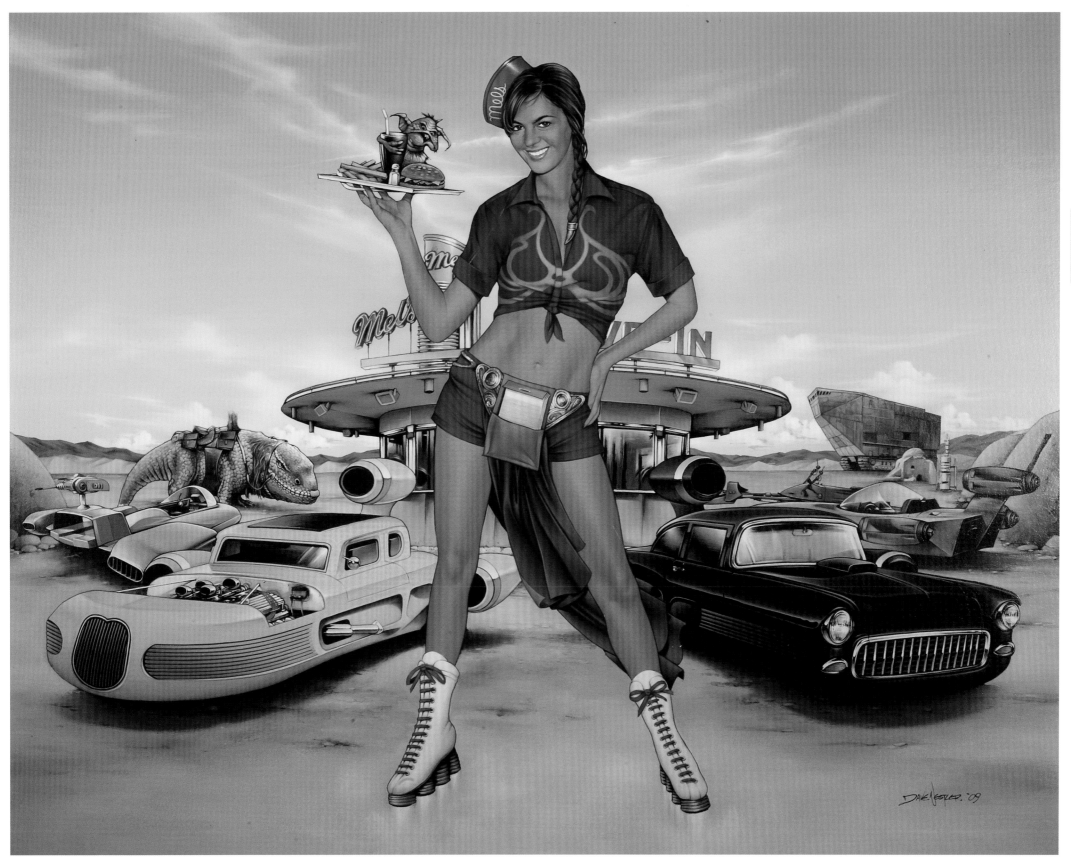

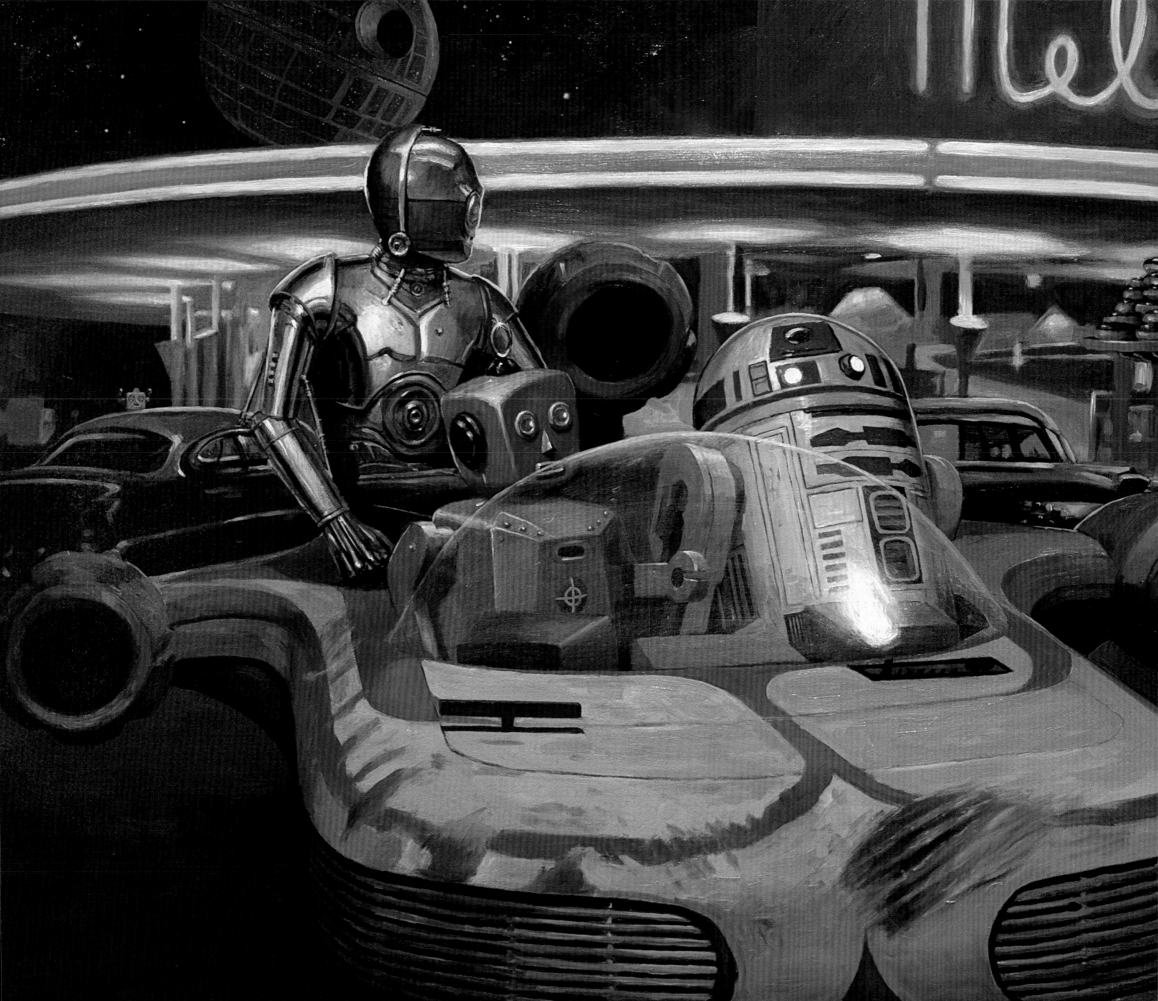

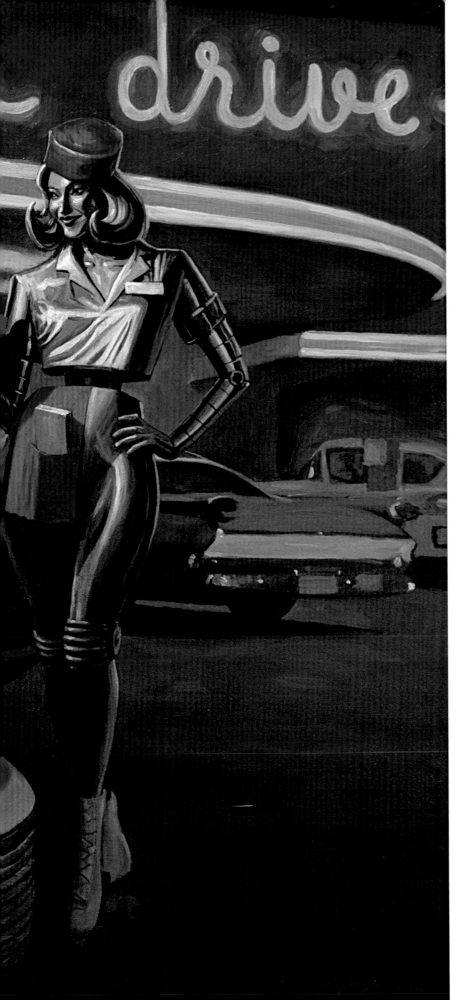

LEFT:
ERIC JOYNER
Dining at Mel's

Oil on wood panel
25½ × 42˝

LEFT:
AOI NISHIMATA
Leia

Digital

RIGHT AND OVERLEAF (DETAIL):
JULIE BELL AND BORIS VALLEJO
Forest Rancor

Oil on artist's board
26 × 18 ″

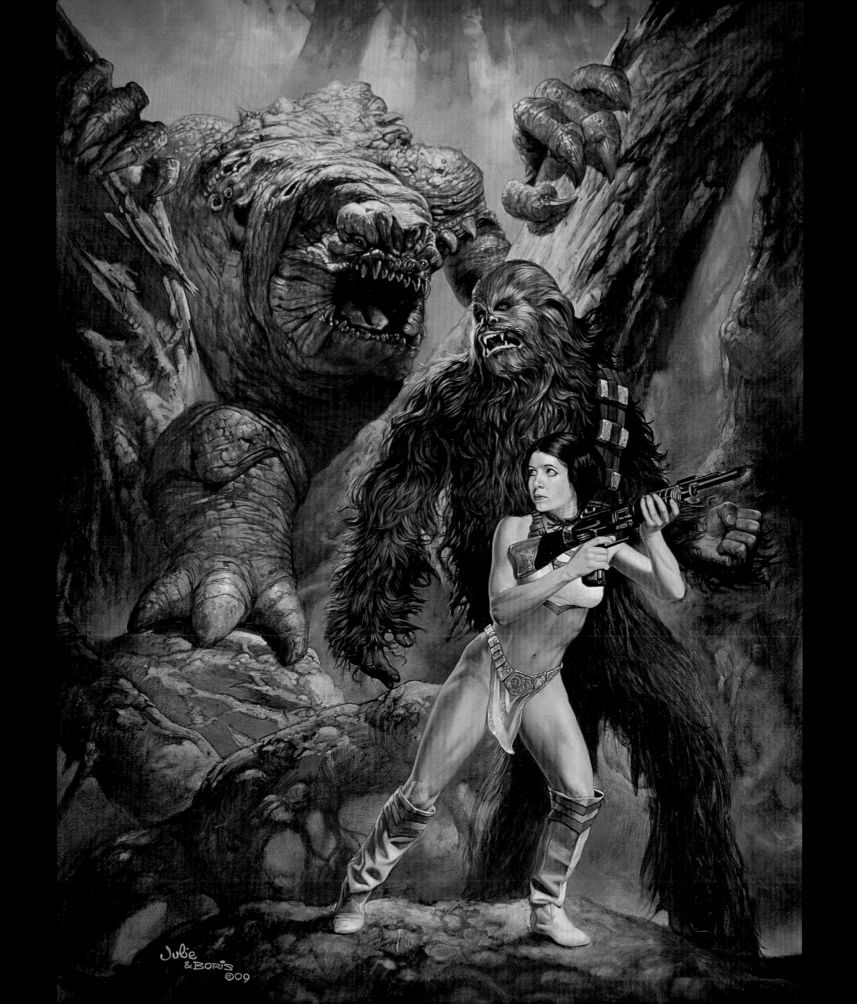

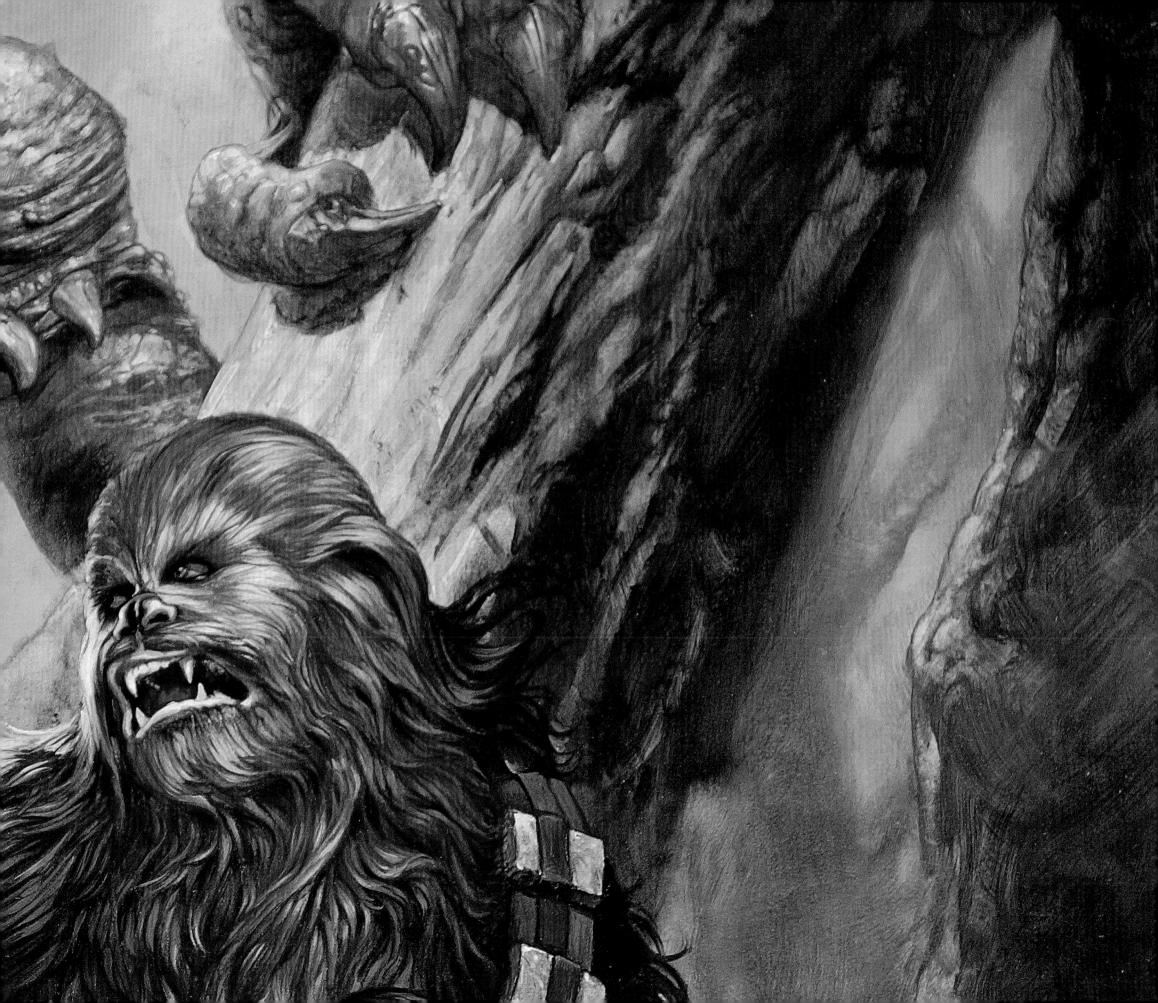

74

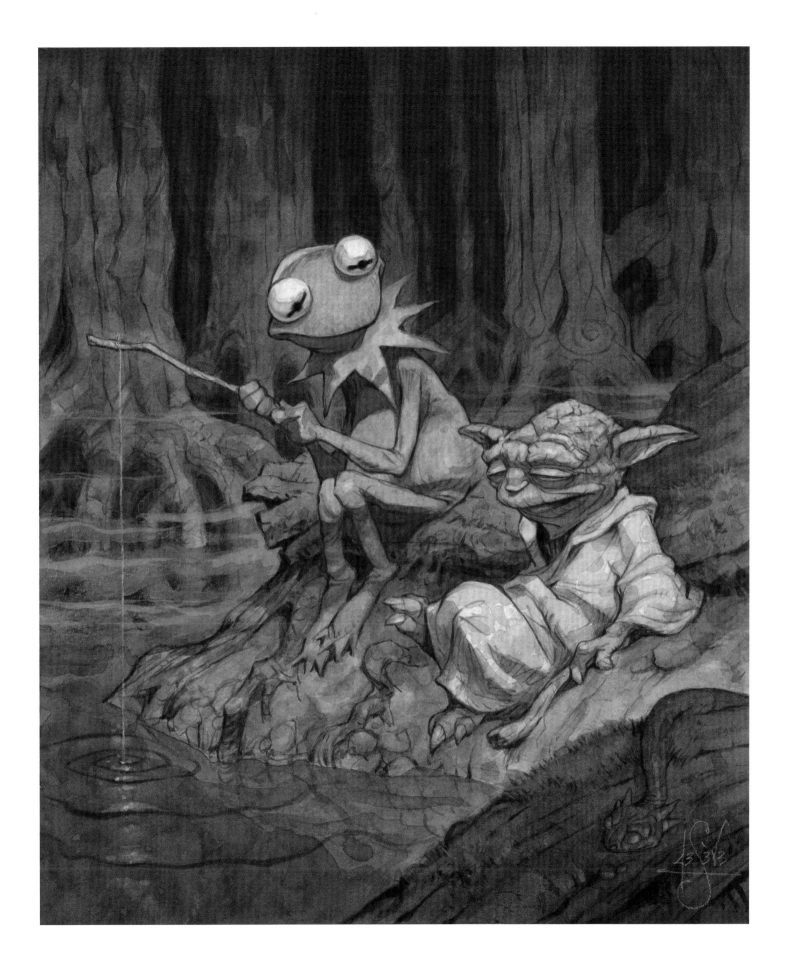

76

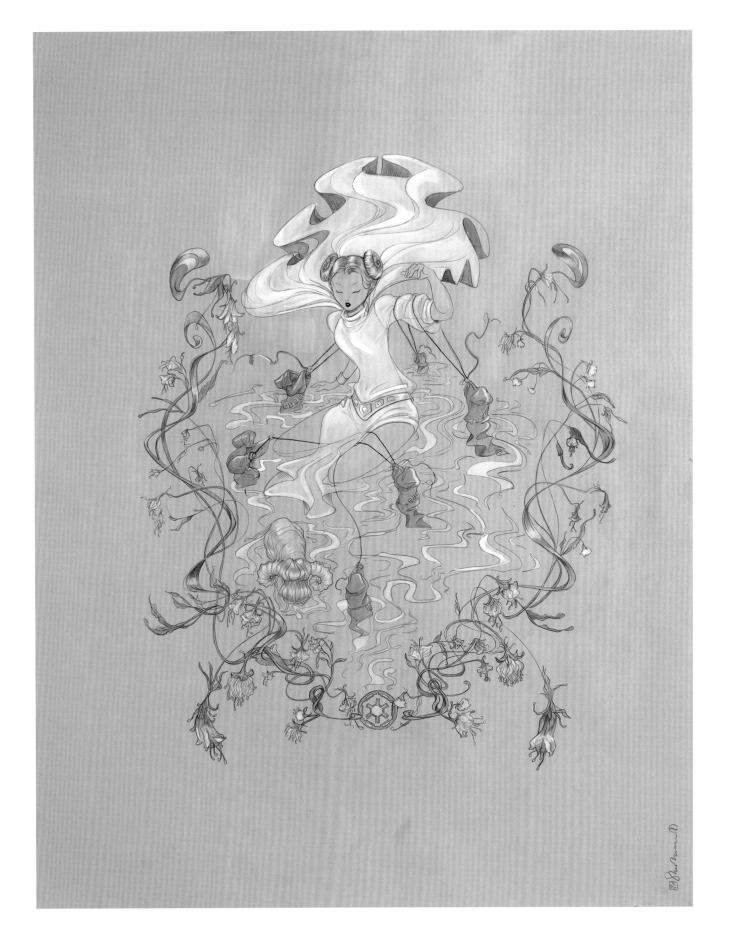

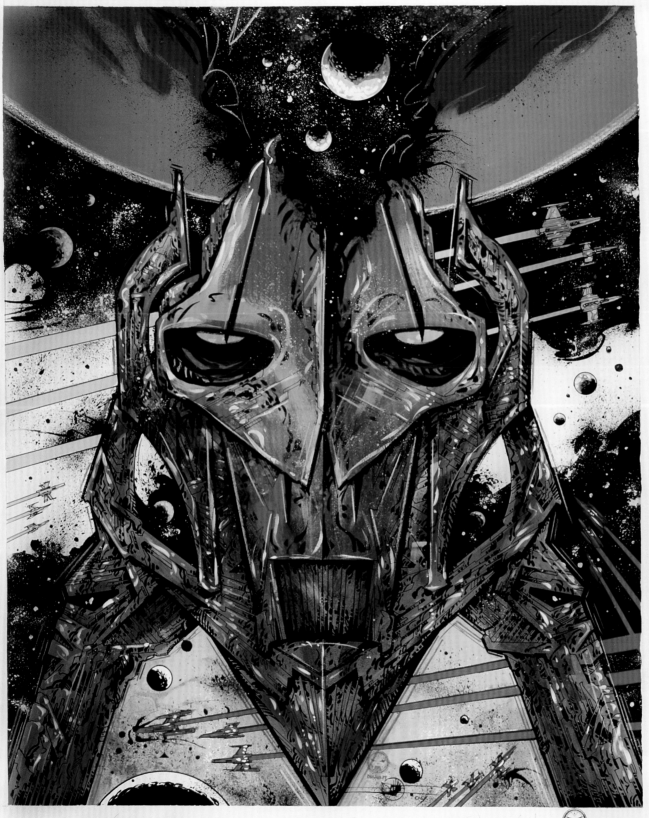

LEFT:
PHILIPPE DRUILLET
Hommage à Georges Lucas, donc à
Star Wars

(*A Tribute to Georges Lucas, and so,*
to Star Wars)

Acrylic, pastel, and colored pencils
on paper
37 × 29 ˝

RIGHT:
CHRISTIAN WAGGONER
Worlds Collide

Oil painting
60 × 36 ˝

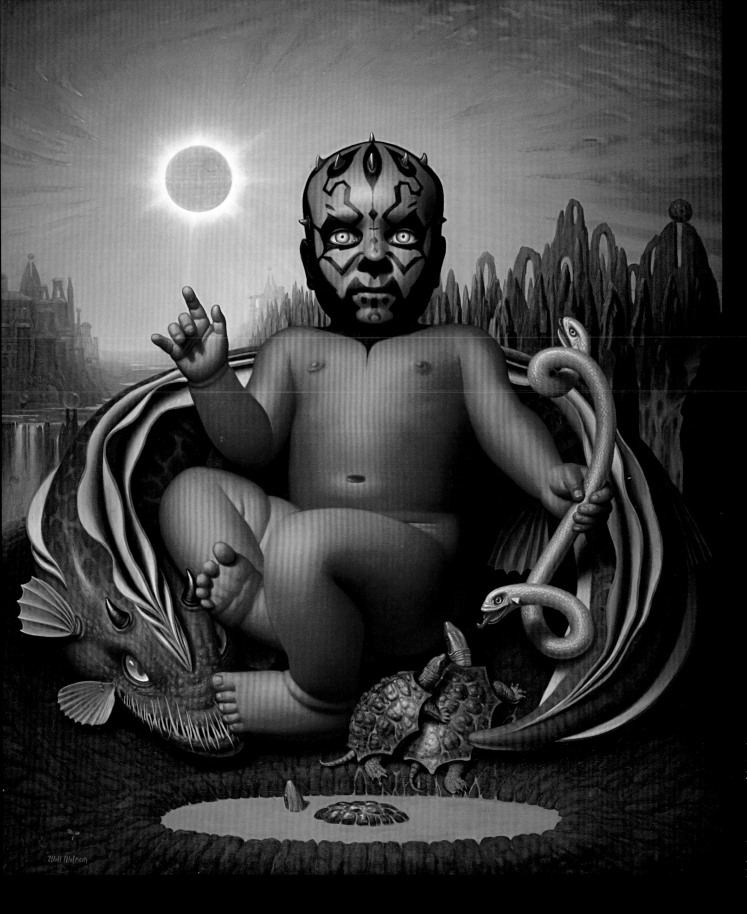

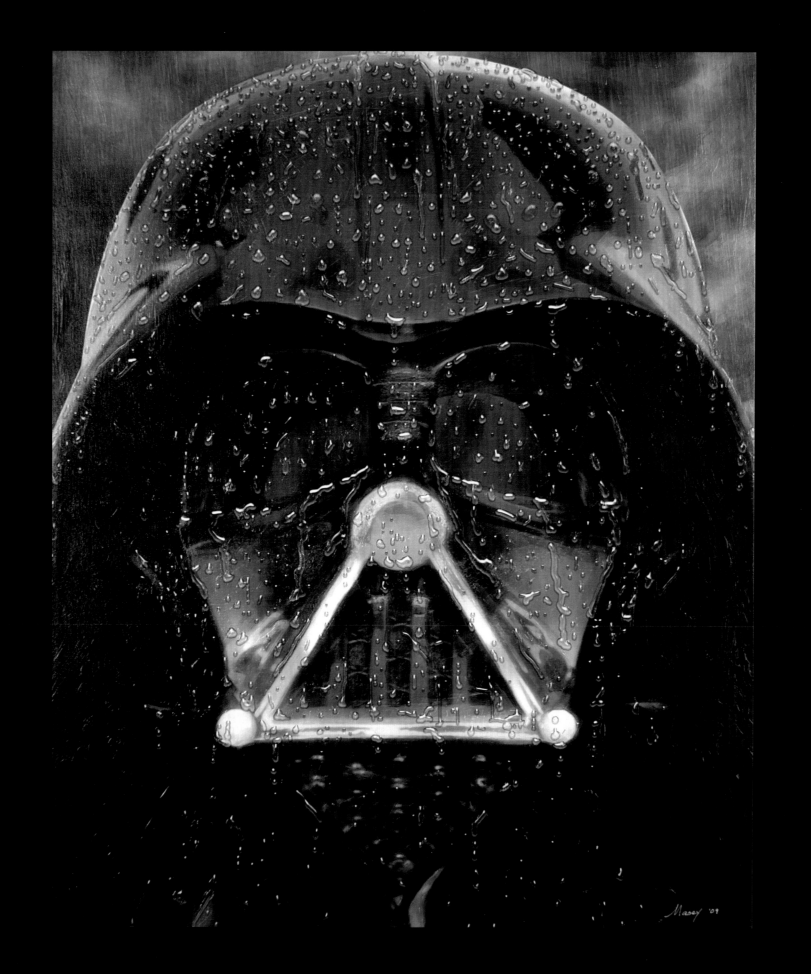

Massey '09

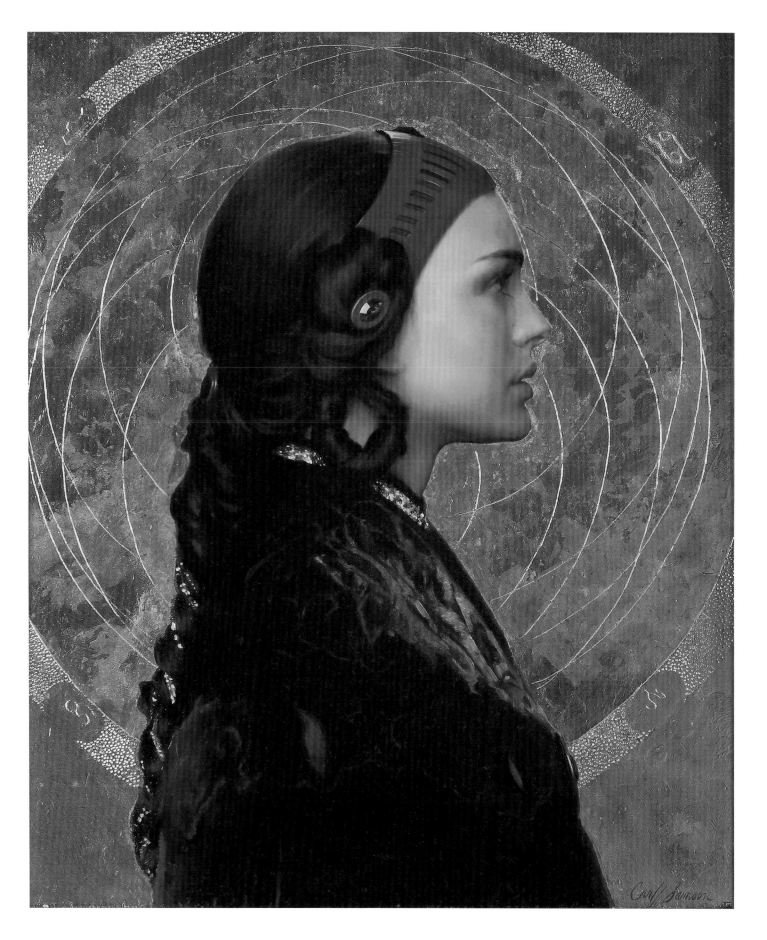

84

ABOVE (DETAIL) AND RIGHT:
ARANTZAZU MARTÍNEZ
Rancor

Oil on linen
57 × 44½˝

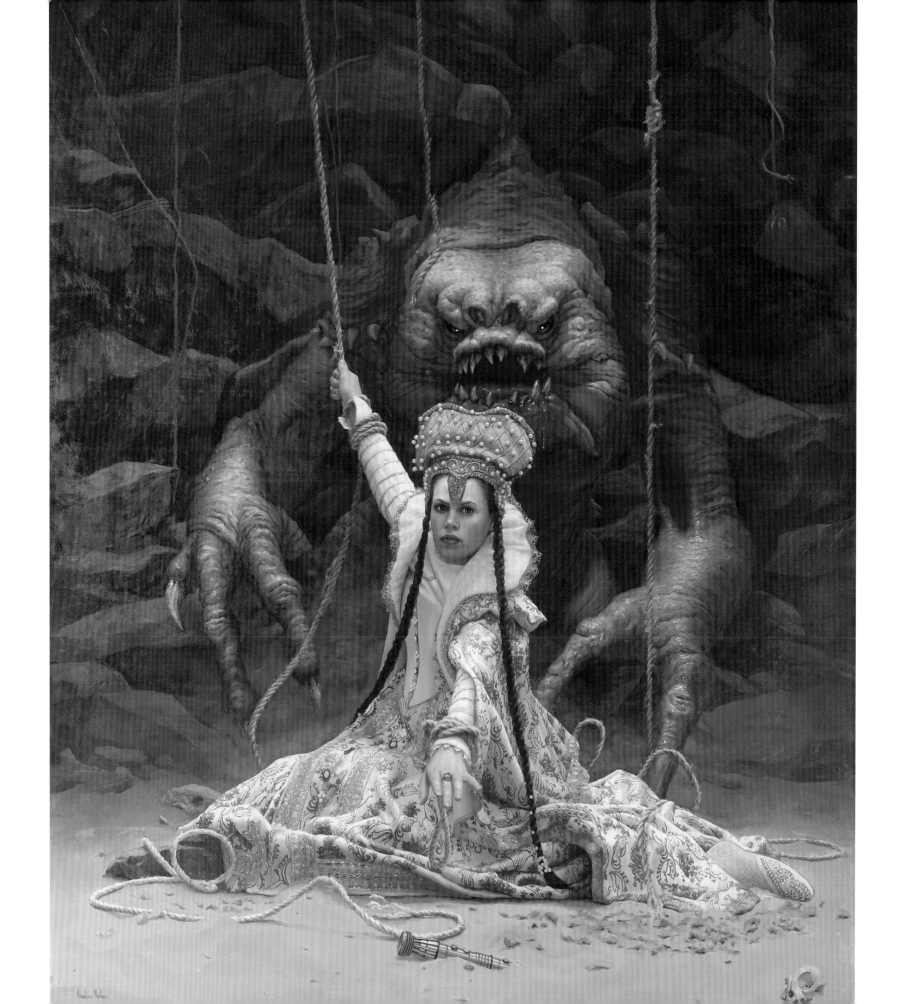

RIGHT:
PETER FERK
The Stuff That Dreams Are Made Of

Acrylic on Gessoboard
16 × 20 ˝

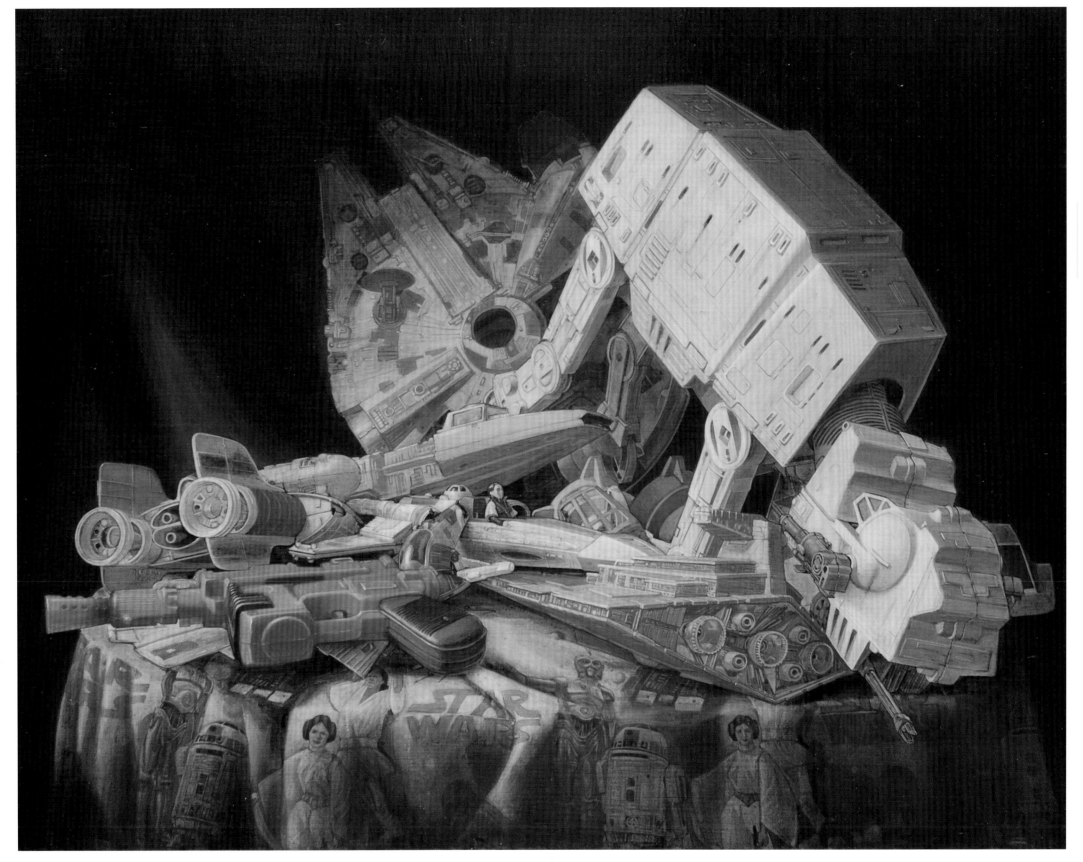

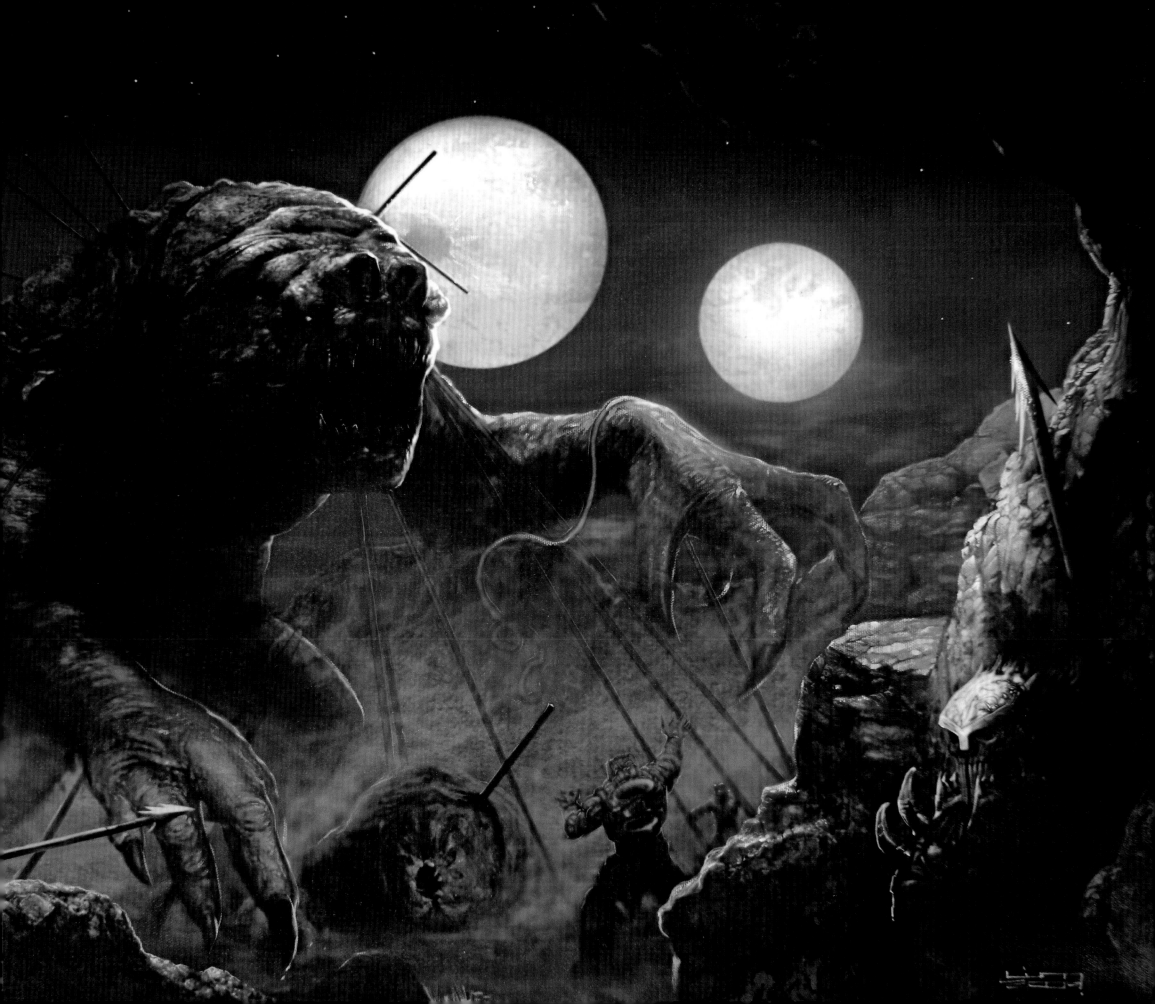

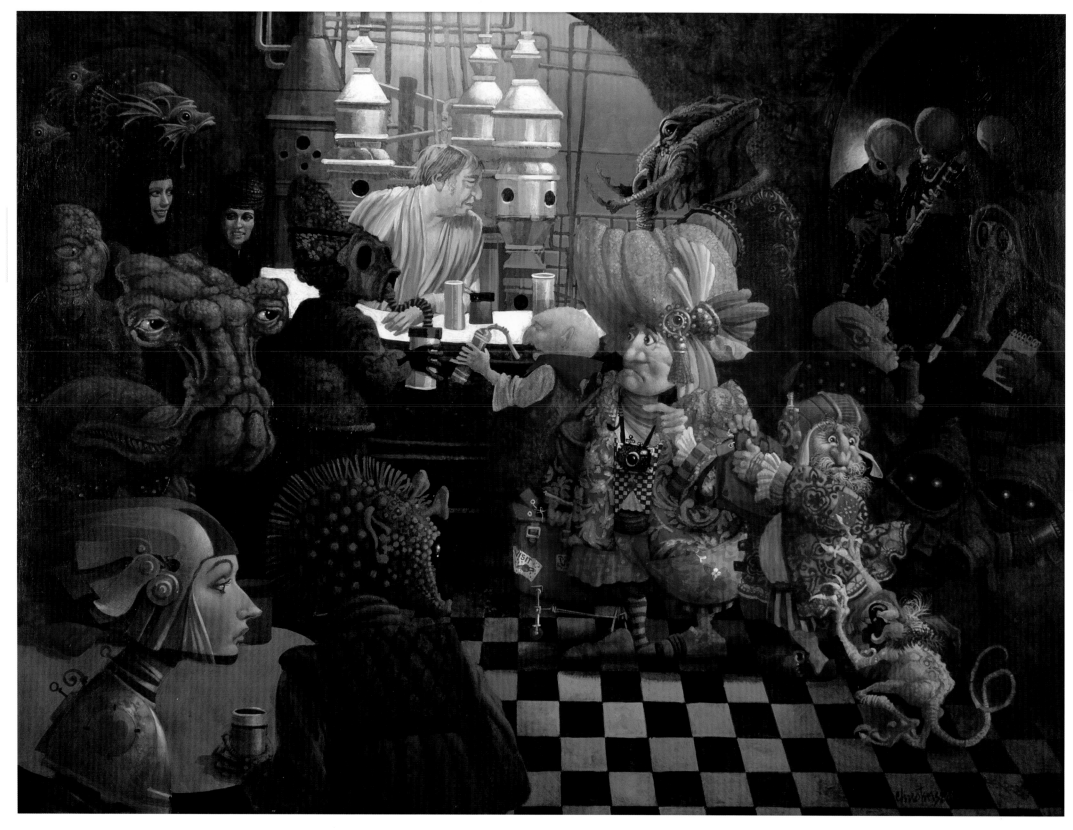

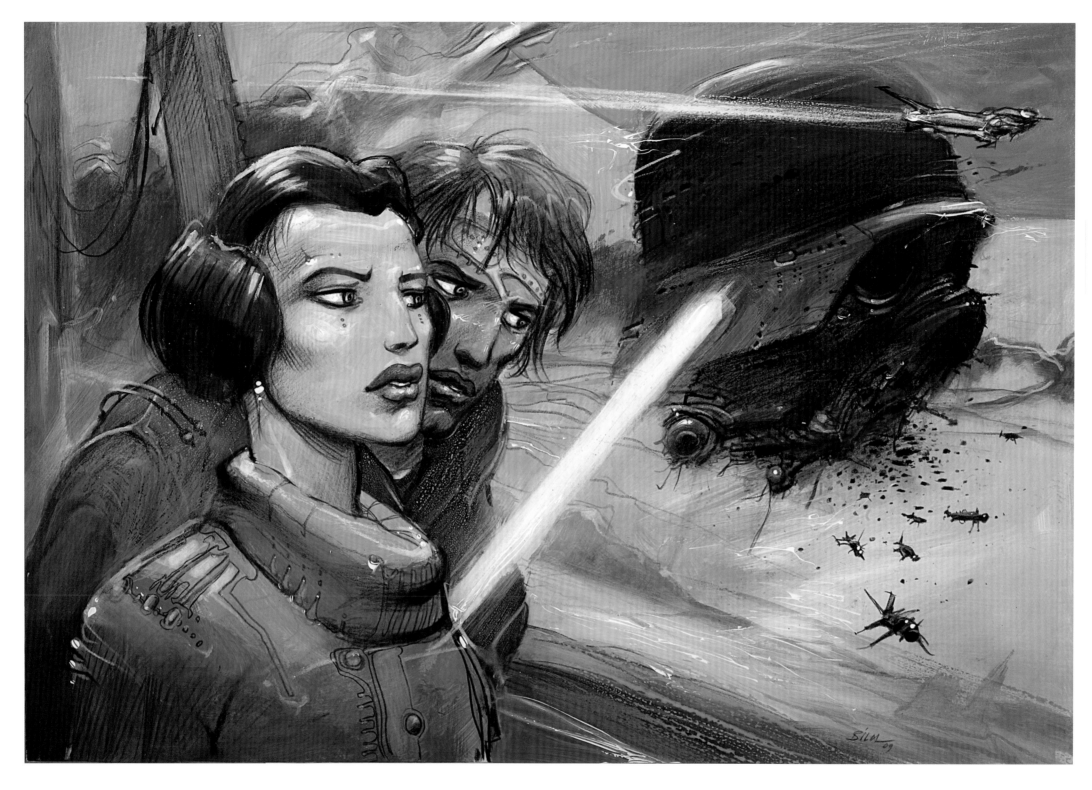

LEFT:
JAMES C. CHRISTENSEN
An Unexpected Layover at Mos Eisley

Oil on panel
18 × 24 ″

ABOVE:
ENKI BILAL
Never Ending Fight Against the Darkness

Mixed media on illustration board
11½ × 16½ ″

OVERLEAF:
NELSON BOREN
Maverick Bounty Hunter

Watercolor on paper
26 × 68 ″

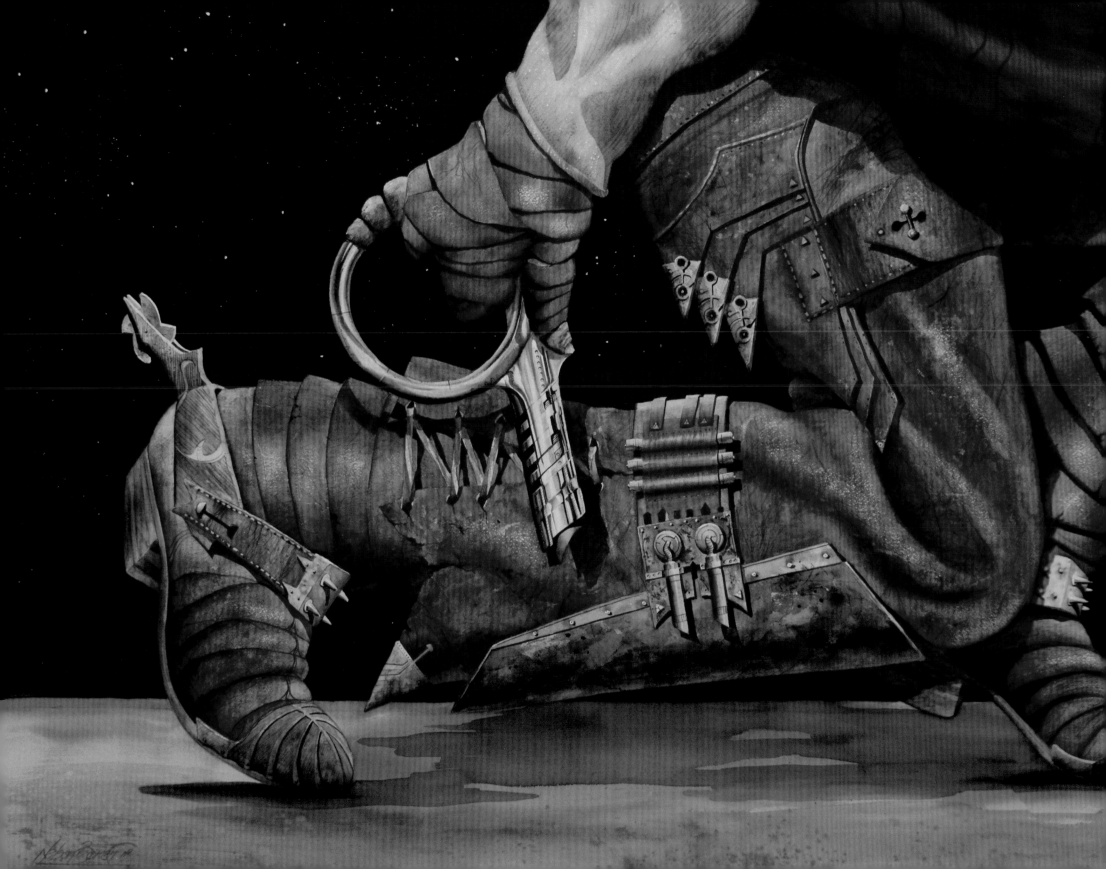

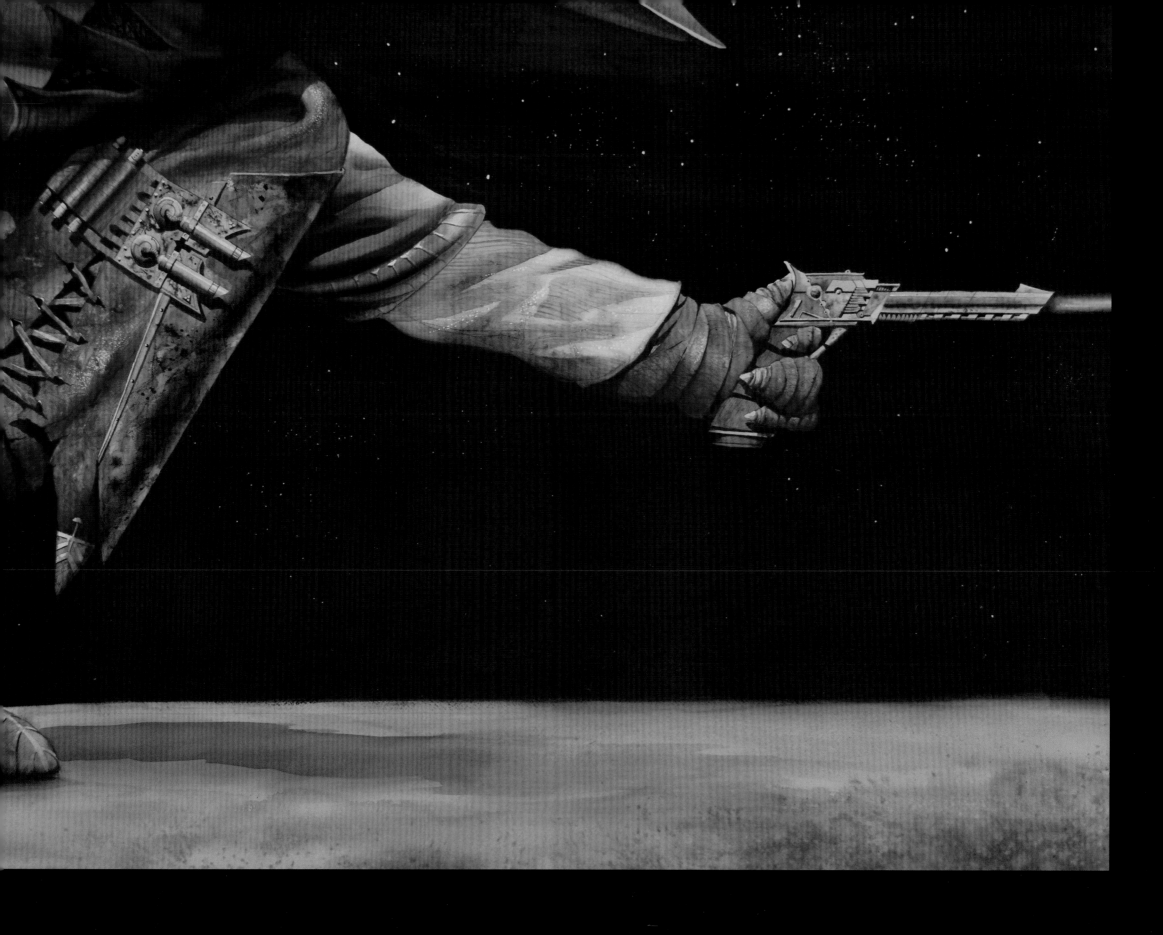

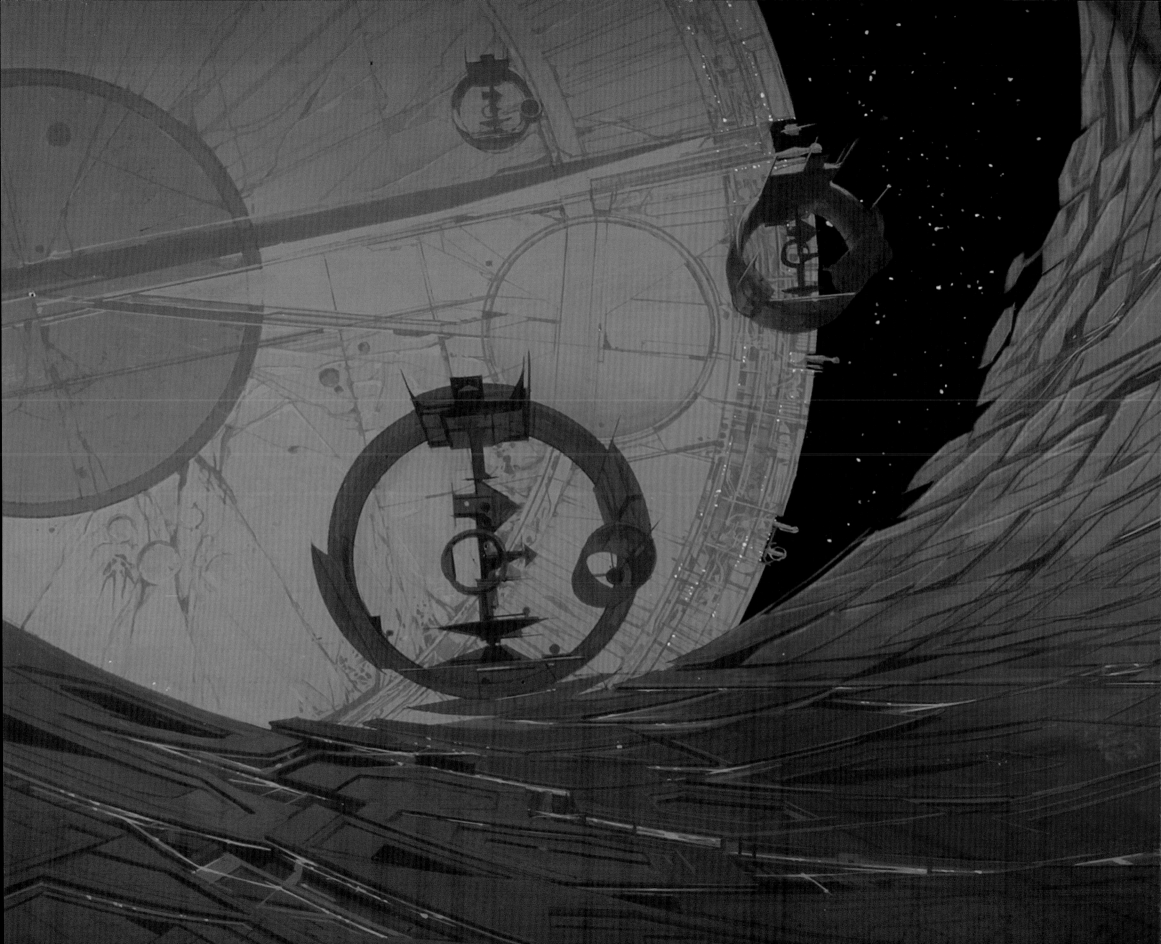

SYD MEAD
Abandoned Sith World

Gouache on illustration board
15 × 20˝

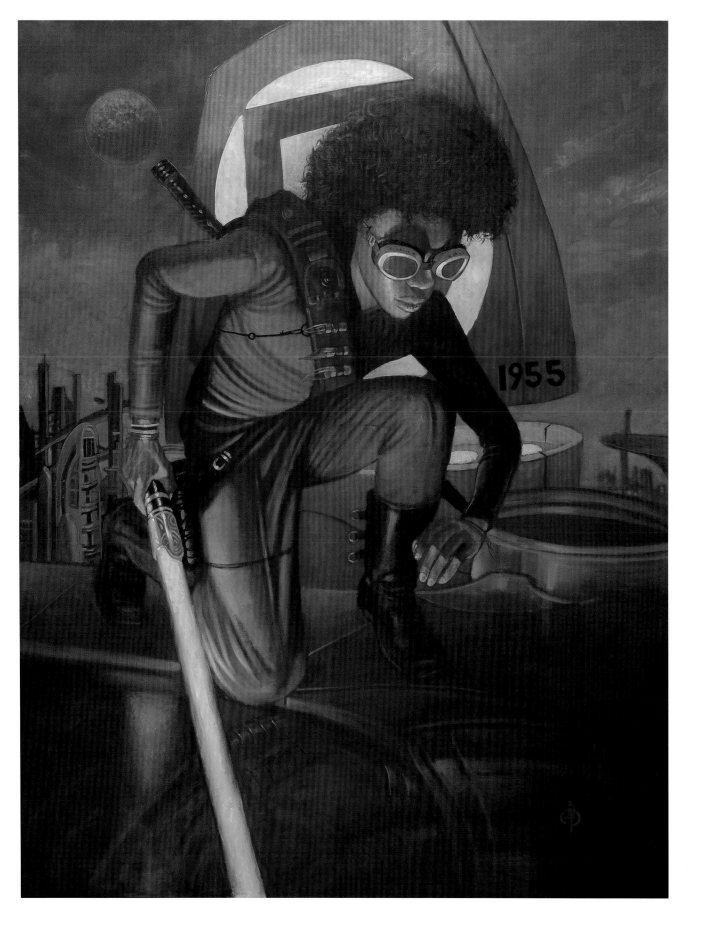

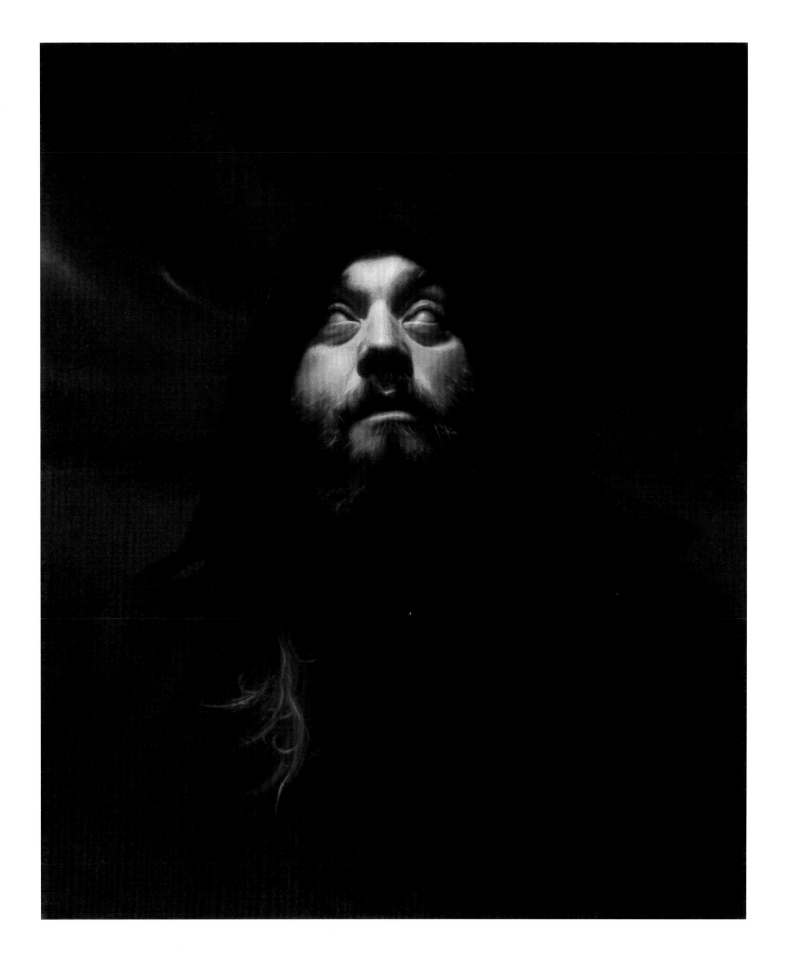

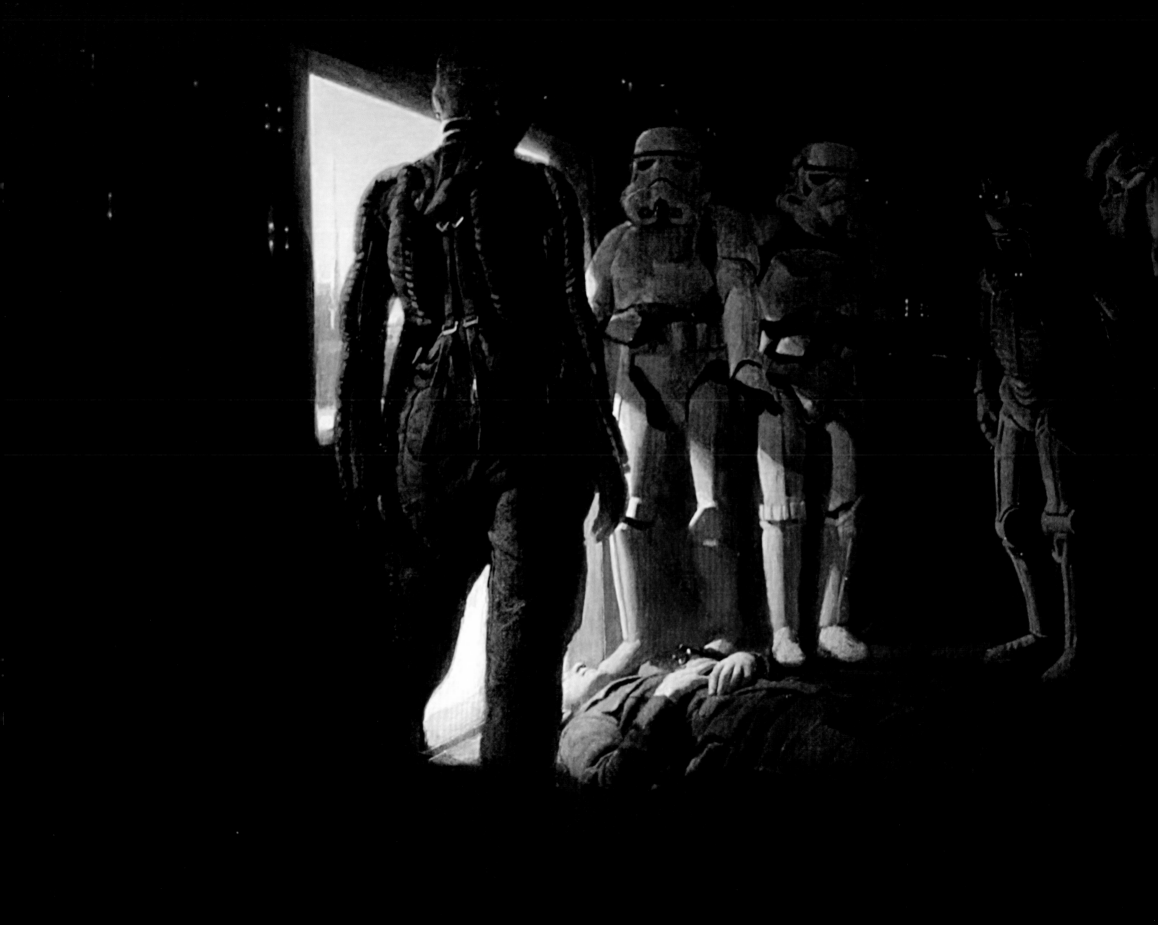

LEFT:
MICHAEL GRIMALDI
Incident at Mos Eisley Spaceport

Oil on canvas
25½ × 44 ″

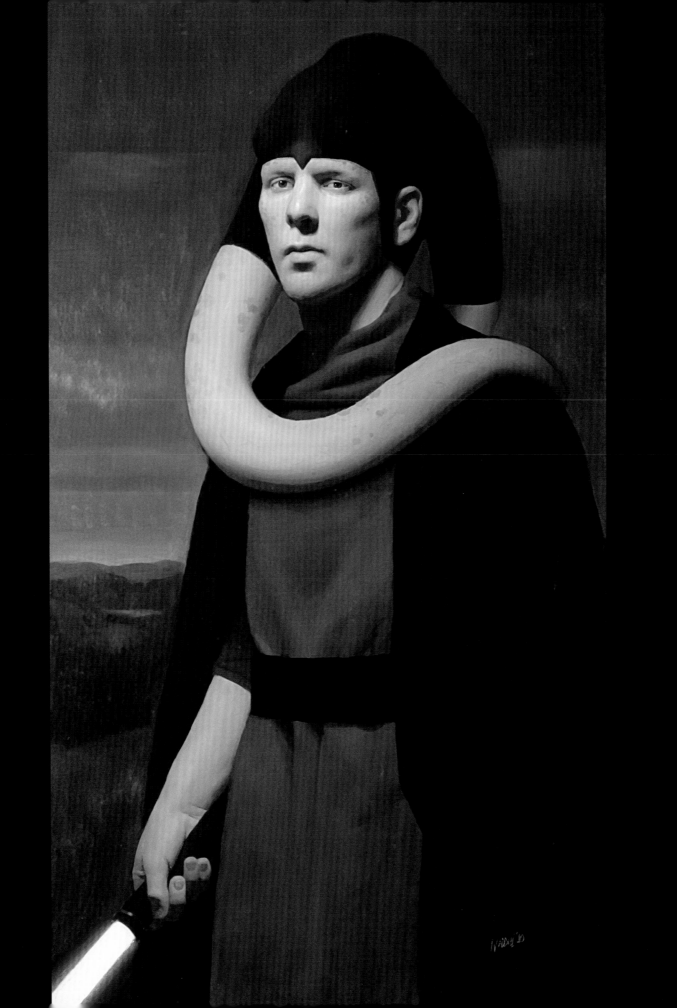

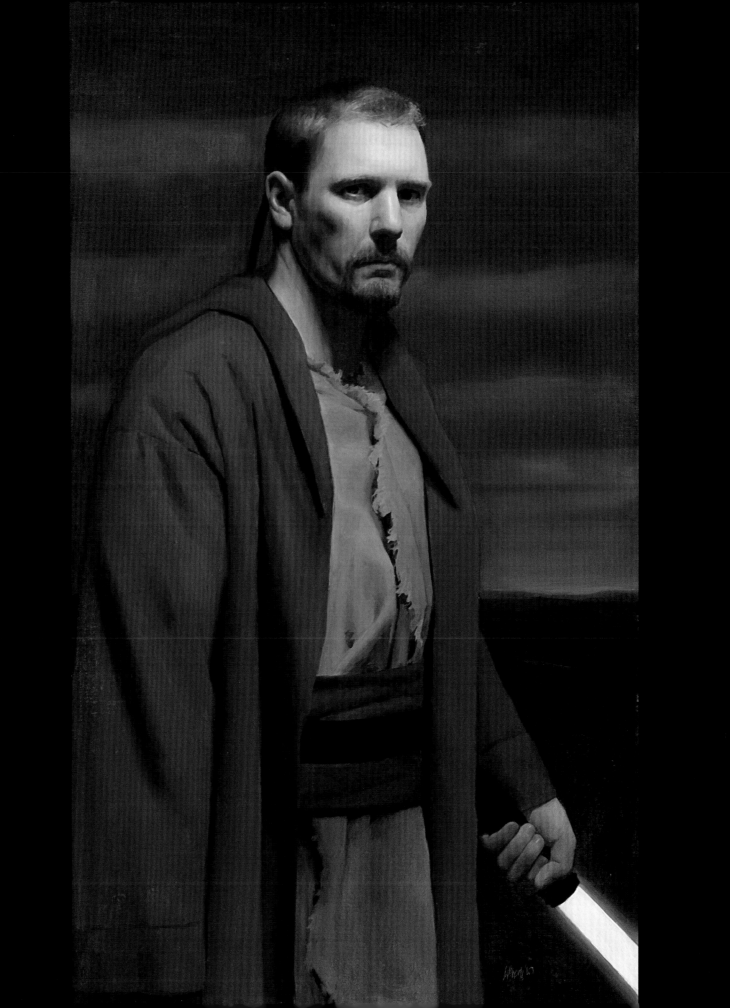

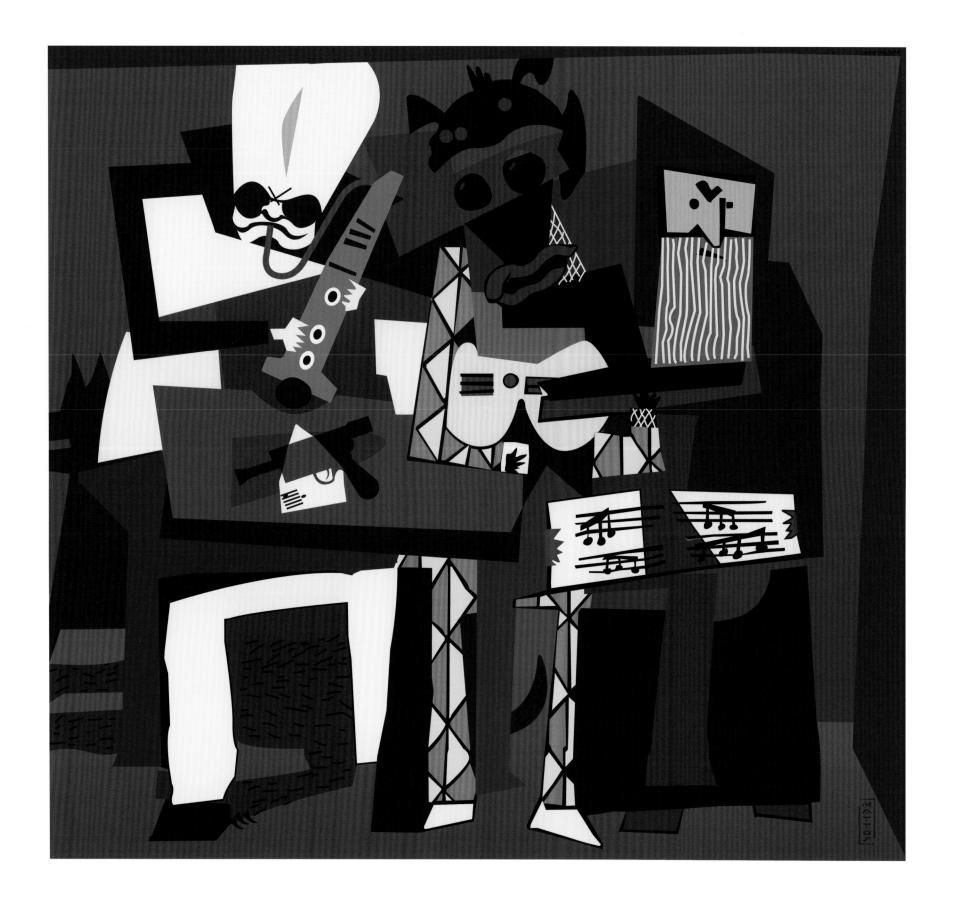

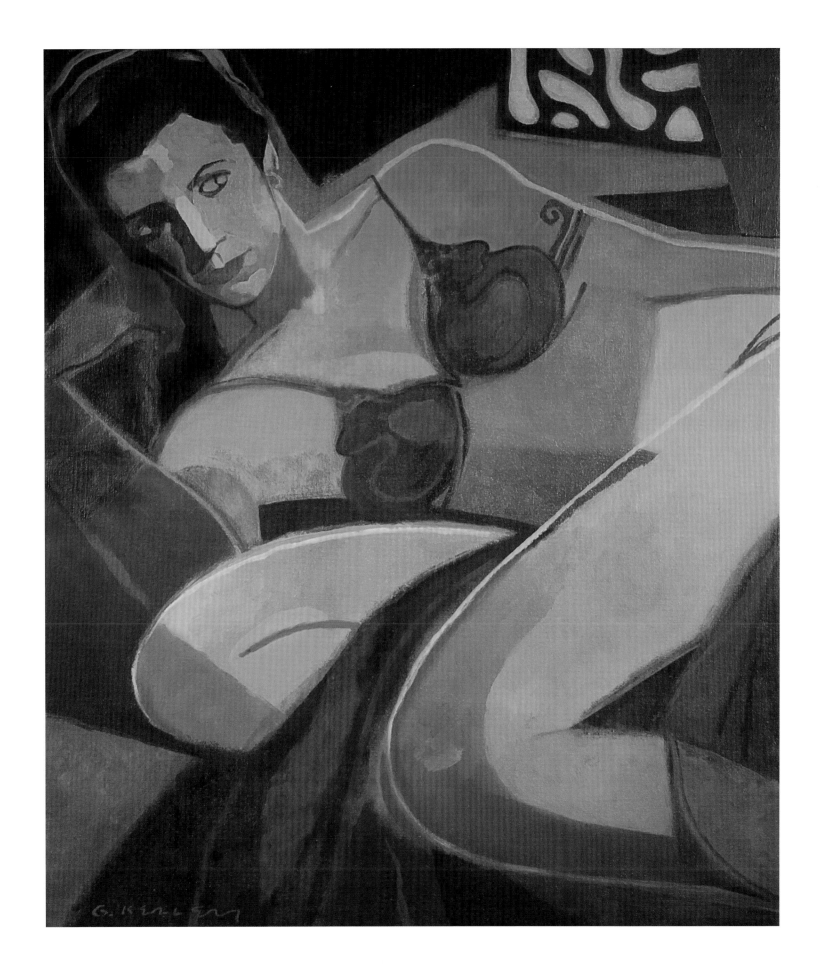

LEFT:
JOHN MATTOS
Pablo's Cantina

Digital on paper
36 × 36˝

RIGHT:
GARY KELLEY
Leia

Oil on canvas
24 × 18˝

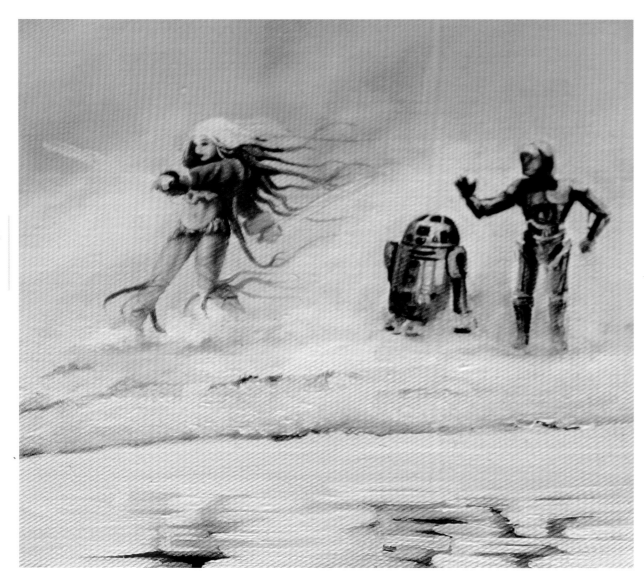

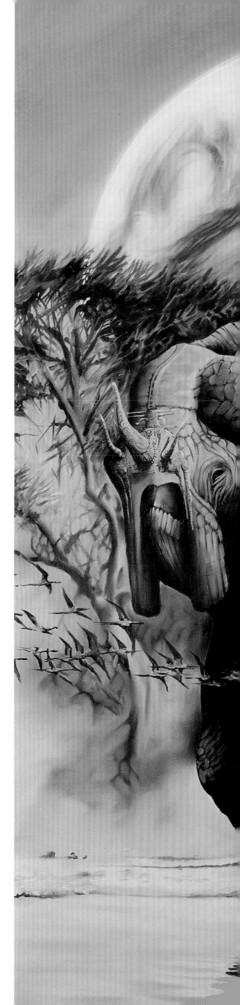

ABOVE (DETAIL) AND RIGHT:
DOLFI STOKI
*Mosi-oa-Tunye (The Smoke That
Thunders)*

Oil on canvas
39 × 50⅔ ˝

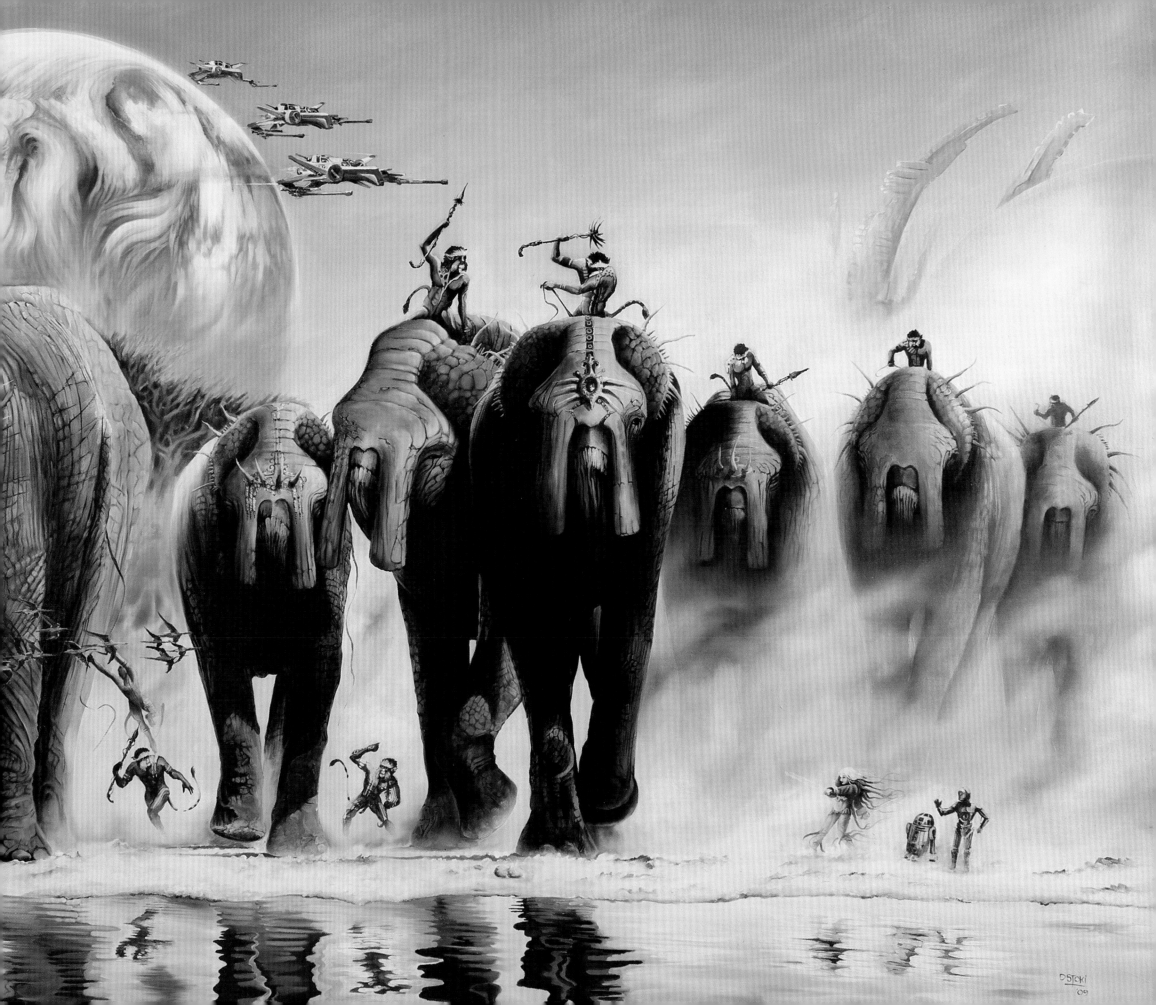

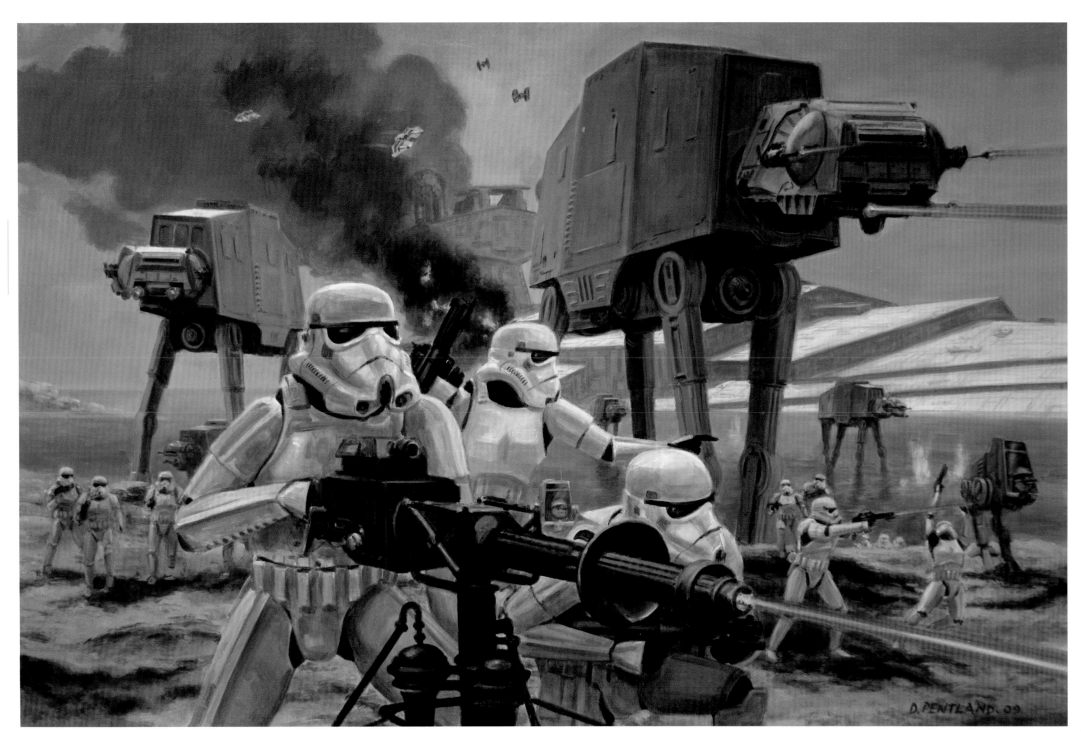

ABOVE:
DAVID PENTLAND
Clash on Kothlis

Oil on canvas
20 × 30″

OPPOSITE:
DAVID PENTLAND
Raid on Kothlis

Oil on canvas
20 × 30″

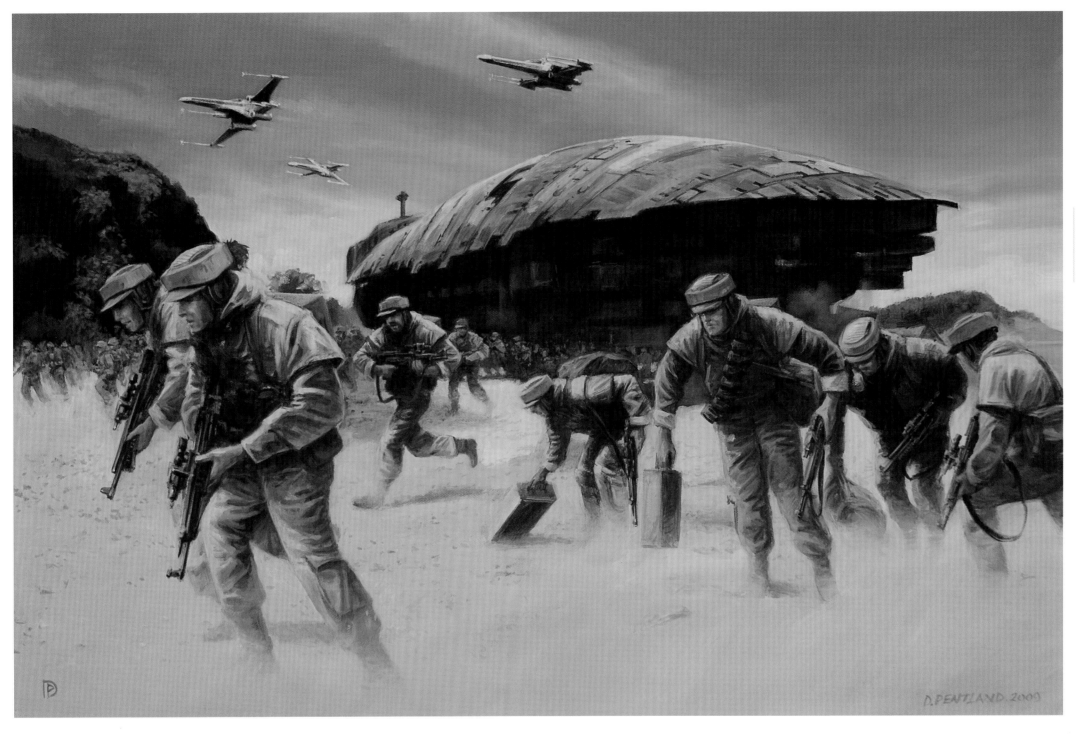

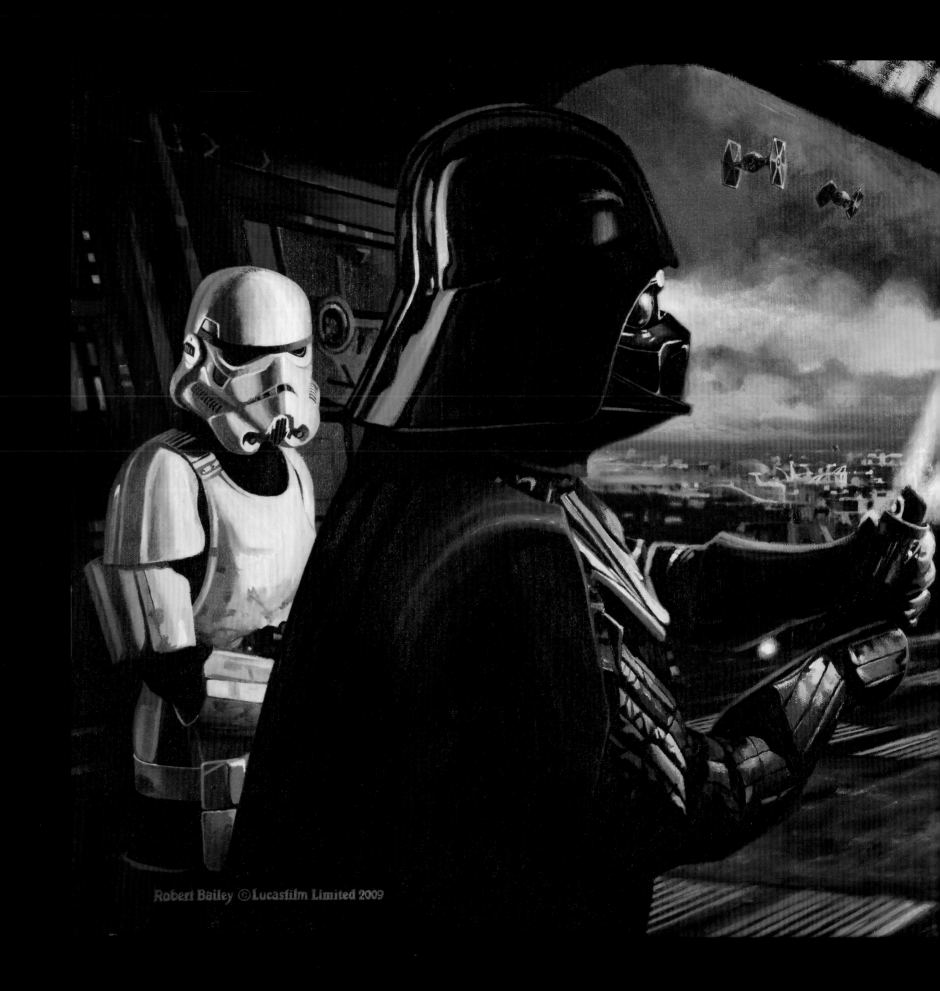

RIGHT:
ROBERT BAILEY
Now My Enemy

Oil on canvas
22 × 44 ″

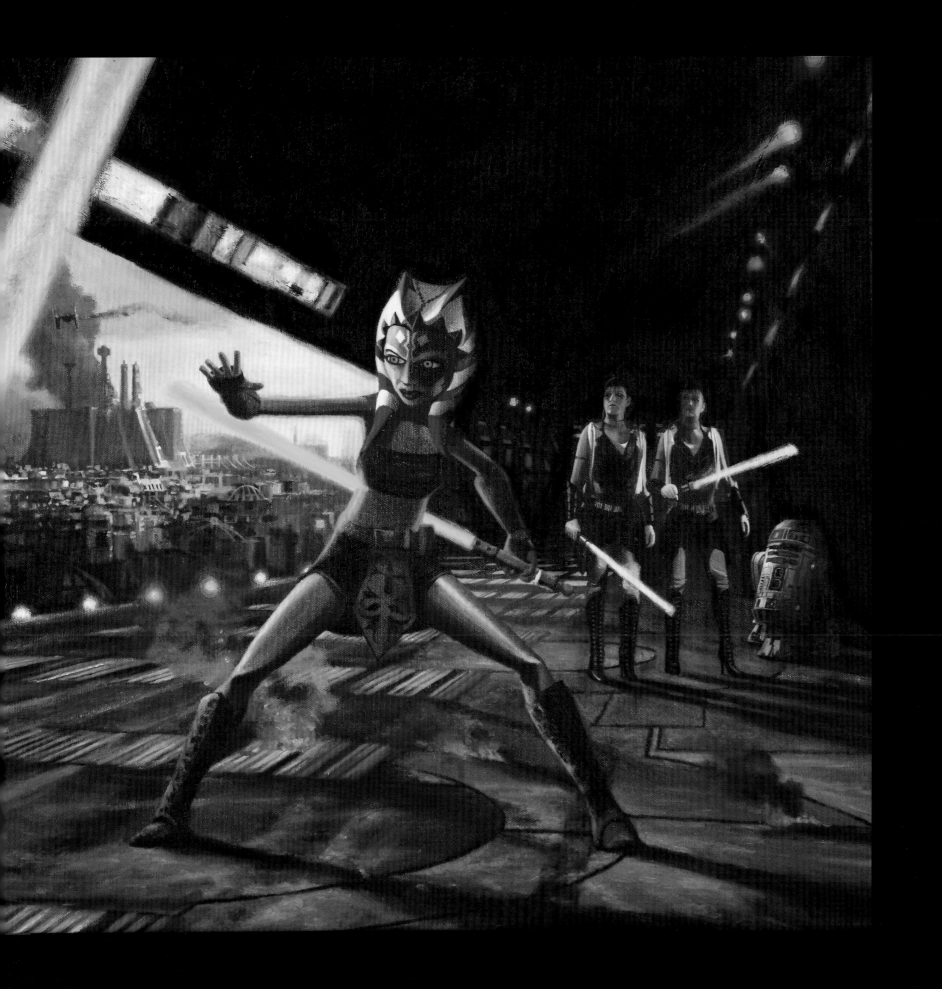

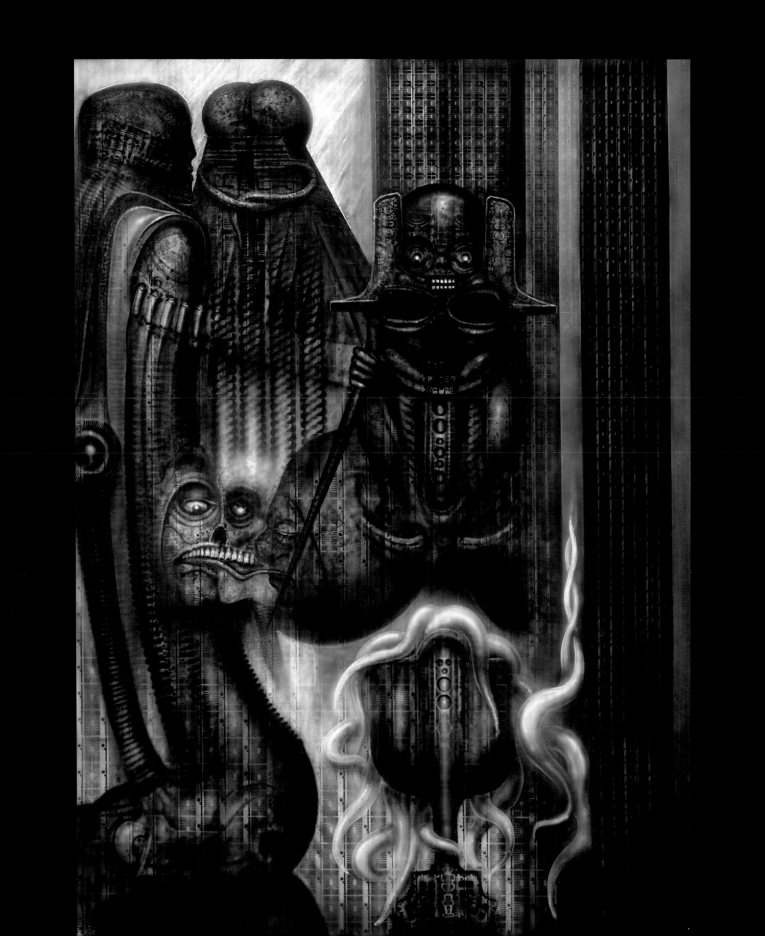

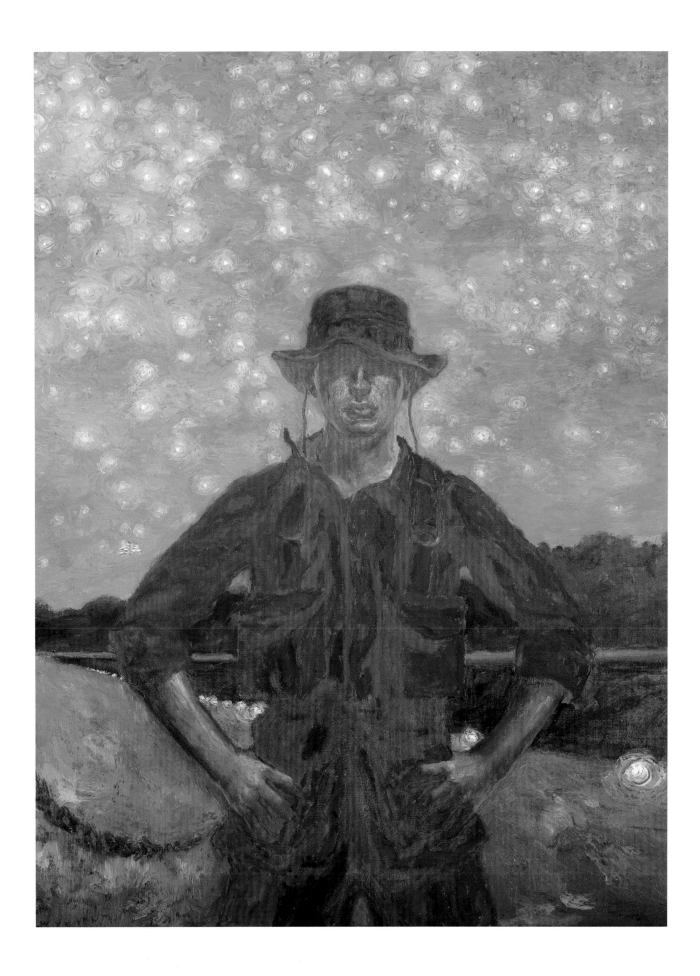

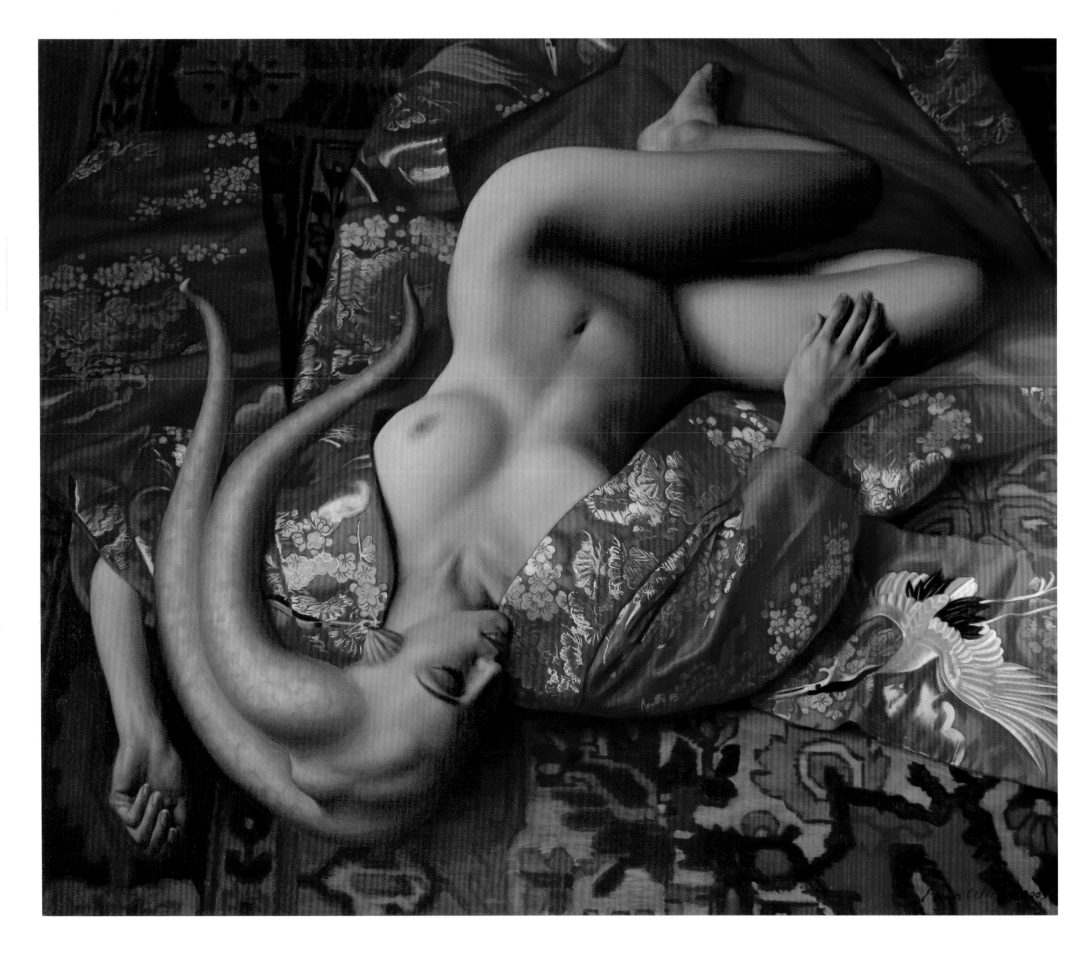

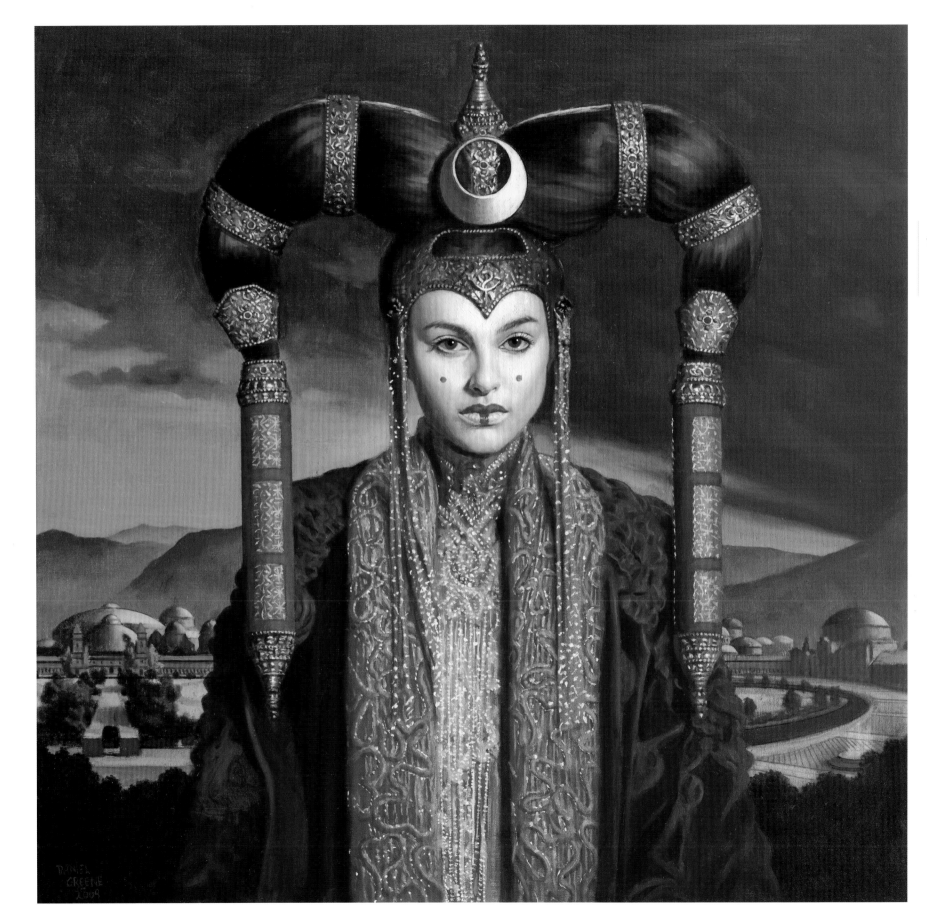

LEFT:
EVAN WILSON
Sleeping Aayla

Oil on canvas
36 × 42 ˝

RIGHT:
DANIEL E. GREENE, N.A.
Queen Amidala of Naboo

Oil on linen
30 × 30 ˝

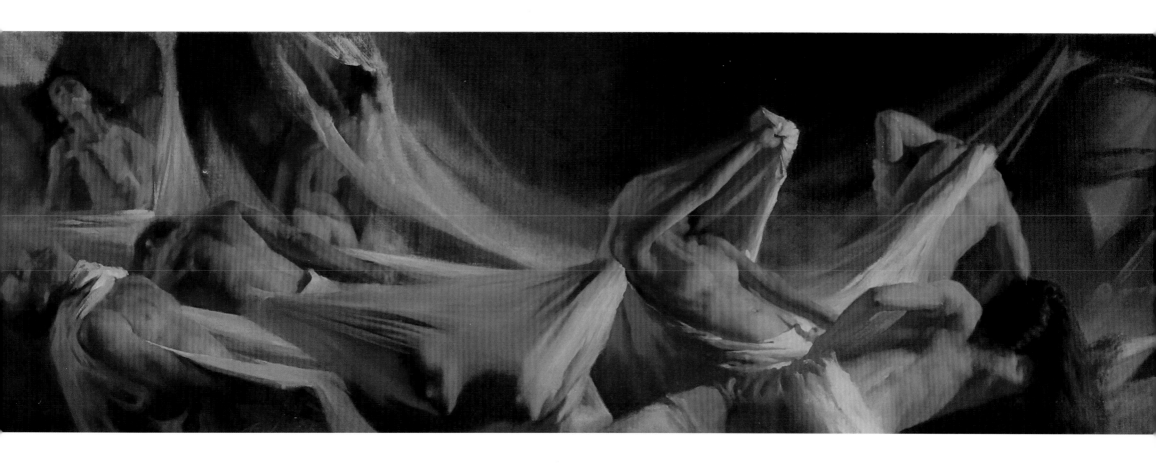

ABOVE AND OVERLEAF (DETAIL):
STEPHEN EARLY
The Struggle Behind the Mask

Oil on linen
12 × 70˝

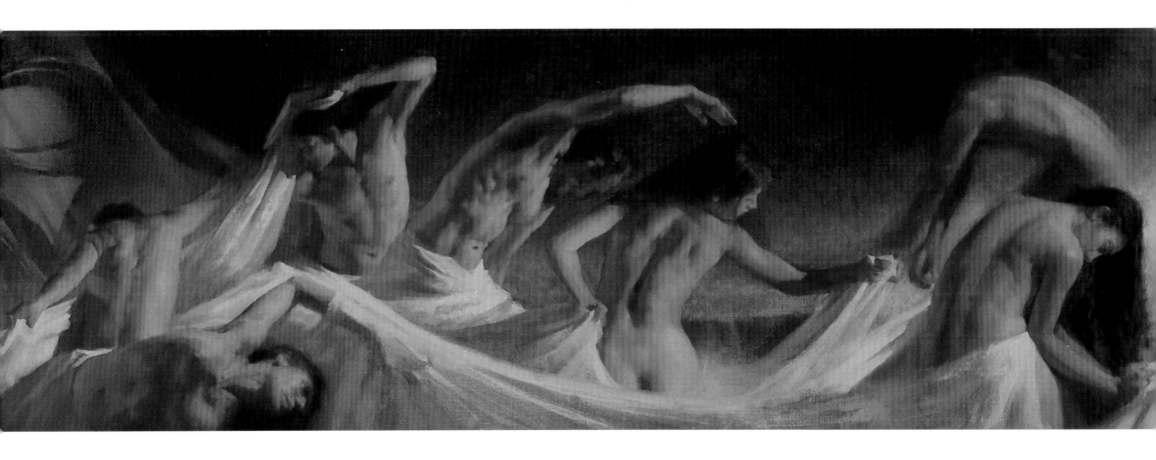

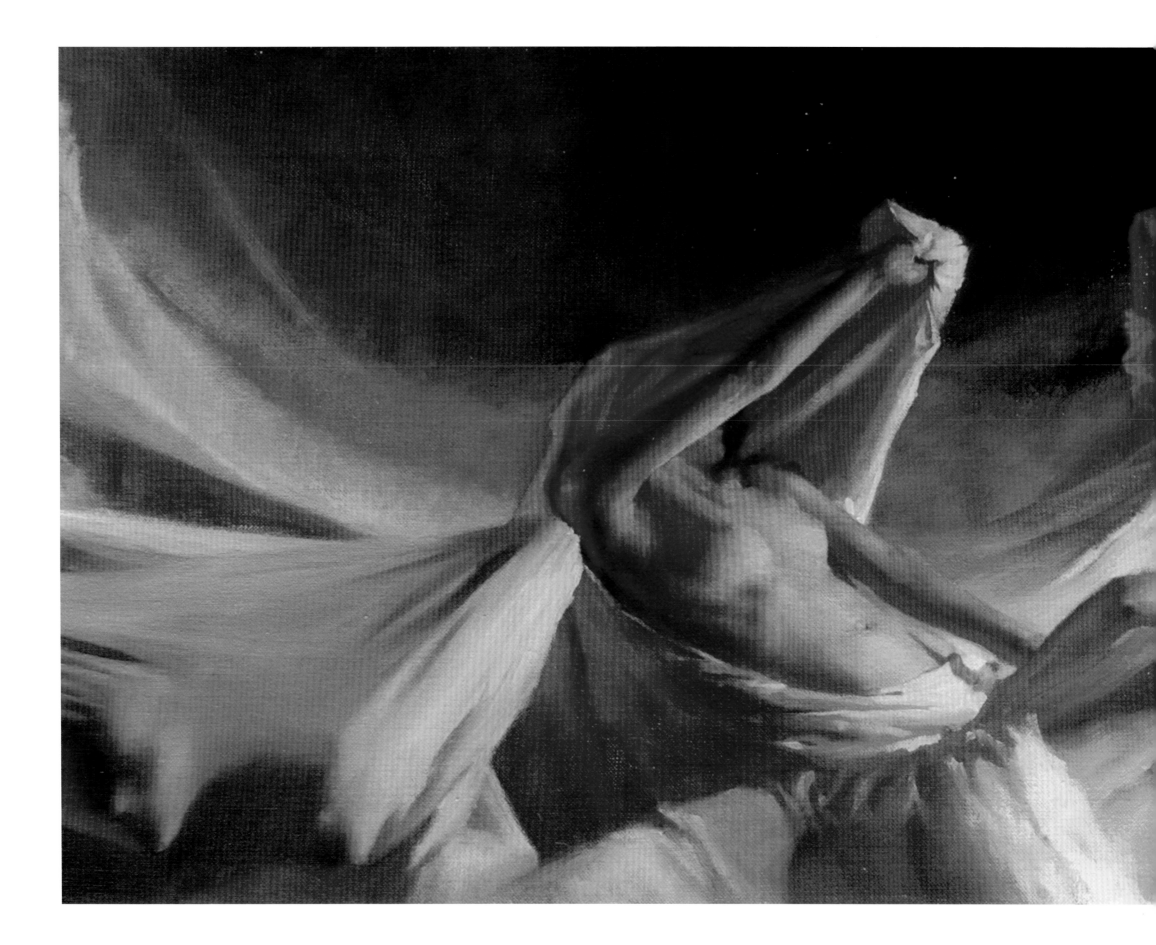

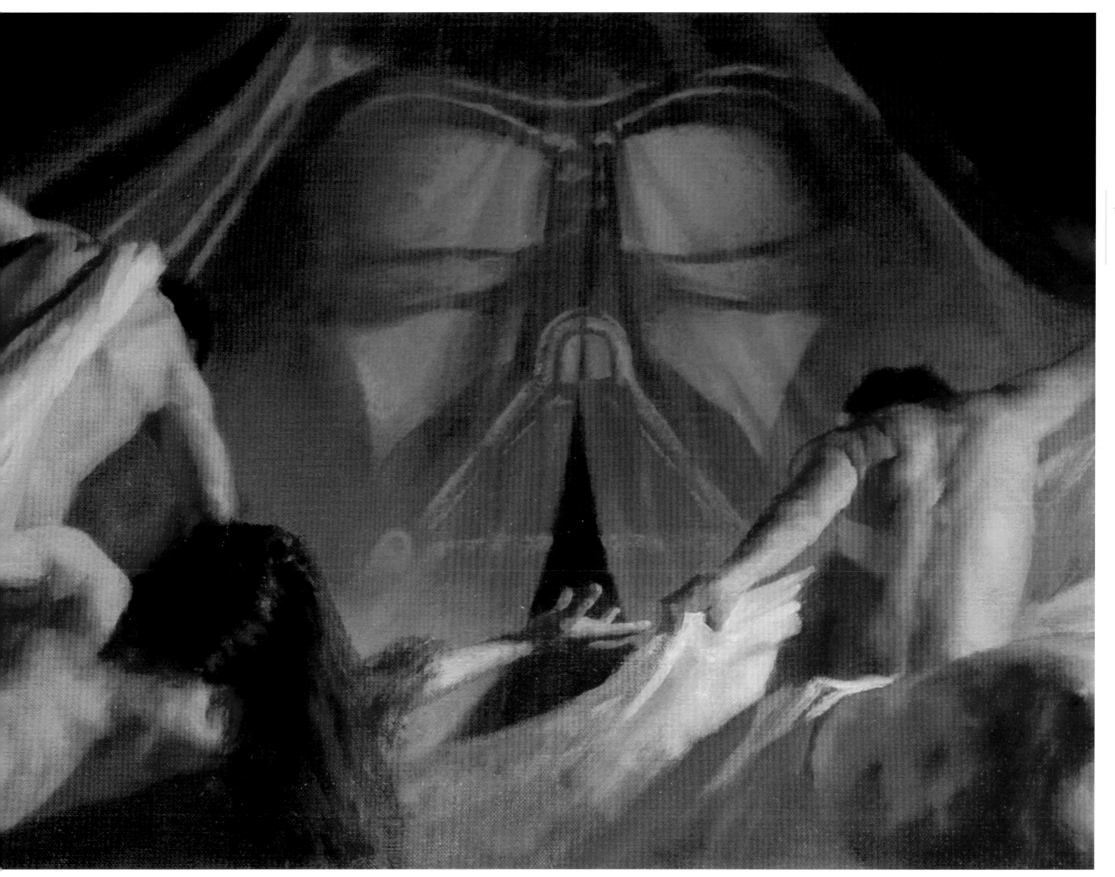

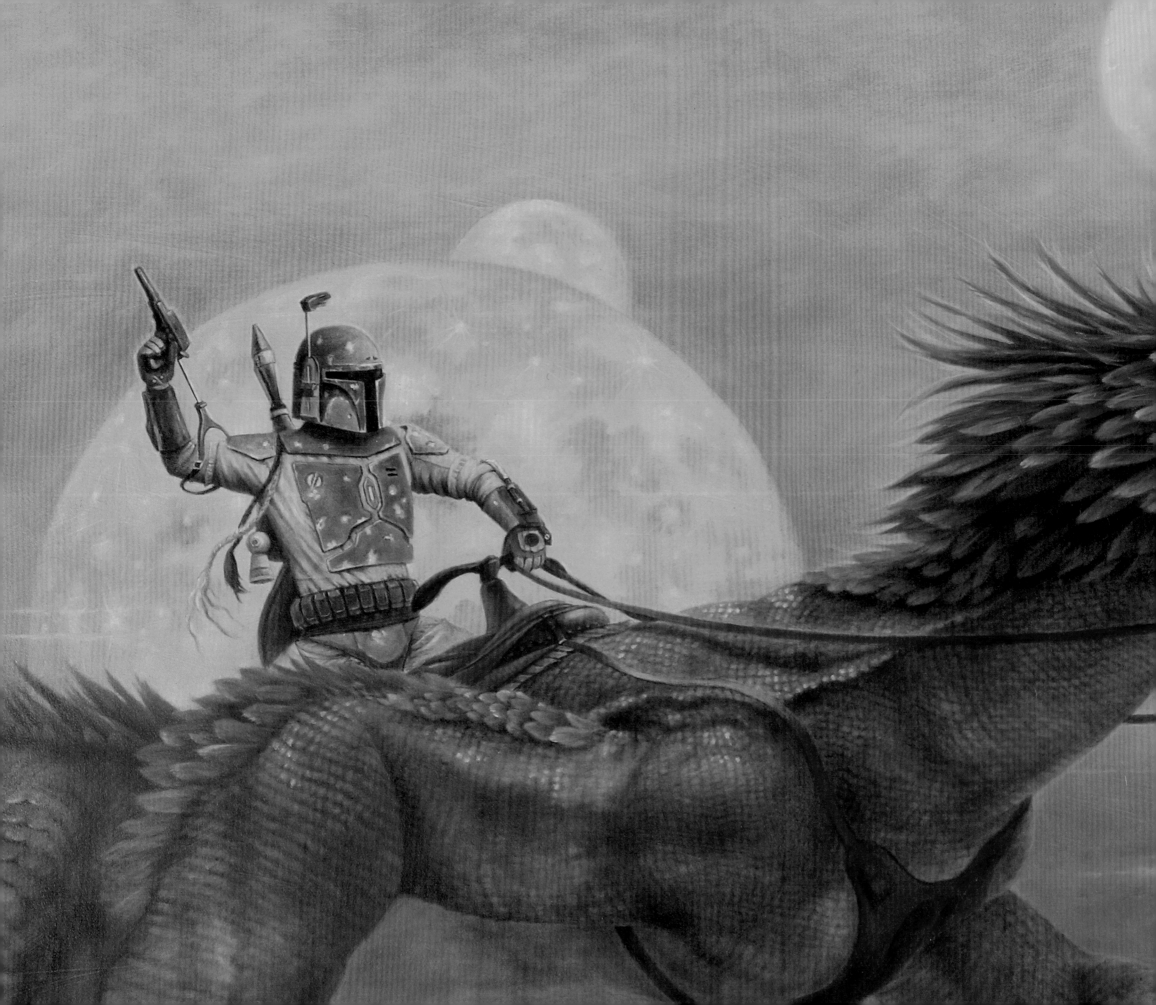

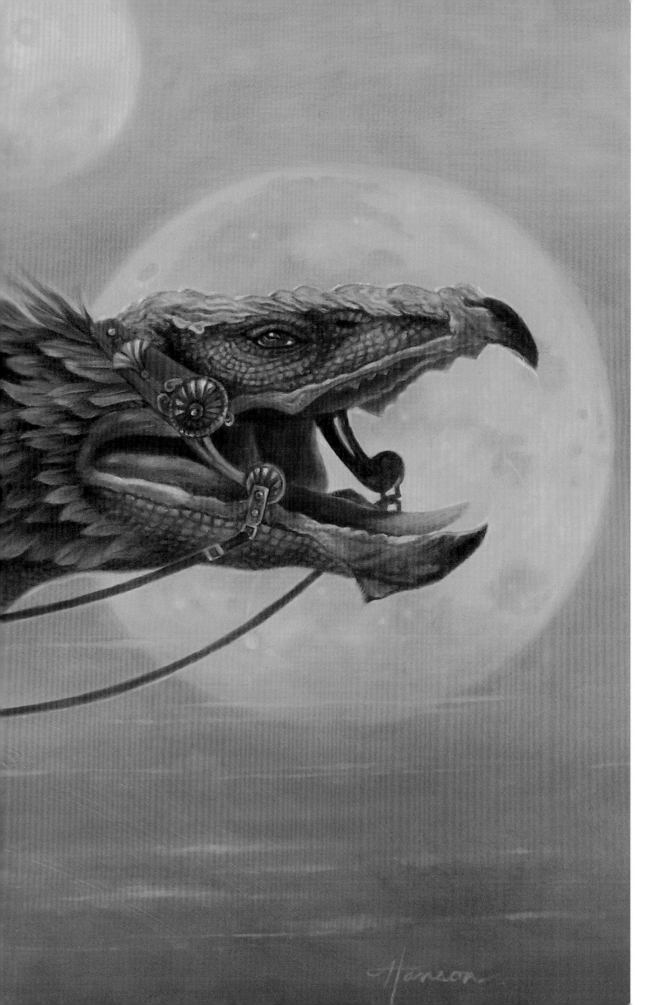

LEFT:
ANN HANSON
On the Hunt

Oil on panel
14½ × 26ʺ

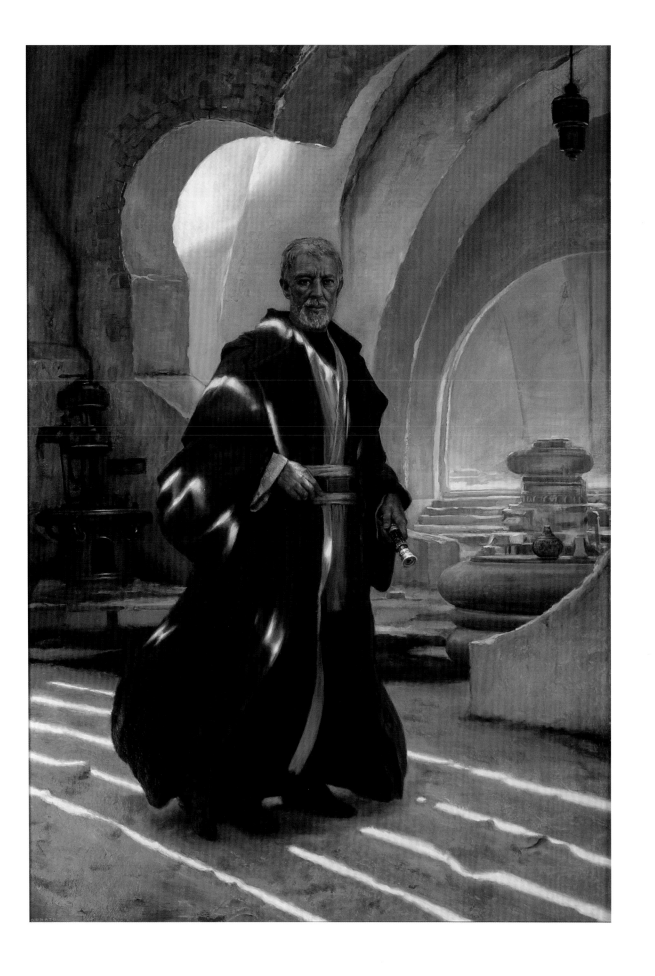

LEFT:
DONATO GIANCOLA
Obi-Wan Kenobi

Oil on panel
48 × 33 ˝

RIGHT AND OVERLEAF (DETAIL):
MICHAEL COLEMAN
In the Forest—Hunting Party

Oil on panel
30 × 24 ˝

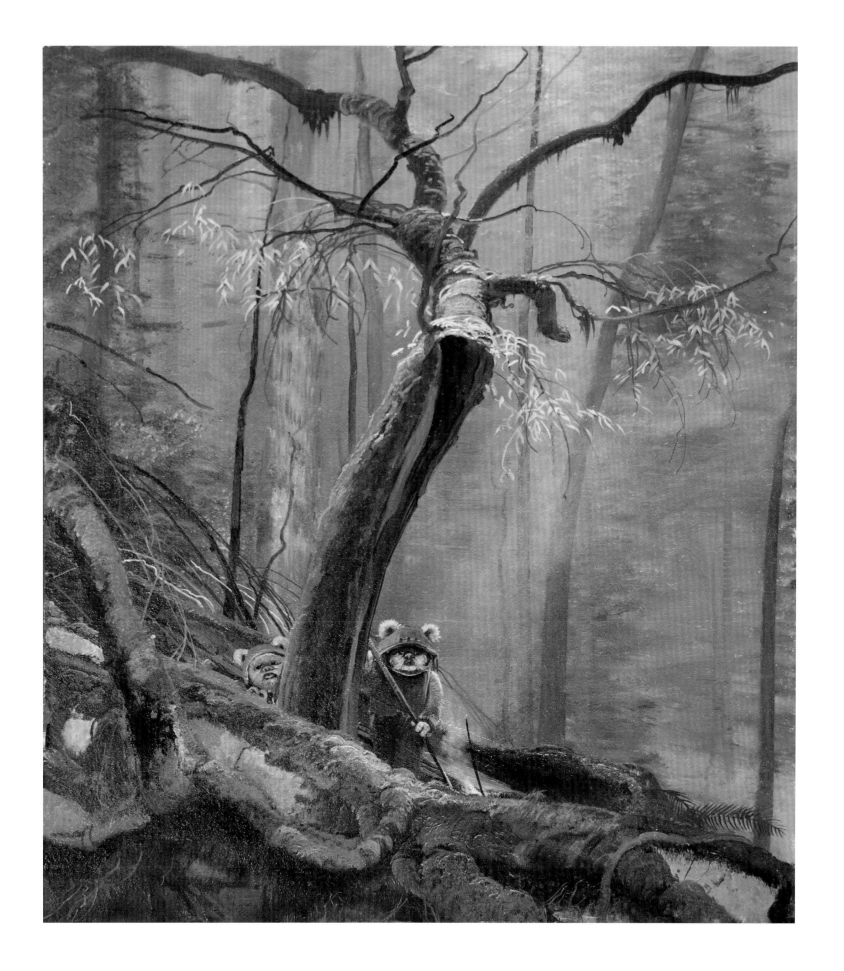

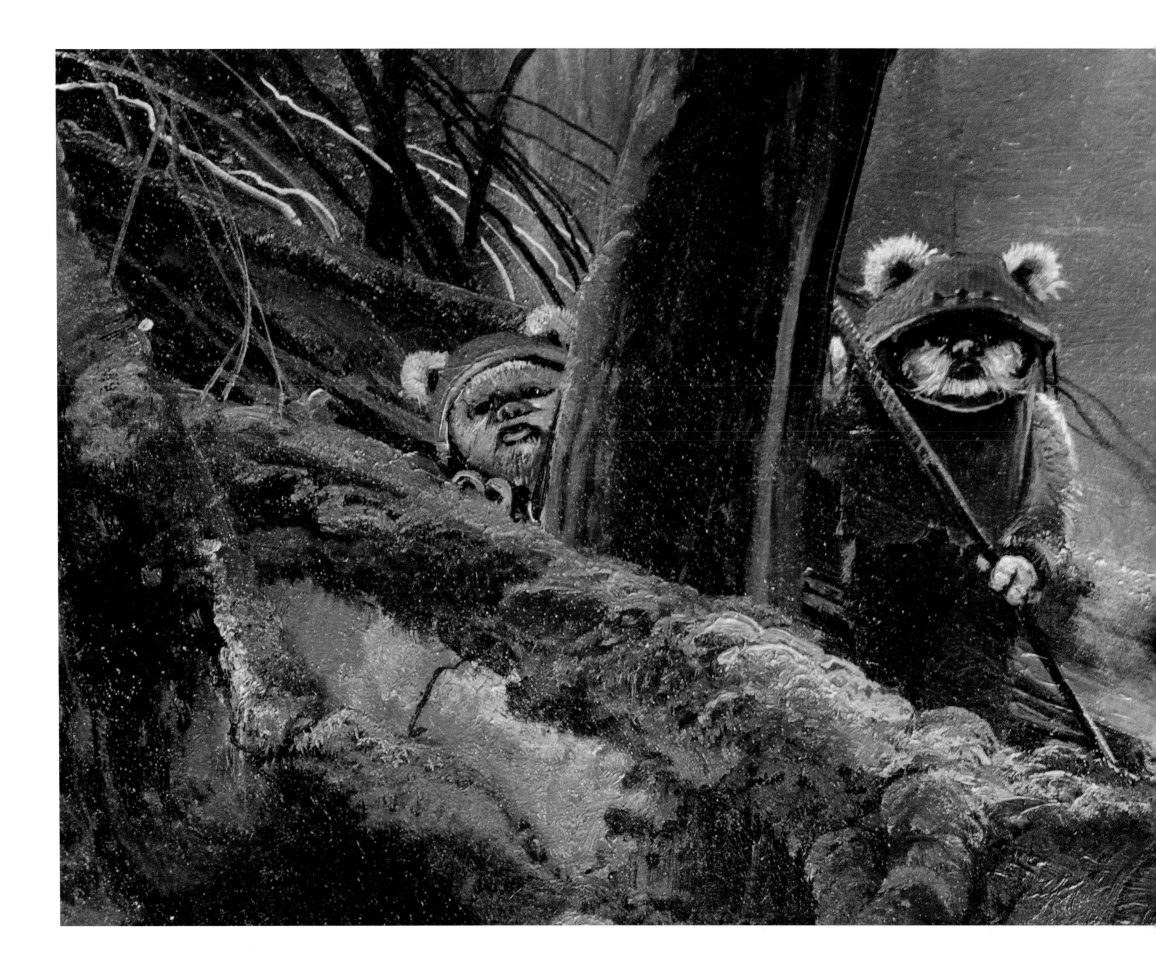

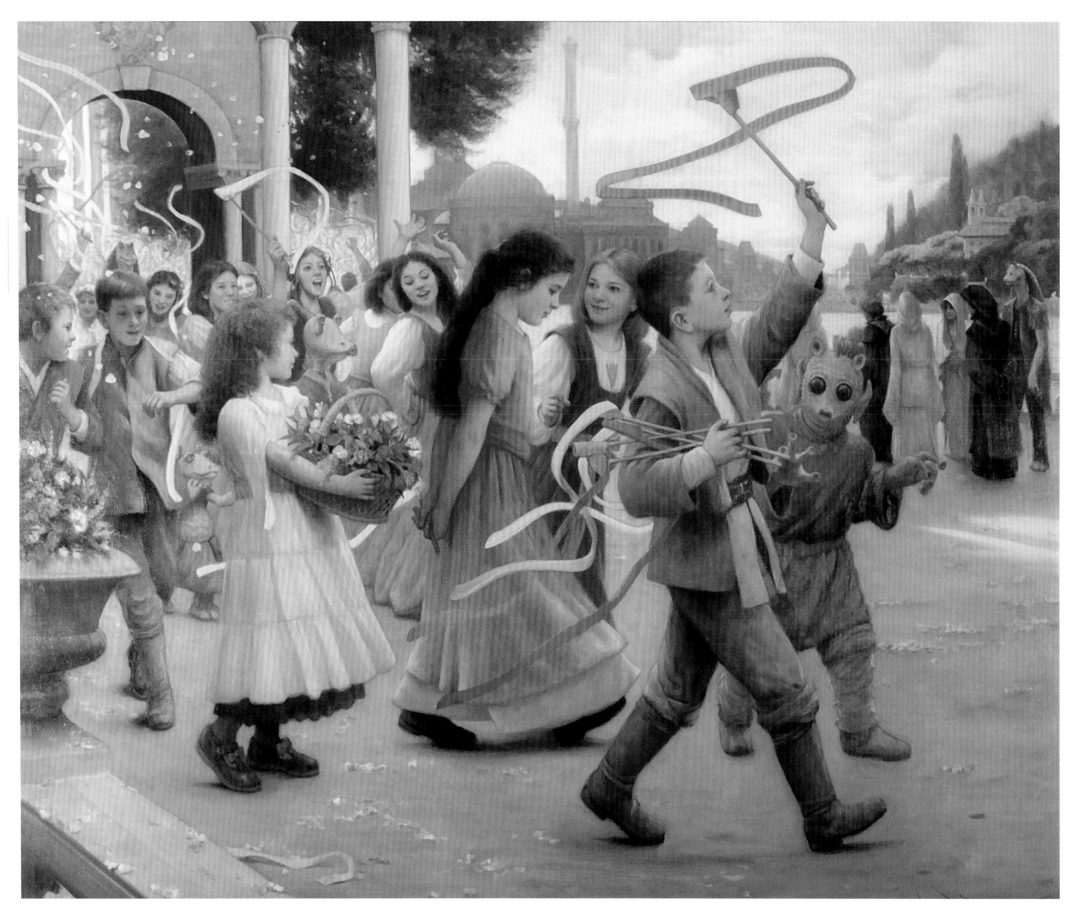

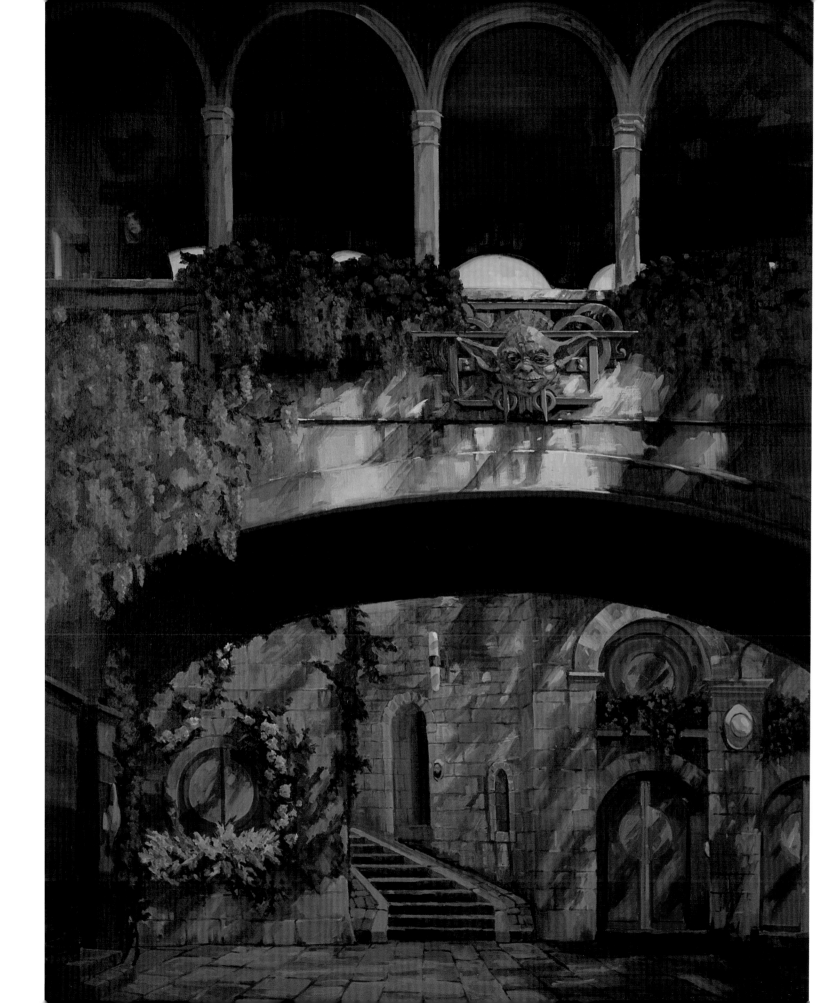

LEFT:
ALLAN R. BANKS
*Celebration of Naboo Youth on
Freedom Day*

Oil on linen
54 × 62 ˝

RIGHT:
LINÉ TUTWILER
Yoda Archway on Naboo

Oil on linen canvas
40 × 30 ˝

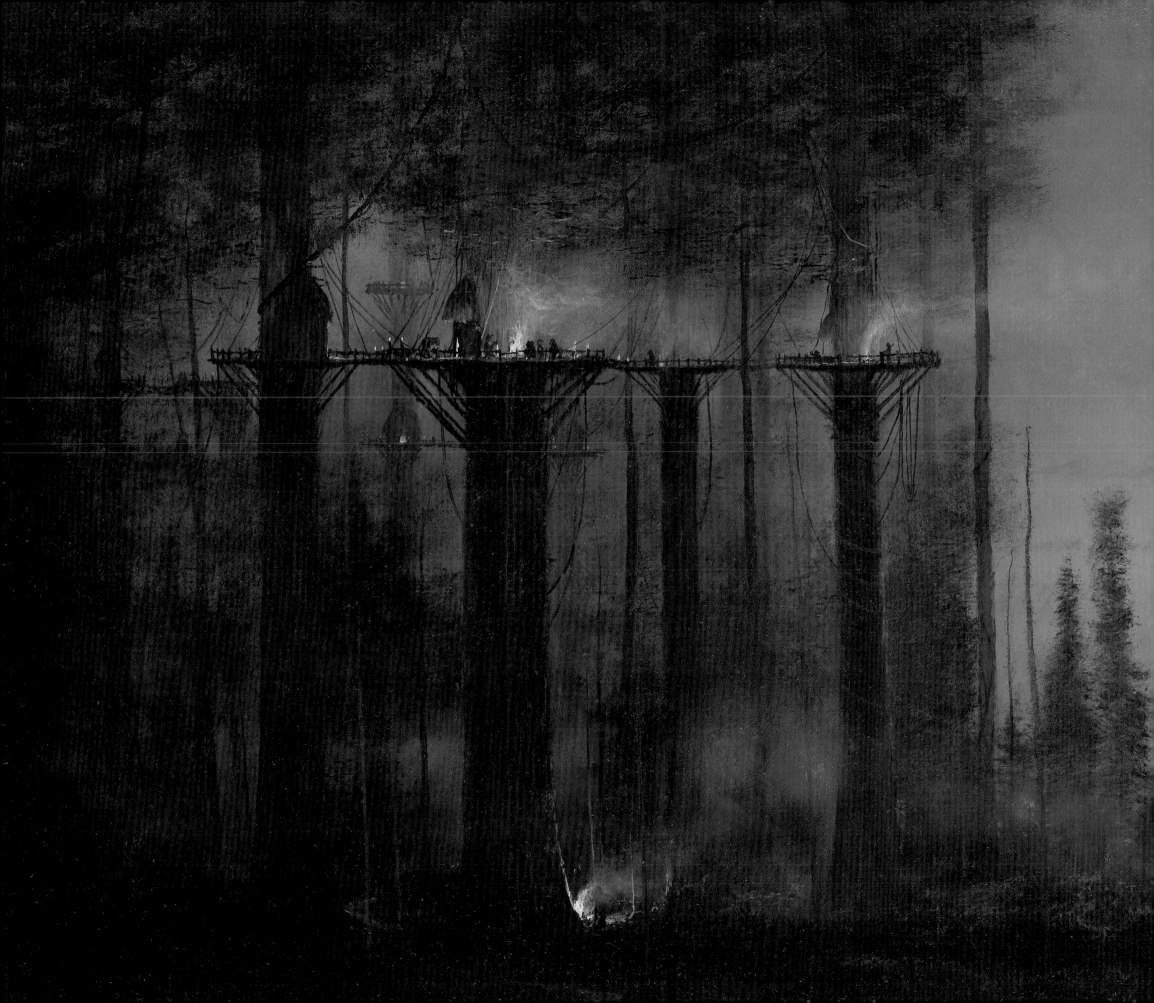

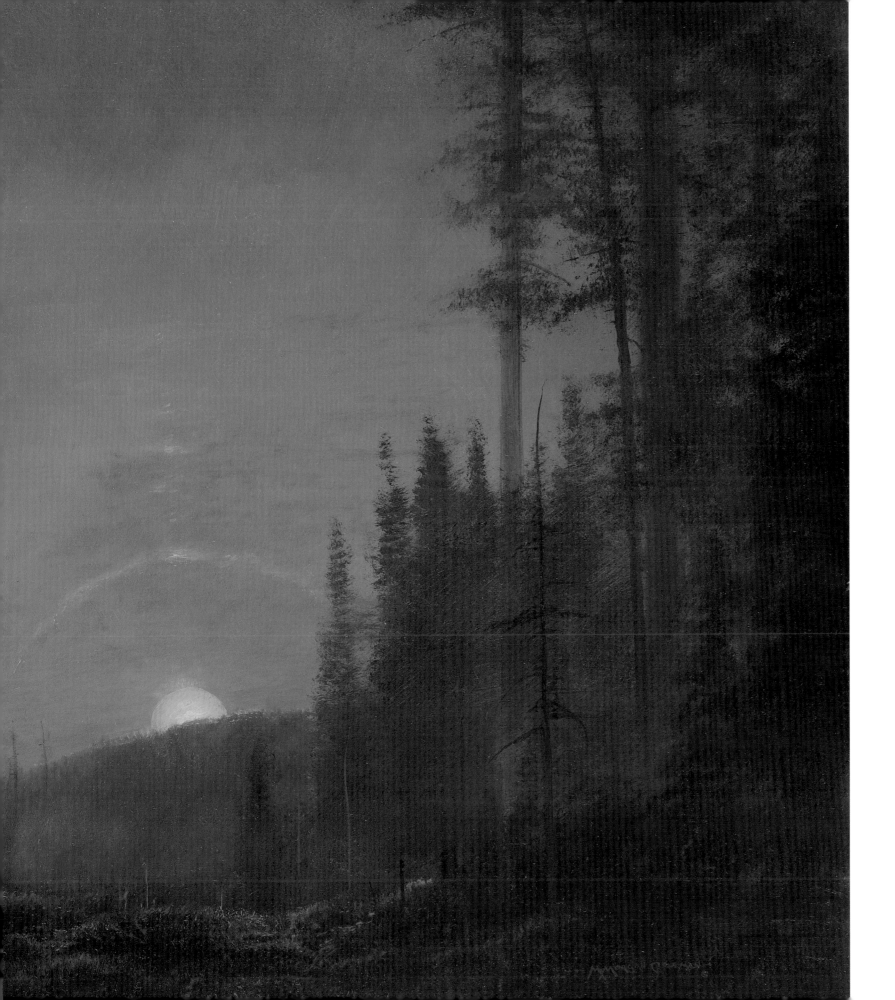

LEFT:
M. MORGAN COLEMAN
Night Stories

Oil on board
18 × 36˝

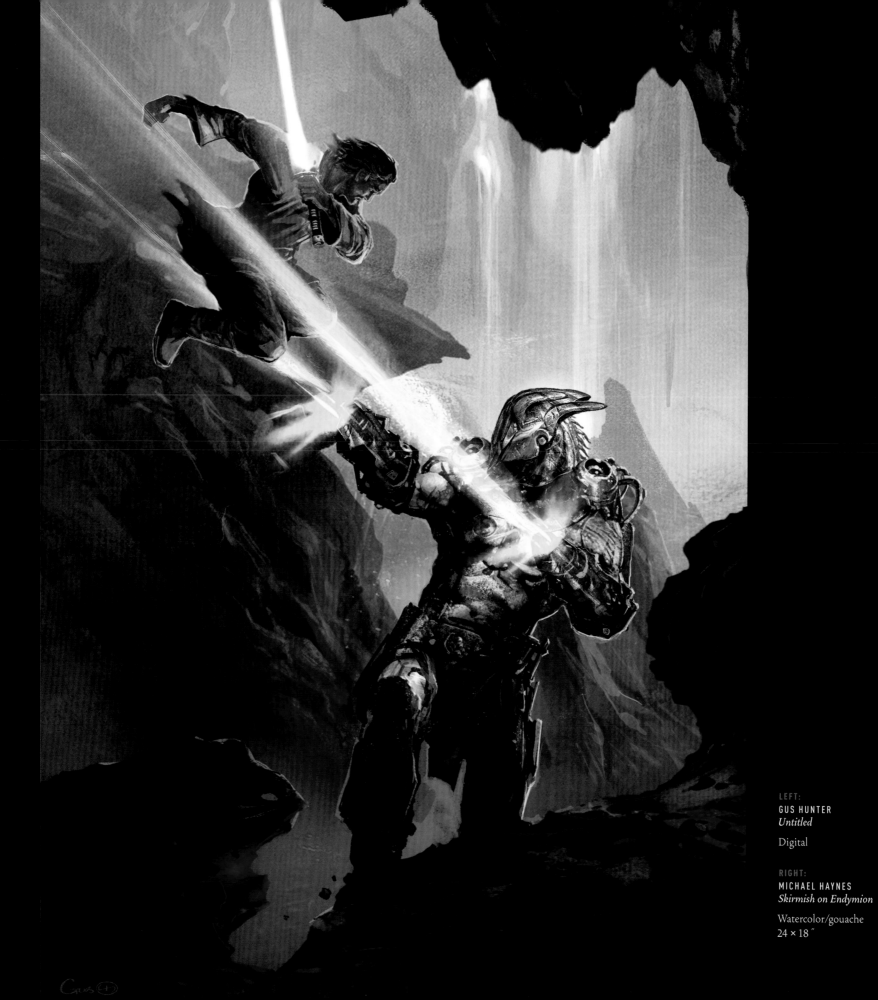

LEFT:
GUS HUNTER
Untitled

Digital

RIGHT:
MICHAEL HAYNES
Skirmish on Endymion

Watercolor/gouache
24 × 18 ˝

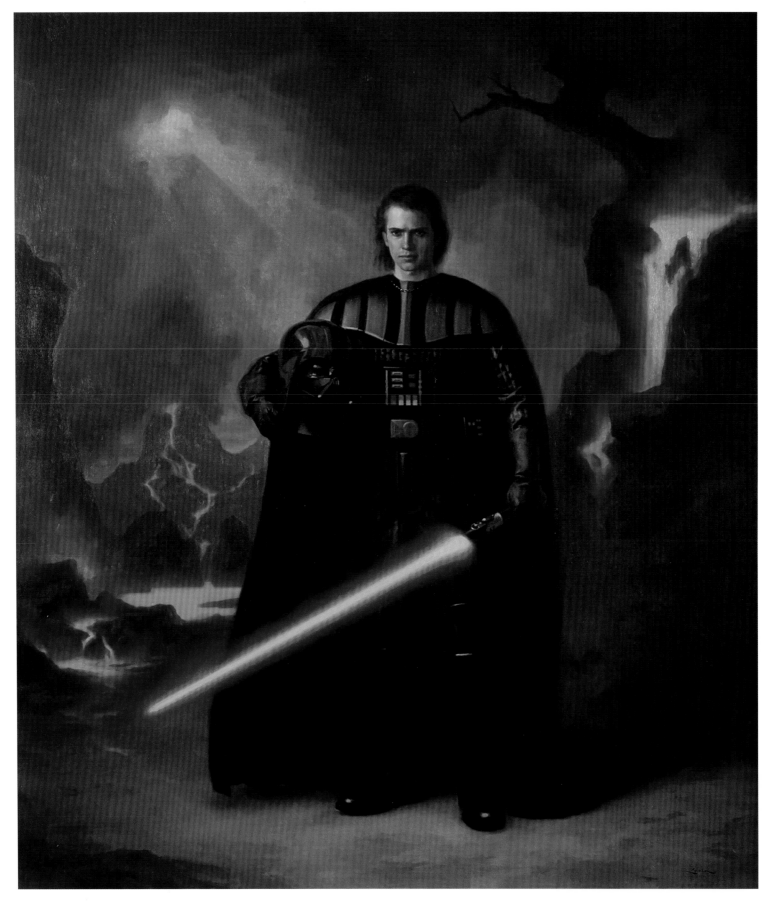

LEFT:
STEVEN J. LEVIN
Portrait of Darth Vader

Oil on linen
56 × 46″

RIGHT:
HARLEY BROWN
Yoda

Pastel on museum paper
20 × 16″

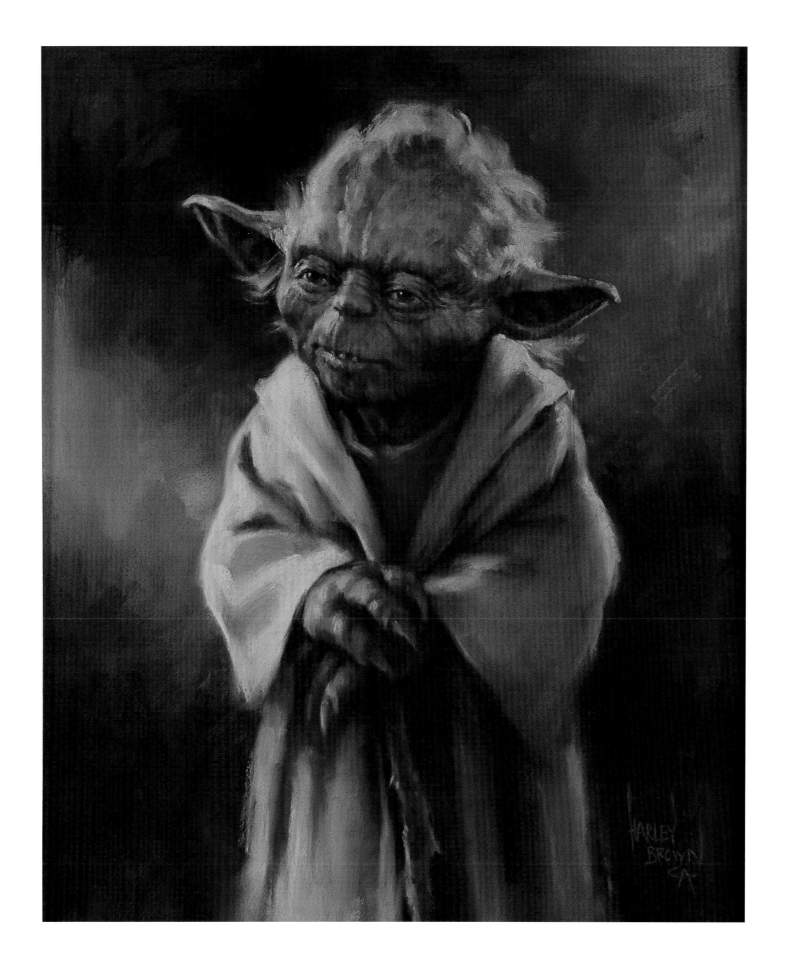

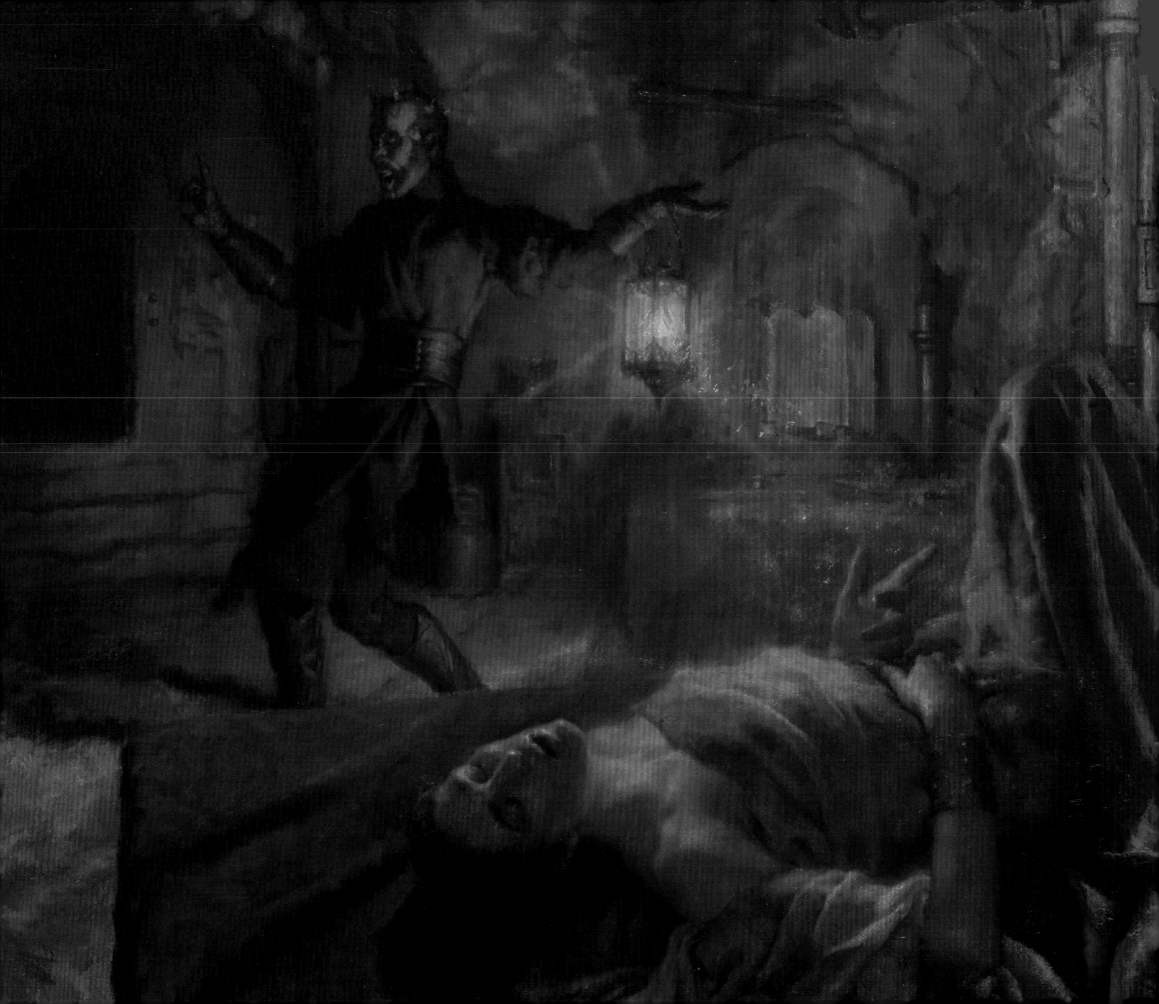

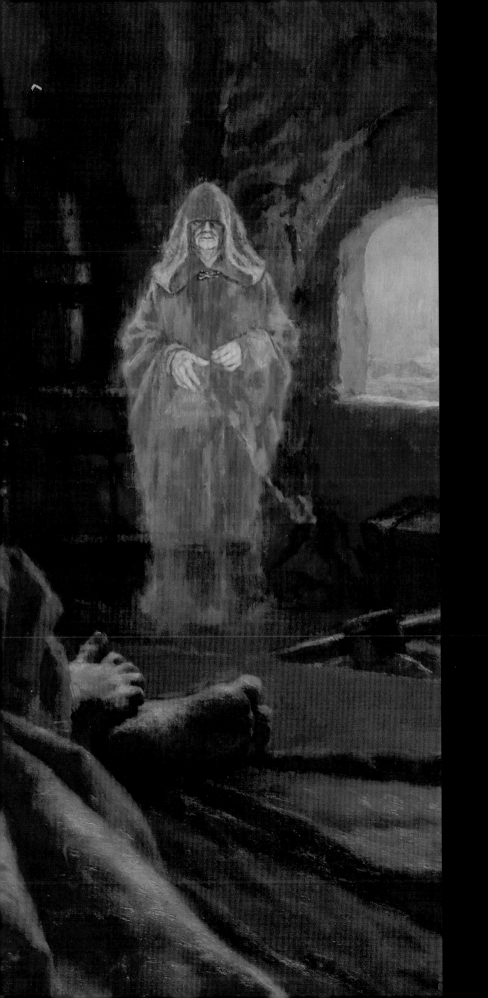

LEFT:
DAN THOMPSON
Sith Annunciation

Oil on linen
37 × 60 ˝

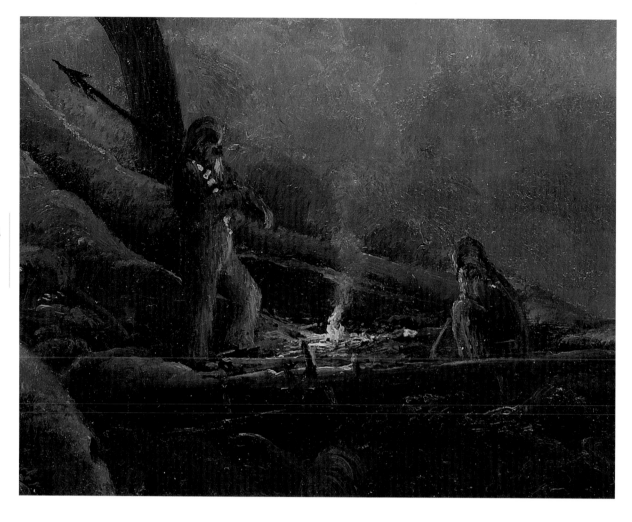

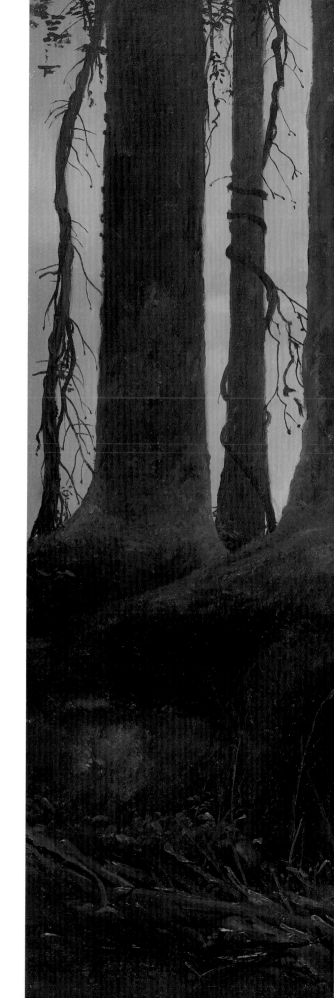

ABOVE (DETAIL) AND RIGHT:
M. MORGAN COLEMAN
Kashyyyk

Oil on canvas
20 × 30 "

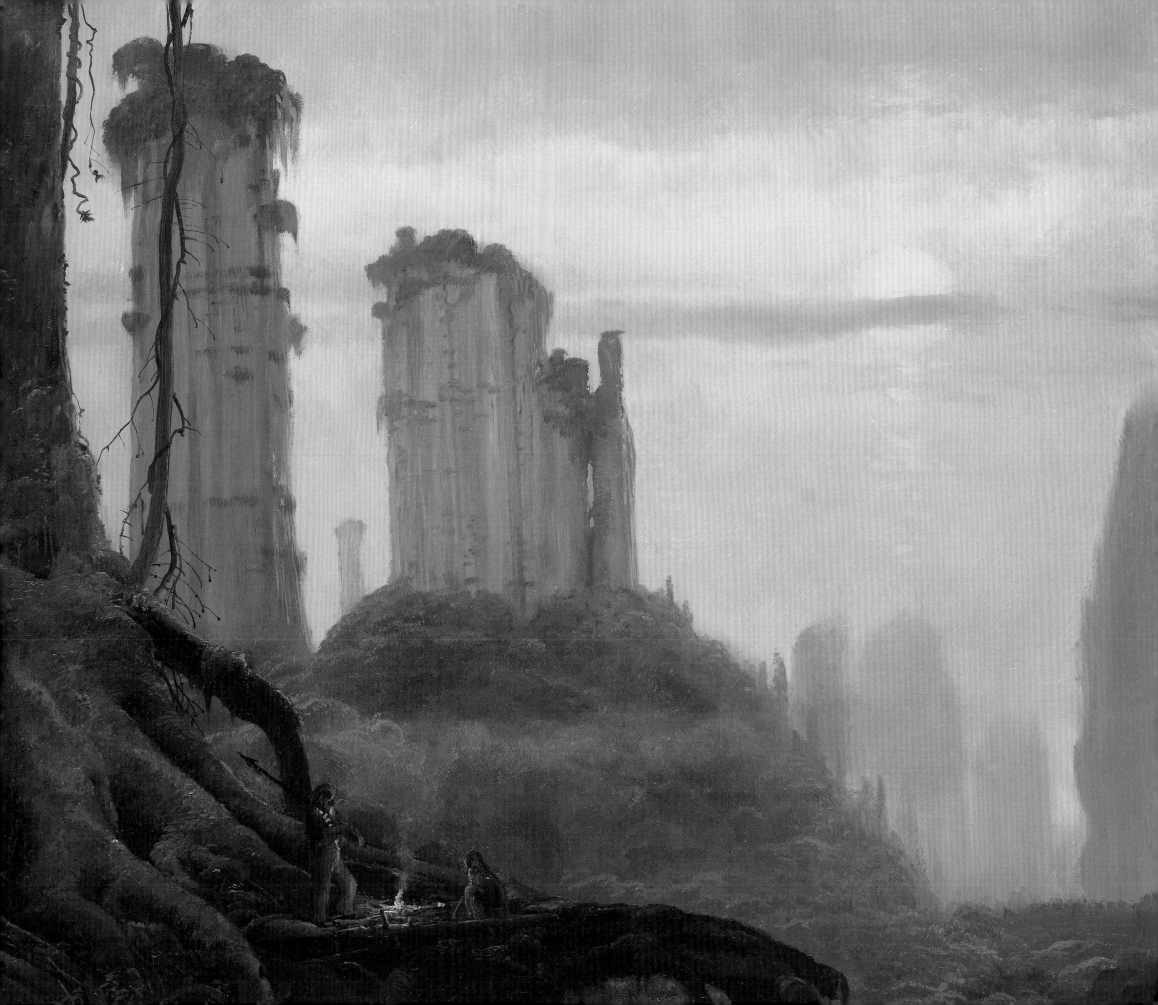

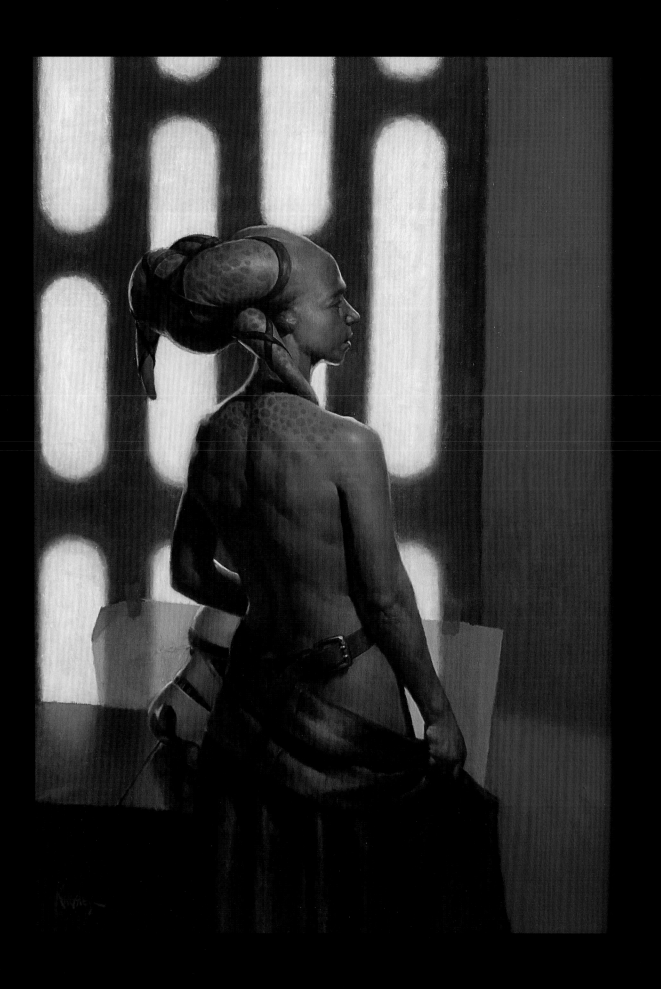

LEFT:
DARREN KINGSLEY
Bluescreen Twi'lek

Oil on linen
36 × 24 ″

RIGHT:
SERGE MICHAELS AND
MICHAEL MALM
Padmé's Dream/Slipping Away

Oil on canvas
36 × 48 ″

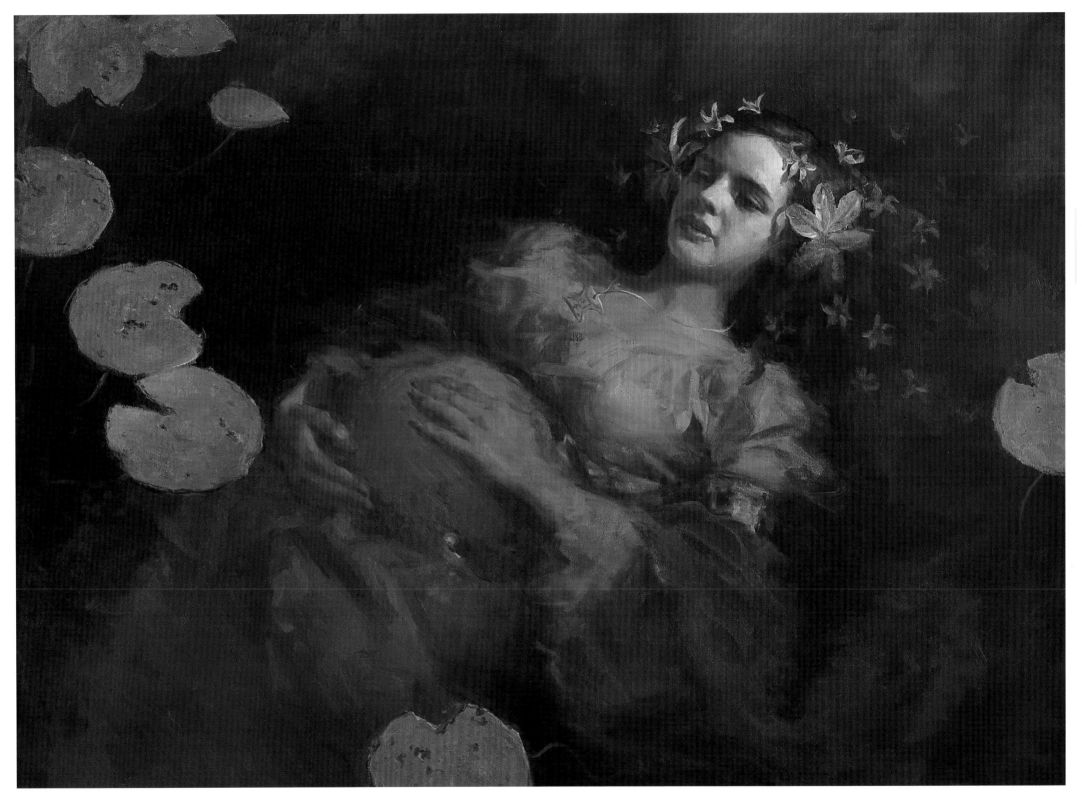

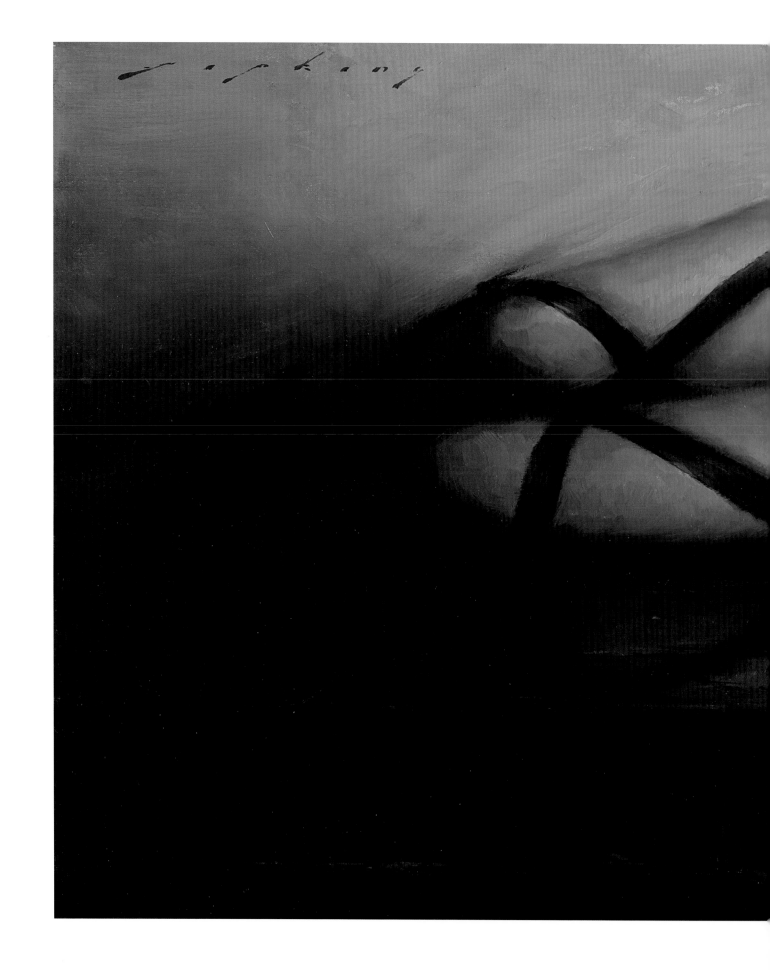

RIGHT:
JEREMY LIPKING
Yobana

Oil on canvas
14 × 30 ″

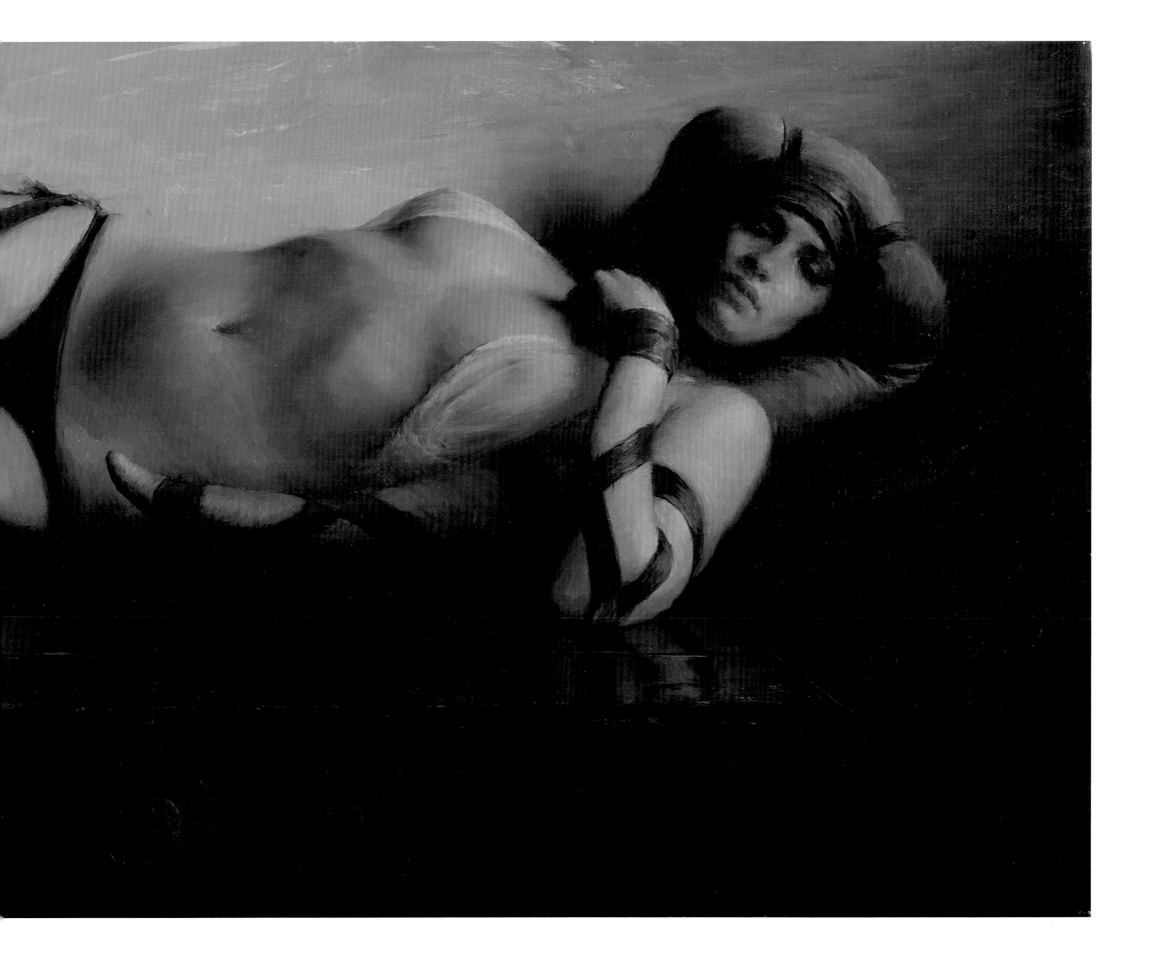

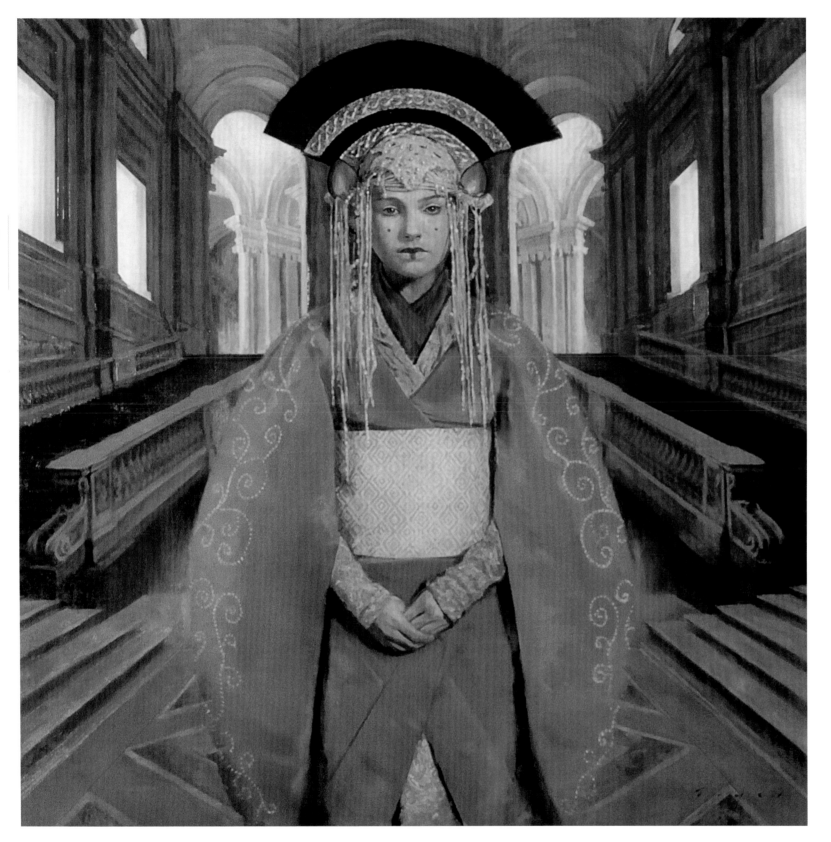

LEFT:
DOUGLAS FRYER
Padmé Amidala

Oil on panel
30 × 30 ″

RIGHT:
NOAH BUCHANAN
Your Father's Lightsaber

Oil on panel
9½ × 10½ ″

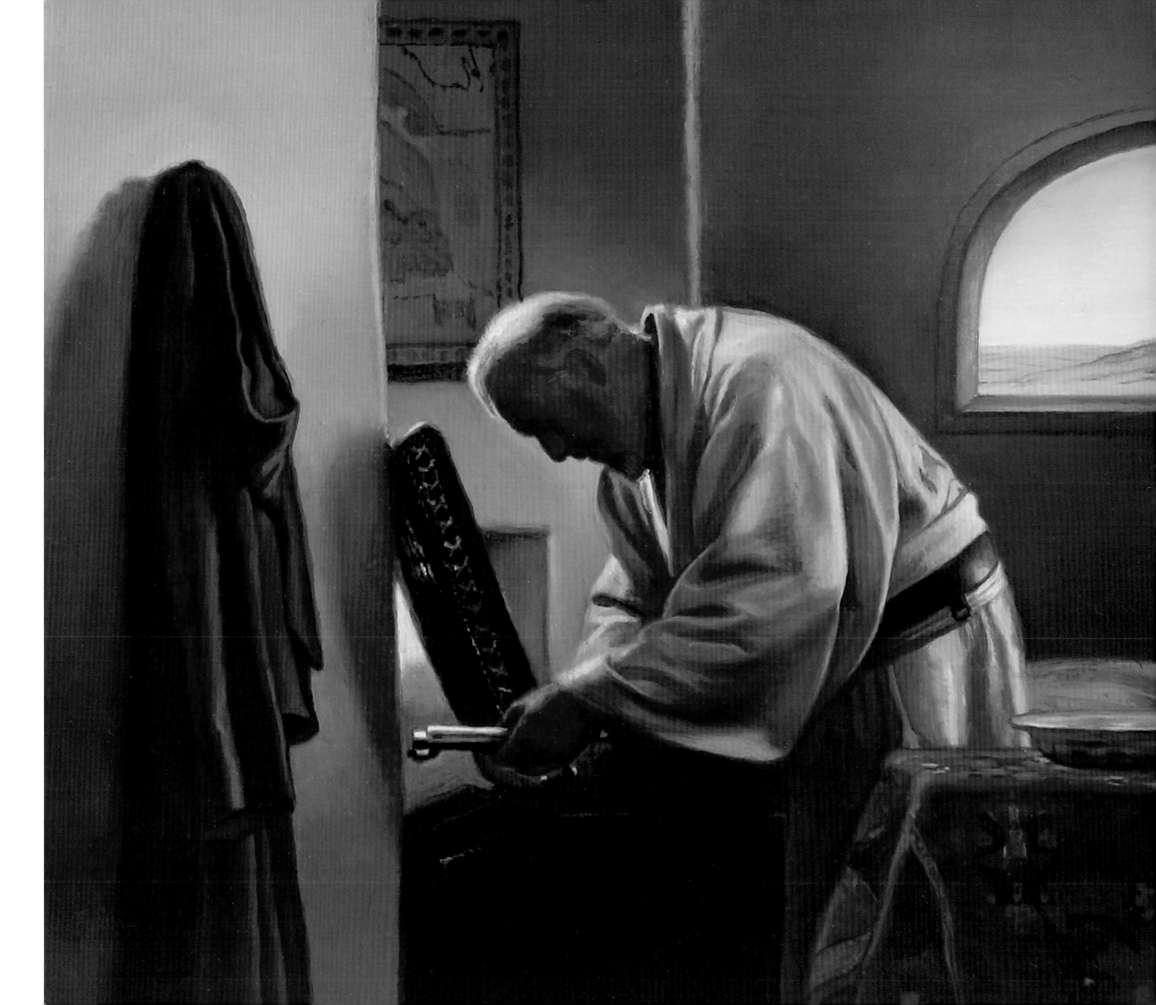

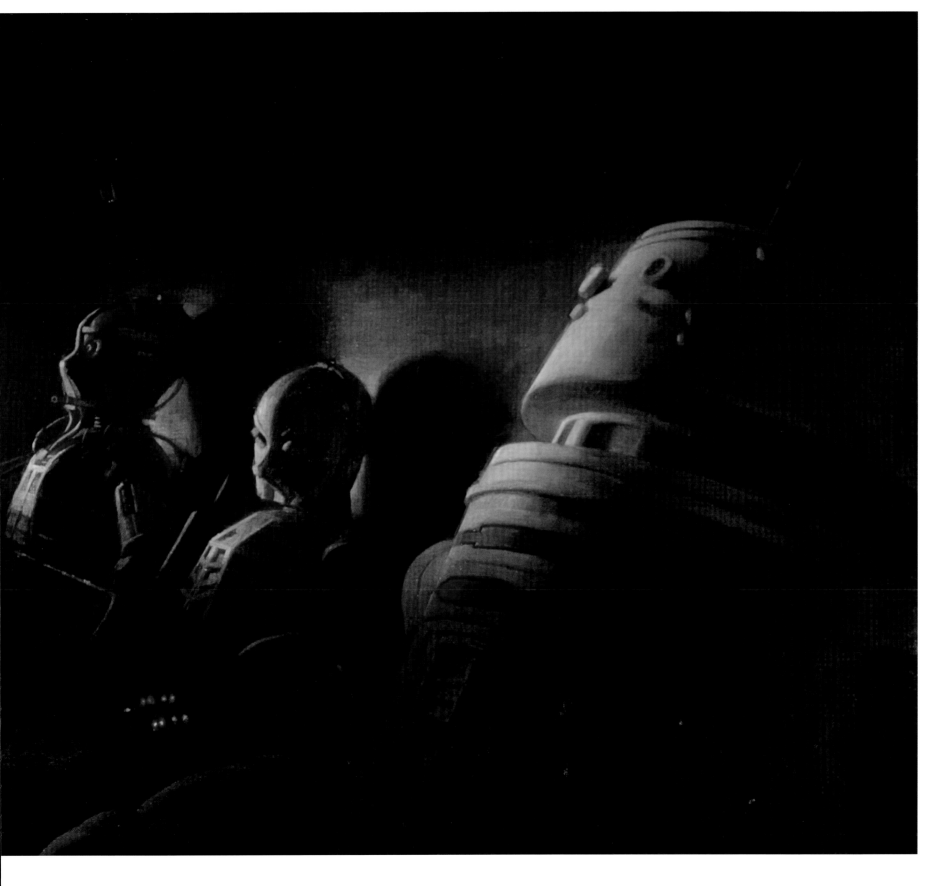

MICHAEL GRIMALDI
Dusk on Tatooine

Oil on canvas
22 × 44 ˝

ARTISTS' BIOGRAPHIES
& STATEMENTS

Tom Altenburg

Tom Altenburg is a nature and Western artist who has won national awards for his acrylic paintings. He currently works as an artist and designer for Hallmark Cards, Inc. He is also an artist member of the Society of Animal Artists, Artists for Conservation, and the National Oil and Acrylic Painters' Society.

Use the Force p. 47

Young Anakin Skywalker demonstrates how to overcome fear by using the Force. Considering all of the massive challenges we currently face, I felt that this would be a fitting message. Of course, Anakin would be able to slay this dragonlike creature easily.

Amano

Amano was born in 1952 in a small town at the foot of Mount Fuji in Shizuoka, Japan. His artistic success won him access to concept illustration for video games. Amano's first project, *Final Fantasy*, became an international hit. He also created character designs for the games *Front Mission*, *Gun Hazard*, and *Emblem of Eru* (to be released in Japan by Capcom). His 1997 "Think Like Amano" exhibition in New York's Puck Building presented a retrospective of his work and debuted his series of ambitious New York paintings.

Darth Vader p. 17

Jason Askew

Jason Askew was born in South Africa; went to the Johannesburg School of Art, Ballet, and Music; and attended the City and Guilds of London Art College, Kensington. His interest in military history started as a teenager while learning the history of South Africa—namely the Zulu and South African wars, where Askew found inspiration for his first major epic series.

Askew is often commissioned by many British and overseas regiments, including 2 RGR, the Gurkhas, the Queens Lancashire Regiment, the Coldstream Guards, and the Staffordshire Regiment. He was also an official war artist for the Staffordshire Regiment in Iraq.

Hoth Snow Battle (The Empire Strikes the Rebel Stronghold) pp. 56–59

The motivation behind this painting was to effectively illustrate the conditions in the Rebel trenches as they are overrun by AT-AT walkers and swarms of snowtroopers.

Robert Bailey

Robert Bailey attended the College of Art in England and subsequently has been a television show host, film cameraman/editor, and newspaper/magazine journalist. He is known mainly for his World War II combat canvases, and examples of his work are in museums and private collections from Australia to the United States (including the Pentagon), Canada, and the United Kingdom.

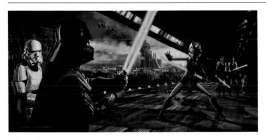

Now My Enemy pp. 108–109

I was introduced to a network of local people who own *Star Wars* outfits. Some were kind enough to visit my studio, where they posed to fit into the frame of this painting. This is a huge advantage over visual references from other sources, as the artist can light the subject as he/she wishes.

Allan R. Banks

Allan R. Banks received his classical-art training in the private studios of Richard Lack and R. H. Ives Gammell. Visits to Europe brought about further artistic development and the rediscovery of the role of plein air painting. Banks has exhibited widely in galleries and museums across the United States, with numerous works in private and public collections. He is represented by Rehs Galleries in New York and GandyGallery.com online.

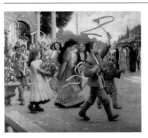

Celebration of Naboo Youth on Freedom Day p. 124

After victory has been won, the entire city of Naboo celebrates with all fanfare: The youth of the city-state, along with the Gungans, are jubilant at the prospect of a new world of hope, peace, and freedom on Naboo. Banners and drums and the sounds of trumpets fill the air with shouts of unity and peace throughout the Republic. Children are seen laughing, waving streamers, and looking ahead to a bright new future. The scene depicted shows a joyous procession spreading out to all corners of Naboo.

Julie Bell and Boris Vallejo

Julie Bell was born in Beaumont, Texas. A former competitive bodybuilder, Julie applies the same discipline and intensity to her art career; her knowledge of anatomy has allowed her to imbue her figures of humans and animals with grace and strength. At the heart of her work is an element of empowerment and independence.

Bell's work has appeared on hundreds of book covers, comic books, trading cards, and collectibles. Volumes of her work include: *Soft as Steel*, *Hard Curves*, *The Julie Bell Portfolio*, and many books with her husband, Boris Vallejo, such as *Fantasy Workshop*, *Superheroes*, *The Ultimate Collection*, *Fabulous Women*, and, most recently, *Imaginistix*.

Boris Vallejo attended the National School of Fine Arts in Lima, Peru, before immigrating to the United States in 1964. He arrived in the United States with a suitcase of clothes, some samples of his artwork, a violin, and eighty dollars in his pocket. In the years since, he has become a legend in the fantasy and science fiction art world. His paintings have been seen on hundreds of book covers, calendars, magazines, and movie posters. Many of his paintings have been collected in a number of art books, including *The Fantastic Art of Boris Vallejo*, *Fantasy Art Techniques*, and *The Boris Vallejo Portfolio*. He has also published two collections of his photographic work, *Bodies* and *Hindsight*.

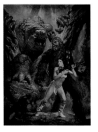

Forest Rancor pp. 71–73

We thought it would be fun to play with an interesting mix of textures and temperatures. Chewbacca's fur and the rancor's hide set up an opportunity to notice the silkiness of Princess Leia's skin. And Leia's summer outfit, along with the blazing light on the rancor's back, make us think of a sweltering hot day—but, in contrast, the surrounding forest looks cool and refreshing.

Ivan Berryman

Over the last twenty-five years, Ivan Berryman has become one of the leading aviation artists in the United Kingdom. He is widely acclaimed and collected throughout the world, and his attention to detail is unsurpassed. His portrayals of aviation and naval life hang in galleries and private collections around the world.

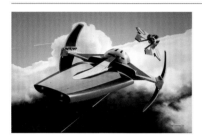

Hot Pursuit pp. 34–35

I am best known for painting aviation subjects, mainly classic air battles from the two World Wars, so I thought it would be fun to create something similar, but set in the distant future—and this was the result!

Enki Bilal

Enki Bilal was born in Belgrade, Yugoslavia, to a Slovak mother and a Bosnian father. He moved to Paris at the age of nine. At age fourteen, he met René Goscinny and with his encouragement applied his talent to comics. He produced work for Goscinny's comics magazine *Pilote* in the 1970s, publishing his first story, *Le Bol Maudit*, in 1972.

Bilal is best known for his *Nikopol* trilogy (*La Foire aux Immortels*, *La Femme Piège*, and *Froid Équateur*), which took more than a decade to complete. Bilal's most recent publication is *Quatre?* (2007), the last book in the Hatzfeld tetralogy, which deals with the breakup of Yugoslavia from a future viewpoint.

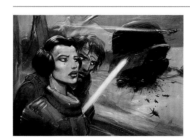

Never Ending Fight Against the Darkness p. 91

Ed Binkley

Ed Binkley is the national design director and partner of BSB Design, a nationally recognized design and planning firm with fifteen offices across the country. His responsibilities include collaborating with designers nationally in an effort to maintain exposure to current and future trends, educational programs, and promoting creative solutions to everyday housing needs. Binkley's experience began in 1979 and incorporates work on a wide variety of residential, commercial, and hospitality projects. Two of his most recent endeavors are the lead design role in the 2005 and 2007 New American Home projects, each of which were showcased during the International Builders Shows of those years.

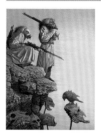

Tusken Sentries p. 24

Nelson Boren

Nelson Boren was born and educated in Tempe, Arizona, receiving a degree in architecture from Arizona State University. Boren's Western and fishing watercolors can be found in leading galleries and museums in the United States and in private and corporate collections around the world. Boren, his wife, Jeanne, and their pet tractor live on a small farm in northern Idaho.

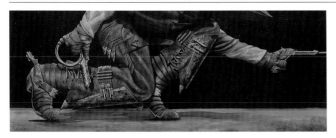

Maverick Bounty Hunter pp. 92–93
As a cowboy artist, I was intrigued with the challenge of creating a character that embodied the texture of the Old West, combined with an outlaw attitude, in a *Star Wars* setting. The maverick bounty hunter is garbed in rough leather chaps, wild spurs, worn-out leather boots, and rusty weapon chin guards. Juxtaposed against his traditional weather-beaten cowboy gear is a shining chrome lightsaber—a symbol of his destruction of a Jedi warrior.

Alex Bostic

Alex Bostic is an illustrator and artist. He was raised in Brooklyn, New York. He received his BFA from Pratt Institute and his MA from Syracuse University. Bostic began his career as a studio artist, working in Kansas City, Missouri, and Los Angeles. He returned to New York City and began a full-time career as a freelance illustrator and co-owner of Illumination Studio, which specialized in advertising art.

Bostic is represented by Portsort Artist Representative, and his work is in the collection of the National Baseball Hall of Fame, Cooperstown, New York; the Ludwig Museum, Germany; Wilberforce University, Wilberforce, Ohio; the National Gallery of Zimbabwe; and NASA Headquarters in Washington, DC.

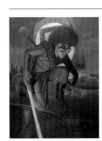

Young Lando p. 96
Star Wars was the first movie that I saw more than once. This was a fun painting for me to do, because Lando is a black man in the future. I also had fun doing the background and setting up the light source.

Harley Brown

Harley Brown received his art education in Calgary, London, and New York. He is an artist/member of the Cowboy Hall of Fame, Cowboy Artists of America, the Autry Museum, and Rendezvous of Artists.

Brown started out selling his art door to door. He has a lifetime obsession with painting people and loves to write about art, with three books and numerous articles on his resume. He believes that art is a lifetime of spirited study that happily never ends, and he credits his parents for getting him on the right track and his wife, Carol, for adding to his inspiration.

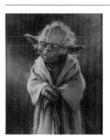

Yoda p. 131
Studying the nuances of Yoda became an obsession while painting his portrait. I observed scenes of him a multitude of times to make the right strokes to bring out his character. A change here, a subtle alteration there; finally I had to be led away from the painting, but not before I put in that final touch that brought him to life.

Noah Buchanan

Noah Buchanan received an M FA from the New York Academy of Art. His work is based in the academic tradition of the figure, and favors themes of the mythic, symbolic, and heroic.

Buchanan has received a number of awards and four Individual Artist Grants, the Stobart Foundation Grant, the Posey Foundation Award, the Stacey Award, and the Sugarman Award. He has participated in exhibitions in New York, Pennsylvania, and California, and has exhibited internationally. His paintings and drawings are featured in private and public collections throughout the United States.

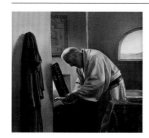

Your Father's Lightsaber p. 141

I like the idea of Obi-Wan as a monk. He's much more than the hermit we're initially led to believe in the film. One can infer that Obi-Wan had to seclude himself on Tatooine for almost twenty years, with nothing to do except deepen his spiritual practice.

Luke, now finally of age, comes searching for "Old Ben who lives beyond the Dune Sea." This is the moment Obi-Wan has been waiting for. When he takes the lightsaber from out of its hiding place and gifts it to Luke, this marks the passing of the torch. I hoped for a haunting feeling in the light to evoke spiritual force, as this moment also marks the beginning of the path that comes to be the last chapter in Obi-Wan's life.

Ciruelo Cabral

Ciruelo Cabral was born in Argentina but has lived in Spain since 1987. He has worked for prominent publishers in the United States and Europe, creating fantasy art for book covers, prints, and calendars, with dragons as his main subject. He has painted book covers for the trilogy *Chronicles of the Shadow War*, album covers for rock guitarist Steve Vai, and cards for *Magic: The Gathering*. Currently, Cabral is writing and illustrating fantasy books.

Tatooine p. 46

Tatooine is the perfect habitat for large saurians, and as a dragon artist I wanted to paint dragonlike creatures immersed in strange and beautiful landscapes. Being involved in the *Star Wars* universe was an unforgettable experience; it was like revisiting familiar places.

Gary Carter

Gary Carter has received many awards and honors, and his work has appeared in *Art of the West*, *Western Horseman*, *Horse and Rider*, *Cowboy*, *Big Sky Journal*, *Southwest Art*, *True West*, *Outdoor Life*, *Horse Journal*, *Northwest Living*, *Wild West*, and *Equus*, to name just a few.

Carter belongs to and is active in groups and organizations such as the Montana Cruising Association, Big Sky Kids, Kentucky Colonel, the National Rifle Association, the National Muzzle Loading Rifle Association, and SASS (Single Action Shooting Society—for all the children of the '50s who used to sneak their cap pistols into the matinees).

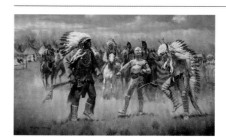

Untitled pp. 44–45

Sean Cheetham

Sean Cheetham is a fine artist and portrait painter. He received a BFA, with honors, from the Art Center College of Design. Cheetham has exhibited in museums and galleries internationally, and his work is included in many private and public collections. He currently resides in Los Angeles with his wife, Gretchen, their son, Gunnar, and dog, Roscoe.

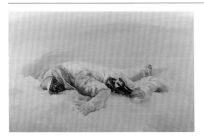

Untitled (Luke Skywalker on Hoth) p. 65

James C. Christensen

James C. Christensen studied painting at Brigham Young University, as well as the University of California, Los Angeles, before finishing his formal education at BYU. Since then, he has had one-man shows in the West and the Northeast and his work is prized in collections throughout the United States and Europe. Christensen's art includes unique people, places, and things that exist somewhere between adult dreams and childhood memories.

His first book, *A Journey of the Imagination: The Art of James Christensen*, was published to great acclaim in 1994. His second, the adventure fantasy *Voyage of the Basset*, has more than 75,000 copies in print. His most recent coffee-table book is *Men and Angels*.

Christensen is currently serving as a bishop in a Utah Valley University student ward.

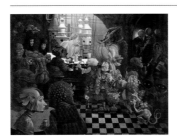

An Unexpected Layover at Mos Eisley p. 90
Who doesn't remember the first time they saw *Star Wars* and entered the Cantina? Crazy, wonderful stuff! My painting depicts two of my "poofy guy" characters who thought they were going to Club Med but found themselves unexpectedly in Bosnia. They are just not quite prepared for the Cantina. Most of the scene is accurate, but I have added a few of my own elements. (Did you know the Cantina had a checkered floor?)

Dorian Cleavenger

In less than a decade, Dorian Cleavenger has made his mark in the fantasy-art industry. After creating works for more than a hundred comic-book covers, card sets, and limited-edition prints, he branched into his own original art genre. Several art books on his work have been published, as well as a line of collectible figures based on his paintings. Working in acrylics, he has developed techniques that rival oils, but can be completed in a fraction of the time.

Cleavenger currently has his own art program at Douglas Education Center in Pennsylvania, where he passes these techniques on to the next generation of fantasy artists.

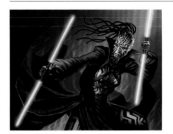

Darth Simi p. 26
An ancient priestess kept alive for thousands of years by sacrificing young Jedi to the dark side now scours the galaxy for her next victim.

Gene Colan

Gene Colan's career in comics began in 1944 at Fiction House, where he drew *Wings Comics*. Stan Lee at Timely Comics then hired Colan for around sixty dollars a week. Since 1946, Colan has been associated with DC and Marvel, and has worked on the *Silver Surfer*, *Iron Man*, the *Sub-Mariner*, *Captain America*, and *Dr. Strange*, and had long runs on *Tomb of Dracula* (with Marv Wolfman) and *Daredevil*; he also collaborated with Steve Gerber on *Howard the Duck*. Colan's final story for Marvel, *Captain America* #601, sold out instantly.

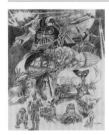

Star Wars Montage p. 52

I allowed myself to take about a month just to reflect on the *Star Wars* characters. It was a process necessary for me to envision who among them stood out, and why. Once I knew who would be in the piece, it followed fairly quickly as to how I'd portray them and what the composition of the montage would look like. I found myself deliberately playing with size and form in some cases. The concern in taking on a composition of this size is to not get lost; as I began to draw, the characters spoke for themselves, almost as if they knew where they needed to be.

When I am given an assignment with such a wealth of creativity, humor, and imagination as provided by George Lucas's *Star Wars*, I become eager to pick up my pencil and see where it takes me. It was a great challenge and great fun. Thanks for the ride! I hope I've entertained you and surprised you a little!

M. Morgan Coleman

M. Morgan Coleman was born and raised in Provo, Utah. In addition to the artwork of his father, Coleman is influenced by the artwork of John Singer Sargent, Winslow Homer, and George Inness, as well as his own travels. Coleman is drawn to serene landscape settings, which help remove one from the rigors of work and life. His artwork can be found in a number of galleries across the United States and is included in many prominent private collections.

Kashyyyk pp. 134–135

Night Stories pp. 126–127

Michael Coleman

Award-winning artist Michael Coleman was born, raised, and currently resides in Provo, Utah. In 1978, Coleman was given his first retrospective at the Buffalo Bill Historical Center. In 1999, he won the Prix de West Award at the National Cowboy Hall of Fame for his bronze titled *September*, and he is also the winner of many other prominent awards. His works can be found in numerous galleries, museums, and private collections around the world.

In the Forest—Hunting Party pp. 121–123

Nicholas Coleman

Nicholas Coleman was born in Provo, Utah, the son of artist Michael Coleman. Brought up in an artistic environment, Coleman has been painting and drawing for as long as he can remember. Coleman finds inspiration in his travels, hunting and fishing along the way, as well as in art museums and the Old Masters. Coleman endeavors to create a connection between his paintings and the observer by invoking a mood that the viewer can walk into.

To Be a Jedi p. 10

This is the point at which Luke Skywalker decides to become a Jedi. I imagine it taking a little longer for him to think over everything that was happening to him. Obi-Wan Kenobi has invited Luke to start Jedi training, and Luke rushes home, only to find his only reason for staying murdered or killed. I imagine the scene a very contemplative one, lasting at least until the suns set on Tatooine.

Tony Curanaj

Tony Curanaj was born and raised in New York. He studied at the School of Visual Arts and the acclaimed Water Street Atelier. Although his focus has always been on classical art, he started his career as a legendary figure in the worldwide graffiti scene and as head designer and painter for Disney before he decided to concentrate solely on his love for representational realism.

Curanaj has exhibited in museums and galleries internationally; his work can be found in many prominent public and private collections. He also teaches drawing and painting at the Grand Central Academy in New York City.

A Good Find, Portrait of a Tusken Raider p. 25

The inspiration behind *A Good Find, Portrait of a Tusken Raider* is in what the sand people of Tatooine must do to survive the harsh and desolate desert climate. My vision was not of the occasional attacks on caravans or lone travelers, but the less seen and more intimate activity of scavenging and collecting from what the land can supply or what can be found. In this case, the Raider comes across a nonfunctioning IG-88 robot that most likely has been there for a long time and will provide much needed materials for survival.

Stylistically, I looked toward the nineteenth-century Orientalist painters for their meticulous and beautifully designed images of life in the desert. I was able to find a great Tusken Raider costume and model robot, which enabled me to paint from life as well as from imagination.

Jon deMartin

Jon deMartin is a New York–based artist whose work can be found in many private collections, both national and international. He received a BFA from the Pratt Institute, then studied at the Art Students League with Gustav Rehberger and Nelson Shanks, and independently with Michael Aviano. DeMartin received an Award of Distinction by Stephen Doherty of American Artist for the Contemporary Portrait. He currently teaches life drawing at Studio Incamminati in Philadelphia and the Parsons New School of Design.

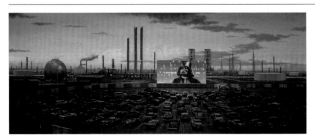

Magic Hour p. 7

I'm thinking of a landscape, actually an American landscape, depicting a drive-in movie theater with a very iconographic image projected on the screen, a scene from *Star Wars*. I think both aspects of the subject are compelling in that they are symbolic of American culture.

Peter de Sève

A native of Queens, New York, Peter de Sève began drawing at an early age and developed a love of comics and illustrated books. He attended Parsons School of Design in New York City, where he was exposed to contemporary and nineteenth-century American and European illustration. He is one of the leading character designers in the animated-film industry and has worked on such films as *The Hunchback of Notre Dame*, *The Prince of Egypt*, *Mulan*, *Tarzan*, *A Bug's Life*, *Finding Nemo*, and *Robots*. He was the sole character designer for *Ice Age* and its sequel, *Ice Age: The Meltdown*, both of which were nominated for Academy Awards.

Easy Being Green, It's Not p. 75
© 2010 The Muppets Studio, LLC

Philippe Druillet

Philippe Druillet is one of the most influential French authors and is well known for his baroque drawings and bizarre science fiction stories. Druillet made his debut in comics with *Lone Sloane, le Mystère des Abîmes* in 1966. Afterward, he worked as a comedian at the Théatre de Soleil. In 1975, together with Bernard Farkas, Jean-Pierre Dionnet, and Moebius, he founded the publishing house Humanoïdes Associés and the *Métal Hurlant* periodical.

In 1975 and 1976, after the death of his wife, Druillet drew *La Nuit*, a cry of revolt. He founded Space Art Création in 1984 and made his first glass sculptures. Experimenting with film, photography, and painting, Philippe Druillet remains an innovating artist.

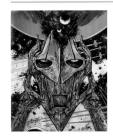

Hommage à Georges Lucas, donc à* Star Wars *(A Tribute to George Lucas, and so, to* Star Wars*) p. 78
This is the galaxy of *Star Wars*, via a portrait of General Grievous. I chose this subject matter because it is proof of the vitality and richness of Lucas's vision. *Star Wars* is a saga for the millennia, for it spans the past and extends into the future.

Stephen Early

Stephen Early was born in Philadelphia and is an award-winning visual artist who has found his inspiration in the profound eloquence of nature and the complex beauty of the human figure. Over the past twenty years, Early's desire to capture visual truth has provided him with the opportunity to be involved with a wide array of projects and to work with some of the world's finest contemporary painters.

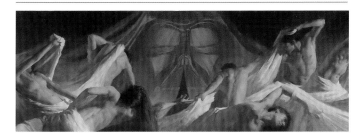

The Struggle Behind the Mask pp. 114–117

Peter Ferk

As both a fine artist and entertainment industry professional, Peter Ferk has explored and mastered several of his personal interests in artwork. He has won several national and international awards for miniature painting and is a frequent judge of these competitions. In a professional capacity, Ferk is an Emmy Award–winning storyboard artist and director of animation. He has worked on such notable popular culture titles as *Batman: The Animated Series*, *Superman*, *Animaniacs*, *Pinky and the Brain*, *101 Dalmatians*, and *Growing Up Creepy*, and is currently working on a *Kung Fu Panda* adaptation for television. Ferk has also been instrumental in developing and designing the popular Character Key line of collectibles.

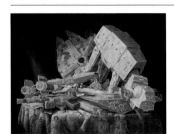

The Stuff That Dreams Are Made Of p. 87
I wanted to show a different side of the films: the stories that exist in the minds of children as they play with the toys. These may be the best stories of all, and they often result in heavily worn toys— which is what my still life depicts. *The Stuff That Dreams Are Made Of* seemed a natural title, and I wanted to paint it in a style akin to the old-world still-life masters, comprised of a huge amount of layers from the underpaint to the final varnish.

Juan Carlos Ferrigno

Juan Carlos Ferrigno fell in love with motorsports after seeing a race in his native Buenos Aires at the age of ten. Throughout his youth he learned his craft, depicting power and movement with absolute attention to detail.

Now living in Barcelona, Ferrigno has established a reputation that spans the world, and his work is admired and sought after by generations of drivers and team owners, including Sir Stirling Moss OBE, Ron Dennis, Jody Scheckter, and Eddie Jordan.

Ferrigno also has a passion for music art; his paintings feature the world's music legends, including Mick Jagger, the Beatles, Eric Clapton, and Tina Turner; these paintings are sold with profits going to the charity Hope for Tomorrow .

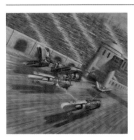

Podracers p. 66
I liked painting the Podracers because, in some ways, they are similar to my motor-racing paintings. I also liked some of the other vehicles, such as airspeeders, but I decided to choose these vehicles because, in the film, it is very exciting watching the race between them. I chose the image of them going through the finish line with the crowded grandstand in the background.

Scott M. Fischer

Scott M. Fischer graduated with honors from the Savannah College of Art and Design in 1994. He illustrated Geraldine McCaughrean's bestselling *Peter Pan in Scarlet* and is a notable cover artist for many of today's leading book publishers, including Tor, Harper Collins, Scholastic, Penguin, and Del Rey. In addition to being a renowned cover illustrator, Fischer is an emerging children's book writer/illustrator. His first children's book, *Twinkle*, hit the shelves in 2007, followed by *Animals Anonymous* in 2008. His latest book is *JUMP!* Fischer is currently working for Disney on their *Tron* franchise.

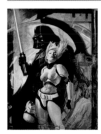

Fem Trooper p. 37
I've always thought stormtroopers had the coolest costumes of all in the *Star Wars* galaxy. In fact, I even had the plastic Halloween costume back in the '70s and went trick-or-treating as one. But if I were a stormtrooper, naturally I would need the perfect partner, thus the Fem Trooper idea was born! All the coolness of the stormtrooper armor, wrapped around the sensuality of the female form . . . the perfect subject to paint!

Douglas Fraser

Born in Lethbridge, Alberta, Douglas Fraser attended the Alberta College of Art + Design in Calgary, Canada, and received his MFA from the School of Visual Arts in New York. For the last twenty-five years, he has been an award-winning illustrator for an array of international clients such as the *New York Times*, *Time*, *Newsweek*, *Rolling Stone*, and *Mother Jones*. He is a member of the Society of Illustrators, New York, and has contributed to shows in the United States and abroad.

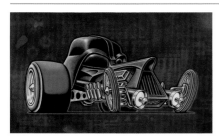

1/24th Scale p. 27

The first *Star Wars* very much impacted my imagination as a teenager in Canada. Visually there had not been anything like it. I know it was the hardware and costumes that really struck my eye. The film affected my visual thinking, much as had another film of George Lucas's, *American Graffiti*. *Star Wars* made the infinite cold void of space cool. Since then, the film has infiltrated every layer of pop culture; I suppose this is what has struck me so much. I wanted to speak to that youthful encounter of a now well-established icon. It's the fusion of the Darth Vader helmet and the hot-rod structure that illustrates the creation of stunning visual graffiti from America, which so excited me in my youth.

Douglas Fryer

Douglas Fryer received a BFA in illustration from Brigham Young University in Provo, Utah, and later returned for an MFA. He has worked as a freelance illustrator and graphic designer for a variety of clients, including Harcourt Brace, Warner Brothers, Humana, and many others.

Fryer has taught fine art and illustration at several universities and art schools. He currently exhibits his work in the Marshall Gallery in Scottsdale, Arizona, the Meyer Gallery in Santa Fe, and the Howard/Mandville Gallery in Kirkland, Washington. Although he works mainly in oil, Fryer enjoys working in a variety of mediums, including watercolor, printmaking, and digital. He hopes that those who view his paintings will sense his love for his subjects and his pleasure in working with his materials.

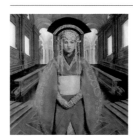

Padmé Amidala p. 140

My friends and I illegally sat through three straight showings of *Star Wars* on the first Saturday after its release in 1977. As a thirteen-year-old boy, I was, of course, moved by the special effects, but it has mainly been the characters, costumes, and settings of the story that have remained with me as an adult. Through these elements, I felt a sense of the history and values of the people represented throughout all six films. The grace, serenity, and authority of the Queen were beautifully conveyed through her costume and the palace architecture.

Donato Giancola

Donato Giancola is a highly respected, multi-award-winning science-fiction illustrator and painter, with his art gracing the covers of more than three hundred novels. A member of the Society of Illustrators, Giancola's recent peer honors include three Hugo Awards, eighteen Chesley Awards from the Association of Science Fiction and Fantasy Artists, and multiple Gold and Silver Medals from *Spectrum*. He serves as an instructor at the School of Visual Arts in New York and lectures at conventions and universities worldwide.

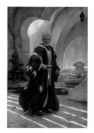

Obi-Wan Kenobi p. 120

Obi-Wan Kenobi has always fascinated me—a tragic hero willing to sacrifice his life for the greater good of others. Posing in his humble abode on Tatooine, away from grand adventure, Ben Kenobi reflects the quiet and inner strength Sir Alec Guinness so wonderfully projected into this character as the meditative Jedi master.

H. R. Giger

H. R. Giger is recognized as one of the world's foremost artists of fantastic realism. After studying architecture and industrial design, he moved on to fine art, when he discovered, via the airbrush, his own freehand painting style, expressed through his surrealistic biomechanical dreamscapes, which formed the cornerstone of his fame.

His first film assignment, Ridley Scott's *Alien*, earned him the 1980 Oscar for Best Achievement in Visual Effects. Giger's other film works include *Poltergeist II*, *Alien*³, and *Species*.

During the last decade, Giger has been honored with museum retrospectives in Switzerland, France, the Czech Republic, Austria, Germany, Spain, and Finland. To date, twenty books have been published about his art.

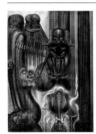

Work No. 467: N.Y. City XVII (Crowley) p. 110
Back in 1980 or '81, when I was in the middle of this futuristic *NYC* series, I went to see *The Empire Strikes Back*, which was in the theaters in Zurich. I remember enjoying the film very much. Later, I subconsciously incorporated a mysterious evil figure resembling Darth Vader into one of the paintings. I didn't realize where it came from until I saw one of the next films in the *Star Wars* series. I've never mentioned this before to anyone until now.

Maya Gohill

Maya Gohill was born and raised in Calgary, Alberta, Canada, in 1974. She graduated in 1997 from the University of Calgary, with a BFA in painting. She then moved to San Francisco to study at the Academy of Art College, where she earned her MFA in illustration in 2001. Maya currently teaches visual communications design at the Alberta College of Art & Design.

Gohill incorporates her current ideologies with her classical-based knowledge to develop the images she creates. Her work has been credited with awards from the New York Society of Illustrators, both in 2001 and 2002.

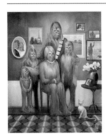

Wookiee Family Portrait p. 29
Considering that Chewbacca is one of the prominent heroes from the series, there is very little that we actually know about him. We know he has a family, but what is his family life like? In this version, his wife exhibits her personal touches throughout the home, his three children have their own unique personalities, the family pet is a hairless cat . . . and, of course, Chewie is clearly the man of the house.

Daniel E. Greene

Daniel E. Greene is one of America's leading portrait painters and one of its foremost pastel artists. Greene is the author of two definitive books, *Pastel* and *The Art of Pastel*, which have been translated into eight languages. He has taught more than ten thousand students, and his books and videos have reached hundreds of thousands of artists. Greene has been elected to the National Academy of Design and to the Pastel Society of America and the Oil Painters of America Halls of Fame.

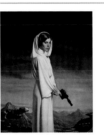

Princess Leia p. 20

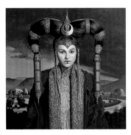

Queen Amidala of Naboo p. 113
The production of the *Star Wars* films was, to me, such an enormous work of imagination that when faced with providing my interpretation of two principal characters, Princess Leia and Queen Amidala, I found the challenge totally daunting. I decided to impart the portraits with elements from the vocabulary of painting in the hope that my renditions could convey some of the inner character of the subjects, as well as their monumental public presence.

Michael Grimaldi

Michael Grimaldi was born in New York City in 1971 and studied painting and drawing at the Art Students League, the National Academy, and the New York Studio School. He also conducted independent studies in anatomy and dissection at La Facultad de Medicina de Buenos Aires, Argentina.

Grimaldi has participated in numerous solo and group exhibitions, and has received many awards. Grimaldi currently teaches drawing, painting, and anatomy at the Art Students League of New York and at the Janus Collaborative School of Art, which he cofounded in 2008.

Incident at Mos Eisley Spaceport pp. 98–99
With *Incident at Mos Eisley Spaceport*, I wanted to explore the genre of multifigure composition while maintaining a measure of ambiguity. By leaving the roles of protagonist and antagonist deliberately vague, I hope to relay some of the confusion in interpreting the scene.

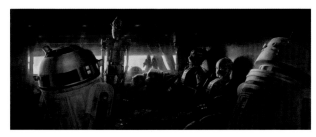

Dusk on Tatooine pp. 142–143
For me, one of the most notable scenes in *Star Wars: A New Hope* was the one in which R2-D2 and C-3PO find themselves in the Jawa sandcrawler. The menagerie of exotic, defunct, floundering droids elicits a profound sense of wonder, humor, and fear—elements I constantly attempt to balance in my artwork.

Roy Grinnell

Roy Grinnell, the Official Artist of the American Fighter Aces Association and the Commemorative Air Force/American Combat Airman Hall of Fame, was an honors graduate of the Art Center School in Los Angeles. Grinnell has received many honors and awards, including the R. G. Smith Award for Excellence in Naval Aviation Art and, most recently, the opening of the Roy Grinnell Gallery in the American Airpower Heritage Museum in Midland, Texas. Grinnell's oil paintings have been displayed throughout the world.

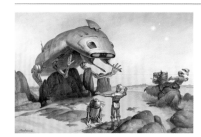

"Wait . . . The Droid Just Wants to Say Hello!" pp. 50–51
R2-D2 and C-3PO, along with a space cowboy, have wandered into a desolate area of a planet. They are suddenly confronted by a lost combat-scout droid who has wanted only to say hello and not to destroy them. I designed the droid to have some human characteristics. I wanted to create a sort of sad, lonesome look with compassion and not a mean, dark appearance.

Rudy Gutierrez

Rudy Gutierrez was born in the Bronx, New York, grew up in Teaneck, New Jersey, and studied at Pratt Institute. His paintings have been published and exhibited worldwide. The award-winning artist counts the Dean Cornwell Recognition Award, Distinguished Educator in the Arts Award, Pura Belpré Honor, and a gold medal from the New York Society of Illustrators among his honors. His work has been described as "wall medicine," ancient yet contemporary, urban in a sense and musical in feel. He has lectured at various institutions and teaches at Pratt Institute.

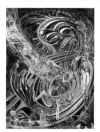

The Exorcism of Darth Vader p. 33
In the battle of good versus evil, the "Real Force"—made up of different ancient and current cultures on Earth—unites to perform an exorcism or the removal of bad spirits, represented by the Emperor, who controls the heart and spirit of Darth Vader.

Ann Hanson

Ann Hanson grew up in rural Wyoming and still enjoys the country lifestyle. She has a studio with a panoramic view of the Bighorn Mountains and paints her friends and neighbors doing what they do every day. Hanson has been in several national Western art shows, including *Cowgirl Up!* She has been featured in *Art of the West*, *Western Horseman*, *American Artist*, and other publications.

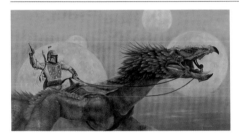

On the Hunt pp. 118–119

When I was younger, I did a lot of science fiction/fantasy artwork. It has been really fun to return to my roots and incorporate some of what I have learned of the Western genre into this piece. Also, the first movie date I had with my husband-to-be was *Star Wars*, so I have been a longtime fan for more than one reason.

Glenn Harrington

The paintings of Glenn Harrington are recognized and collected internationally, and have been featured in such publications as *American Arts Quarterly*, *American Art Collector*, the *New York Times*, and the *Philadelphia Inquirer*. He has had numerous solo exhibitions in New York, Japan, and London, and has exhibited at the Norman Rockwell Museum, the Museum of American Illustration, and the Raushenberg Gallery. His oil paintings have been published on the covers of more than six hundred books, including such classics as *Room with a View*, *Pride and Prejudice*, *Dangerous Liaisons*, *Women in Love*, and *The Golden Bowl*. His portrait work has received the Draper Grand Prize and the Honor Award from the Portrait Society of America.

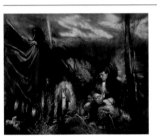

Luke and the Death of Yoda p. 42

Traumatic events in our lives often serve as catalysts to help us overcome difficult obstacles, inciting us to re-create our self-image by leading us to take on new challenges previously thought unattainable. This "new man" is closer to who we really are, but, as always, we never go it alone, and the encouragement and selflessness of others inspire us to take the path of truth. Luke, aided by Obi-Wan Kenobi and Yoda, overcomes Darth Vader with skill, but ultimately it is his compassion for his father that leaves us loving him.

Michael Haynes

Michael Haynes's work has hung in the White House and the office of the Secretary of Defense, and he has won numerous awards, including the Addys, the Communications Arts Show in Los Angeles, and the Society of Illustrators Show in New York. His work is in private and public collections in the United States and abroad, and has been published on five continents. His paintings of the Lewis and Clark expedition are in the collections of the U.S. Army, the National Park Service, and the U.S. Postal Service. Michael has been a guest speaker at the Prix de West Art Auction at the Cowboy Hall of Fame and the C. M. Russell Art Auction.

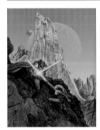

Skirmish on Endymion p. 129

A Twi'lek Jedi Knight has a Sith warlord on the defensive in a skirmish on Endymion, a remote desert outpost in the Pleiades. As war sweeps across the galaxy, life-and-death struggles like this occur on every scrap of interplanetary dust that can support life.

Stephen Heigh

Stephen Heigh was born in 1960 in Pennsylvania. He won recognition early on when famed American illustrator Robert Peak selected him as the winner of the American Artist Magazine National Cover Competition. He studied at the Art Institute of Philadelphia and is currently an illustration professor at Moore College of Art & Design there. He has recently won national awards for his writing and illustrating of the children's books *Mr. George and the Red Hat* and *The Snowman in the Moon*.

Backyard Jedi p. 40

I have long been a fan of *Star Wars* and George Lucas, and I desired to create a universal image. I started thinking about children playing make-believe, and how George Lucas was probably like every kid in the neighborhood, running around and seeking adventure. In those moments, children are the characters they wish to portray. It's a simple joy of being a kid and using imagination. Mr. Lucas used his imagination on a grand scale, a scale that touched our lives forever, and it's really amazing that he shared his vision with us.

David Ho

David Ho has been a freelance illustrator and artist for the past fourteen years. He specializes in fantasy and horror art, and his works have been seen in numerous competitions, including those of *Communication Arts Illustration* annuals, the Society of Illustrators, and the Luerzers Archive. His many clients include book publishers and record companies.

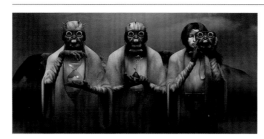

The Sacrifice pp. 18–19

After watching *Star Wars* for the first time as a child, I remember being very taken by the look of the Tusken Raiders. It's funny how, more than thirty years later, I would have the chance to depict them. Instead of portraying them as a cold race, I thought it would be interesting to show them in a more contemplative light.

Gus Hunter

Gus Hunter, an employee of Peter Jackson's Weta, worked as a freelance illustrator from home after completing a diploma in visual communication and design. While at Weta he has created artworks for many high-profile projects, including *The Lord of the Rings* trilogy, *King Kong*, *Avatar*, *X-Men* 3, and *The World of Kong* book. Hunter has worked on concept art for *The Chronicles of Narnia: The Lion, the Witch and the Wardrobe* and was a senior concept artist on *King Kong* from pre-production to post-production.

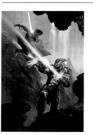

Untitled p. 128

Stephen Johnson

Stephen Johnson is a highly versatile American artist whose visually arresting and conceptually rich body of work forges connections between words, objects, and ideas. His art spans a broad range of concepts, contexts, and mediums, including painting, collage, drawing, sculpture, and installations—all of which can be seen in museum and gallery exhibitions, site-specific public-art commissions, and his original, award-winning children's books, for which he adds a middle initial "T" to his name in his byline.

LEIAPOP! p. 39

Eric Joyner

In 1999, after seventeen years of illustration, Bay Area native Eric Joyner made the transition to gallery artist. He now paints, among other things, robots and/or donuts. His work can be seen in the set dressing of various TV shows such as *Big Bang Theory*, *Zeke and Luthar*, *Zoey 101*, *Chuck*, and others. His art is collected worldwide. Dark Horse published his book, *Robots and Donuts: The Art of Eric Joyner*, in 2008.

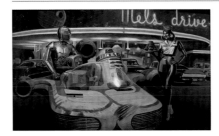

Dining at Mel's pp. 68–69
All of their adventures now far in the past, C-3PO and R2-D2 take a new friend out to dinner. The second Death Star is now a tourist attraction. The droids have become donut connoisseurs.

Ana Juan

Ana Juan was born in Valencia, Spain, where she studied fine arts. Juan has published many illustrated books and children books; the first children's book she authored was *The Night Eater*, which won the Ezra Jack Keats Prize. Her books have been translated into many languages, and since 1995 she has contributed to the *New Yorker*. Her illustrations have received many honors and gold medals from the Society of Illustrators. Juan now lives in Madrid.

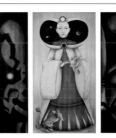

Around Amidala p. 55
Queen Amidala as the center of the universe is placed in the big panel, surrounded by Darth Vader and Darth Maul, menacing her, now or later, forever and ever.

Gary Kelley

Gary Kelley studied painting and design at the University of Northern Iowa, earning a BA in art. His career focused on graphic design and art direction until the late 1970s, when painting and design experiences merged into a career as an illustrator. His awards have included twenty-seven gold and silver medals from the Society of Illustrators in New York, as well as Best in Show recognition in New York and Los Angeles illustrators' exhibitions. He was elected to the Society of Illustrators (NY) Hall of Fame in 2007.

Kelley's list of clients includes *Time*, *Rolling Stone*, the *Atlantic Monthly*, the *New Yorker*, *Playboy*, the *Los Angeles Times*, and the *Boston Globe*. He has illustrated a number of picture books, including *The Legend of Sleepy Hollow*, *The Necklace*, *Poe's Tales of Mystery and Imagination*, and *Macbeth*.

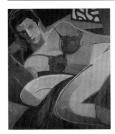

Leia p. 103

Darren Kingsley

Darren Kingsley won the 2000 American Society of Classical Realism Scholarship and was a finalist in *American Artist* magazine's Realism Today competition. He has participated in exhibitions at the Union League of Philadelphia and for the American Red Cross of Central New Jersey and the Daylesford Abbey, Paoli, Pennsylvania. His work is in many private collections.

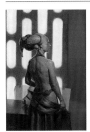

Bluescreen Twi'lek p. 136

My fascination with visual effects has been lifelong. My early fascination with *Star Wars* and the making of the movie is what led me to study painting and drawing, so I wanted to find a way to combine aspects of my interest in that with my interest in figure painting. I've always found the creation of a painting to be interesting; since the time of Impressionism, the idea has become "just paint what you see." Most of the paintings I love weren't really created that way; they have aspects of painting from life, aspects of things created with props standing in for other things, and aspects of imaginary work as well. I find this very similar to the way bluescreens and CG effects are used in film, so I wanted to bring all of this to the painting.

I looked at this as if a painter were actually painting in the universe of the *Star Wars* movies. What would the artists of that universe create? Originally I had intended to do a painting of a human model and fill the foreground and background with props from the movies. George Lucas asked that I do a Twi'lek instead, and it changed the whole concept in an interesting way. It opened me up to doing things in new ways, more as a classic visual-effects artist would, using maquettes and props to build a believable alien from a human model. The blue side of the painting is specifically left empty to allow the viewer to imagine what could be happening in the background.

M. Kungl

After completing an education in fine art and graphic design, Michael L. Kungl achieved a successful career in the advertising field, creating award-winning work for some of the world's biggest companies, including Johnson & Johnson, Bank of America, and Panasonic. He has been profiled in numerous articles in design and decor magazines, and has contributed to feature films and television shows, including Ashton Kutcher's *Beauty and the Geek*, *CSI*, *Law & Order*, and *Gilmore Girls*.

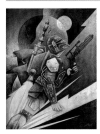

Boba Fett, "The Hunter" p. 32

Having mechanical attributes, Boba Fett enabled me to paint some of my favorite gadgets and objects, including a rocket pack with flame exhaust (his trademark firearm) and distressed-metal armor.

Jérôme Lagarrigue

Jérôme Lagarrigue's roots are composite: he is French and American. He owes his artistic sensibility to his father, Jean Lagarrigue, whose work is a great influence.

Lagarrigue seeks to gather all possibilities in one single solution, constantly approaching and then backing away from his subject as if to better grasp it, searching for everything in a detail and the detail in everything, practically physically confronting his subject as if to possess it while constantly maintaining eye contact, as if in a dance or combat. And yet there is always a strong sense of tenderness and goodness in his paintings, feelings that resemble his true nature. The day he presented his work to the Academy of France in order to become a resident, Lagarrigue was smiling; a powerful yet light physical energy, also to be found in jazz musicians, dancers, and boxers, sprang from within.

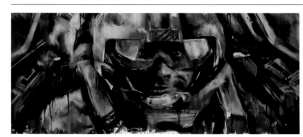

Untitled p. 12

David Larned

David Larned is a painter inspired by the visible world, particularly its people and places. Born in 1976 in New York City, he has dedicated himself to the art of observation. Focusing primarily on portraits, landscapes, and still life, he is always trying to explore through paint what makes nature so intensely beautiful. Larned studied painting at the Pennsylvania Academy of the Fine Arts and the Florence Academy of Art. He also has a BFA (cum laude) from the University of Pennsylvania. He has exhibited in New York, San Francisco, Philadelphia, Connecticut, and other East Coast venues, and has won a variety of awards. In 2004 the Biggs Museum of American Art held a comprehensive exhibition of his work. More recently, in November 2008, he had a solo exhibition at the John Pence Gallery in San Francisco.

Untitled p. 97
I tried not to research a *Star Wars* character, but rather to go back in my mind and recall the spirit of the films—or at least how I felt about them as a child when they came out.

Steven J. Levin

Steven J. Levin received his training at the Atelier LeSueur, a classically oriented studio-art school in Minneapolis. Levin works exclusively in oils, concentrating on figurative and still-life subjects, and is known for his evocative depictions of interior scenes. He is among the vanguard of contemporary realist artists and has been the recipient of numerous national awards. He is represented by the John Pence Gallery, San Francisco; Arcadia Gallery, New York; and Tree's Place Gallery, Cape Cod.

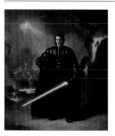

Portrait of Darth Vader p. 130
This is an imagined picture and not really an image of Vader at any particular point in the story line, so I have taken a few liberties. He is the most interesting character to me, the central figure to the story, and a tortured one—the golden boy gone terribly wrong. The Emperor torments him with dreams and promises, carefully driving a wedge between Anakin and the Jedi sect, his only family. At the crucial moment, when the Emperor reveals himself, Anakin might have achieved his destiny right then and destroyed Palpatine, but he didn't, and thus set himself upon a long, dark road that ended only when he finally did fulfill his destiny.

In the films, there is the recurring theme of people leading double lives. I wanted that in the painting somehow, so Anakin is depicted in Vader garb but with the mask off, revealing an unscarred face. The setting is Mustafar, the planet where Anakin sealed his own fate—where Vader was born. The thing that intrigued me about the *Star Wars* saga was the idea of the Jedi as protector knights and conversely of Darth Vader as a kind of dark knight. The portrait is of him in that role, as a knight might have been painted, with sword in hand and helmet under his arm, but hopefully capturing some of the conflict in his character. The clouds are dark and foreboding, but the light breaking through above is symbolic of his eventual redemption.

Jeremy Lipking

In a short period of time, Jeremy Lipking has emerged as one of the country's premier realist artists. His canvases convey the magical aura of convincing imagery emerging out of a field of paint.

Lipking applies paint in broad, loose facets, often leaving areas of bare canvas in between. In subsequent additions the open areas are gradually filled in, creating a breathing lattice-like structure of paint. The magic occurs in the finish. As he progresses, he gradually refines each area, adjusting relationships of color and adding deft touches to define select elements. He brings certain forms to a razor-sharp level of finish. Other passages are left vague and undefined. In this interplay of sharp and loose, the painting opens up and breathes. Instead of resting as static images, his canvases pulse with the subtle energy of a living thing.

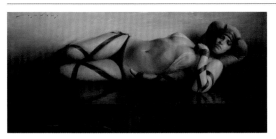

Yobana pp. 138–139

Michael Malm and Serge Michaels

Michael Malm's studies began at Dixie College, where he completed his associate's degree. He then went on to Southern Utah University, and he completed his formal education at Utah State University, where he received an MFA. Malm has studied under other great painters who have had an impact on his own work, including Richard Schmid, Burt Silverman, Dan Gerhartz, Quang Ho, Michael Workman, C. W. Mundy, and Jim Norton.

Serge Michaels taught background painting for animation at Associates in Art in California. "He was a gifted painter and teacher, and a nice human being," background painter Mike Inman, one of his students, has said.

Michaels worked on several Disney feature films, starting with *The Little Mermaid*, where he was an animation trainee. He was an assistant background artist on *The Rescuers Down Under* and *Beauty and the Beast*. He then was promoted to background artist, working on *Aladdin*, *The Lion King*, *Pocahontas*, *The Hunchback of Notre Dame*, *Hercules*, and *Tarzan*.

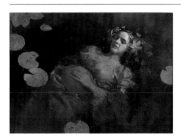

Padmé's Dream/Slipping Away p. 137

The idea for this piece was originally conceived and designed by Serge Michaels (1960–2009). Michaels wrote: "Exhausted, Padmé falls asleep on her bed; she's dreaming of her childbirth while floating half submerged in a stillwater lake. It is the most peaceful, much-needed rest she's had in weeks, especially with the events to come." The final composition is based on Michaels's original sketch and idea. The work was completed by Michael Malm.

Arantzazu Martínez

Arantzazu Martínez is a figurative painter currently residing in Spain. Her training began at the Basque Country University, where she earned a BA. In 2000, she moved to New York City and enrolled in the New York Academy of Art. She was part of the Water Street Atelier, where she studied with artist Jacob Collins. Her works have been exhibited in the United States, Spain, and Great Britain, and she is a fellow of the Hudson River Fellowship.

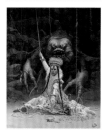

Rancor p. 85

The first time I saw the film *Return of the Jedi*, I was seven years old, and it made a lasting impression on me. Still today, twenty-five years on, adventure, fantasy, and philosophy are some of my core interests in life and work.

Masey

Masey has been working in the art and entertainment fields since the early 90s, developing a reputation for his associations with unique and intriguing projects. Trained in traditional art, fine art photography, and creative writing, Masey has created art that's been experienced by a significant domestic and international audience, as well as a very small and exclusive group of clients and collectors. His personal work has appeared in various publications and galleries worldwide, though one may be hard pressed to find him; Masey is his pseudonym and his real identity remains safely hidden. In a recent interview, he states that, "Those who really want to find me for a project usually do . . . I think? Actually, I have no way of validating that statement, and now it's going to bother me all week!"

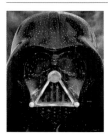

Regrets p. 81

John Mattos

John Mattos graduated from Thomas Downey High School in 1970; George Lucas had graduated from the same school in 1962. Lucas's uncle, Bruce Bomberger, suggested Mattos look at Art Center College of Design (then in Los Angeles).

Mattos graduated from the Art Center in 1975. Since then, Mattos has received more than one hundred awards for graphic excellence from various graphic magazines and design organizations.

Mattos has lectured at UC Berkeley, Stanford, California College of Arts and Crafts, and the School of Visual Arts in New York, and has taught seminars at Chico State and UC Santa Cruz. His artwork was selected by the New York Society of Illustrators as one of the 250 best illustrations of the past fifty years.

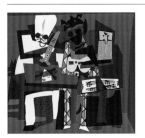

Pablo's Cantina p. 102
This art practically made itself. The challenge was to practice a little restraint and not to try and mash up the entire film into Picasso's brilliant work.

Syd Mead

The term "visual futurist" may well have been coined to describe Syd Mead. His sense of design and his recognizable style have been sought after by major corporations around the world, including Hollywood movie studios, where he worked on *Blade Runner, Tron,* and *Aliens.* Mead continues to provide his design and illustration services and, since 1983, has become a highly sought-after international speaker and presenter to educational, corporate, and special-event groups.

Abandoned Sith World pp. 94–95
Inspired by the movie *Star Wars:* Episode III *Revenge of the Sith,* this image was an attempt to show the Trade Federation ships investigating an abandoned world. In the distance looms a deep-space Alpha facility.

Krystii Melaine

Australian-born Krystii Melaine announced her decision to be an artist at age four and has pursued her passion for painting ever since. Specializing in oil paintings of wildlife, cowboys, and Native Americans, Melaine exhibits in major museums and galleries across the United States. She has won numerous accolades, including many Best of Show awards. Melaine's paintings are included in museum, public, and private collections around the world.

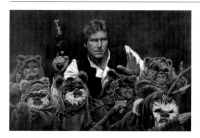

Fur Balls pp. 60–61

I love the idea that forest-dwelling creatures with Stone Age ingenuity succeeded against technology to play a large part in destroying the Empire. Han Solo and the Ewoks are my favorite *Star Wars* characters and they were a natural choice for me to paint, since I am a wildlife and cowboy artist. I had great fun studying the Ewoks and painting the character of each individual.

Mikimoto

Mikimoto is a Japanese anime character designer, illustrator, and manga-ka. Mostly active during the 1980s, during that decade he rose to prominence and is considered one of the top character designers of his time. He graduated from Keio University, attending in the same years as *Macross* creator Shoji Kawamori and screenwriter Hiroshi Onogi. He joined the animation studio Artland while attending school, and was character designer in *The Super Dimension Fortress Macross*.

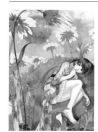

Queen Amidala Waking in Giant Tree p. 74

Moebius

Moebius (Jean Giraud) was born May 8, 1938. At age sixteen Moebius began his only technical training at the Arts Appliqués. He created his first comic strip, the Western *Les Aventures de Franck et Jeremie*, in 1956.

In 1975, Moebius collaborated with fellow artist Phillipe Druillet, writer Jean-Pierre Dionnet, and others to produce the dark-edged comic magazine *Métal Hurlant*. Also in 1975, Moebius was hired as a designer for the movie adaptation of Frank Herbert's science-fiction classic *Dune*. There Moebius met his future collaborator Alejandro Jodorowsky. After the *Dune* project (temporarily) folded, Moebius worked on the design for the film *Alien* with Swiss artist H. R. Giger.

Through the '80s he continued to work on film projects, including Disney Studios' *Tron*, the George Lucas film *Willow*, *Masters of the Universe*, and others. In the '90s he collaborated with Jean-Claude Mezieres, artist of the popular French comic *Valerian*, on the movie *The Fifth Element*. He continues to produce book and poster illustrations.

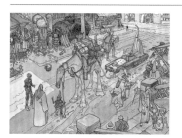

Untitled p. 63

Sho Murase

Sho Murase has worked in animation and advertising from Europe to the United States. Her list of clients includes brands such as Nike, Virgin, Mattel, and Evian, and companies such as Sony and Electronic Arts. Her animation work has been nominated in various animation film festivals, including Annecy, Zagreb, Mendrisio, and Chicago.

Her works have been exhibited at galleries around the world. Murase's first color graphic novel, *SEI*, was published by Image Comics in November 2003. Since then, she has created *ME2* and illustrated more than a dozen graphic novels, including an adaptation of the Nancy Drew series, currently up to volume 20.

Princess Leia's Troubles p. 77

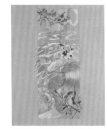

Dewback Riders p. 76
I always loved the strong symbolism and the extremely graphic, unique visual style depicted in the *Star Wars* universe; it has been an ongoing, endless source of inspiration for my generation and the ones to come.

Dave Nestler

Born in Pennsylvania, Dave Nestler attended the Art Institute of Pittsburgh, where he was trained in their visual communications department as a commercial illustrator. One of the most recognized names in contemporary pinup art today, Nestler blends a slick photorealistic touch with elements of pop culture and iconic imagery to produce paintings that stand apart from the classic glamour/cheesecake style.

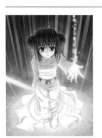

Double Cheeseburger with a Side of Crumb p. 67
As much as I was a fan of *Star Wars* when it came out, it was the film *American Graffiti* that gave me my first introduction to George Lucas and the inspiration for this painting. I wasn't old enough to drive when the hot-rod bug bit me after first seeing that movie. And in a weird twist of creative fate, it was the decision to sell my beloved 1969 Plymouth Roadrunner that raised the tuition money that enabled me to attend art school—a move I regret *and* embrace to this day.

Aoi Nishimata

Aoi Nishimata is a hugely popular female graphic-novel artist in Japan. She is in the forefront of the manga style, producing trendsetting character designs and compositions. She works for Navel, publisher of the successful *Bishop Eroge* graphic novels and video games.

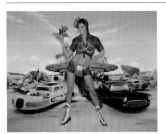

Leia p. 70

Paul G. Oxborough

Paul G. Oxborough is a figure painter whose work is inspired by the great illustrators and Impressionist painters. Trained in the French Academic tradition, he has taken his classical background into the Modern Impressionist movement, where he has established himself as a leader. Encompassing a variety of subjects, Oxborough's work is collected privately around the world and has been exhibited in numerous museums, including the British National Portrait Gallery, the Scottish National Portrait Gallery, and the Smithsonian American National Portrait Gallery.

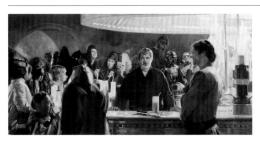

The Mos Eisley Cantina with George Lucas as the Bartender p. 8

I was twelve years old when I first saw *Star Wars*, and I knew instantly what I would paint when asked to be a part of the *Star Wars Art: Visions* project. I hope my piece expresses my affection for the films and lets the viewer feel as if George Lucas is "serving up" his vision to us.

David Palumbo

David Palumbo is an illustrator in the fantasy/science fiction genre who works primarily on book covers and gaming cards. He is known for his iconic heroic portraits, which stem from a traditional education in figurative painting. Palumbo also shows regularly in fine-art galleries in the United States and Europe.

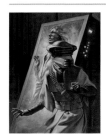

Escape p. 64

Bill Patterson

Bill Patterson's work is primarily about the expression of speed. He was a ski racer as a kid and became hooked on motor racing at his first visit to a racetrack in Buenos Aires as a teenager. He started painting at three and was so driven to paint and draw that in 1988 he left his career as a practicing architect to pursue a career in art. His works are now in the collections of some of the biggest names in motor racing, and he travels the world doing live performance paintings for entertainment, fund raising, and promotional events.

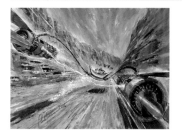

Runaway Slave pp. 49–50

As an artist of speed, and a major motorsports fan, I was thrilled to be asked to participate in this project. Although I spent a lot of time reviewing the movies over and over for inspiration for just the right image, I knew that I would come back to one of my favorite events, young Anakin's victory in the Podrace. After reviewing the movie several times, I gained a renewed appreciation for the significance of the race and its implications to the story line. This in turn inspired a very visceral and emotional connection to the final image.

C. F. Payne

For thirty years, C. F. Payne has worked as a freelance illustrator, first in Dallas and then in his hometown of Cincinnati. He is a 1976 graduate of Miami University and the Illustrators Workshop. He has illustrated extensively for editorial publications such as *Time*, the *New York Times*, and *Der Spiegel*, has illustrated stamps for the U.S. Postal Service, and has done numerous children's books. He is currently the chair of the illustration department at Columbus College of Art and Design, where he has taught illustration for the past thirteen years. He also teaches illustration with Mark and John English at the Illustration Academy and in the graduate program at the University of Hartford, under the direction of Murray Tinkelman.

Jabba the Hutt: High School Reunion p. 38

I find that I am most attracted to the humor in the *Star Wars* series, as well as to the creative design and personalities of the characters in the stories. The idea of Jabba the Hutt's graduation picture made me laugh. But it also became a nice vehicle to connect the dots of George Lucas's film career with his first hit, *American Graffiti*, and the *Star Wars* saga. It just seemed to come together well in making a fun and interesting picture.

David Pentland

Self-taught artist David Pentland has worked for many years as a successful freelance illustrator both in architecture and advertising. Combining his passion for military and aviation subjects with his experience in the commercial field, he has produced a wide selection of military paintings, which have been shown in numerous exhibitions throughout Northern Ireland and the United Kingdom. He has also been commissioned by both public and private clients worldwide, with his images of aircraft and armored vehicles appearing in a number of U.S. magazines. The subjects of his works are drawn from the Ancient, Dark Age, Medieval, Napoleonic, and World War II periods right up to the present day.

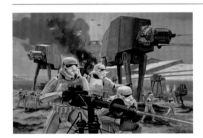

Clash on Kothlis p. 106

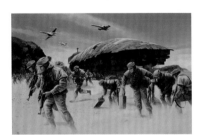

Raid on Kothlis p. 107

Jacob A. Pfeiffer

Jacob A. Pfeiffer works in oil and is equally at home painting still lifes, figures, or trompe l'oeil. He is a meticulous craftsman who paints his surroundings and selects objects that pique his interest. Pfeiffer graduated with honors from the University of Wisconsin, Madison, where he currently paints and lives with his wife and two children. His work can be found in major private and public collections across the United States. Pfeiffer's paintings are represented by the prestigious John Pence Gallery in San Francisco and the Meyer East Gallery in Santa Fe.

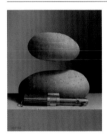

Luke's Lesson p. 22

There are dual inspirations behind *Luke's Lesson*. The first being a reference to one of my favorite moments in *The Empire Strikes Back*, when Luke Skywalker is training with Master Yoda, levitating rocks while learning the ways of the force. The second comes from my fascination with tools and their rich history and symbolism. In *Luke's Lesson*, I have juxtaposed two different kinds of tools. One is the most important and technologically advanced weapon of the Jedi, and the other a tool of primitive man.

Richard Piloco

Richard Piloco received a BFA from the School of Visual Arts in New York. He specializes in realist oil paintings—figures, landscapes, and still lifes. Piloco has had one-man shows at the Eleanor Ettinger Gallery in New York City and has participated in numerous group shows at Ettinger and other galleries across the United States and in England. He currently teaches at the Grand Central Academy of Art in New York. Piloco brought together several prominent realist painters to form the Paint Group, which is credited by some as having sparked the resurgence in traditional realist painting over the past several years.

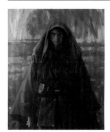

Anakin Skywalker p. 54

Kirk Reinert

Kirk Reinert is an American artist who resides in upstate New York. He got his start painting covers for *Creepy* and *Eerie* magazines, and during his career as a book-cover artist, he became one of the leading illustrators in the genres of fantasy and horror. His cover paintings have won many awards and have been exhibited in the Society of Illustrators, New York. In addition, he has worked as a conceptual designer for film, painted album covers, art-directed video and music projects, and been involved in toy designs. For the past nineteen years, Reinert has concentrated primarily on painting fine-art pieces that have shown in galleries across the United States and in Japan.

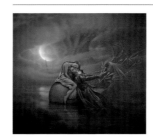

Vader's Dream—A Visitation From Padmé ("I will safe-keep your good heart, Dear One, until you are ready for its return.") p. 43
I wanted the general nature of this dream scene to feel very human, as opposed to Vader's real-life loss of humanity, both physically and spiritually. Vader is dreaming of himself as Anakin, a fallen knight, in the arms of Padmé, who has visited this dream with a purpose and a message. There is an island of peace here, but also the feeling of unease and impending doom on the horizon. The dark side, sensing the presence and threat of the light, sends its minions to pull Anakin/Vader back into chaos and madness.

Alex Ross

The photorealistic paintings of Alex Ross have garnered attention in the comics world and beyond. In addition to his extensive comics work, Ross painted the promotional poster for the 2002 Academy Awards and the opening credits for the motion picture *Spider-Man* 2. He was the subject of the 2003 book *Mythology: The DC Comics Art of Alex Ross*.

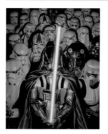

Empire of Style p. 23

Anthony J. Ryder

Anthony J. Ryder studied oil painting and figure drawing in New York City and France from 1983 to 1989. In 1998 he wrote and illustrated *The Artist's Complete Guide to Figure Drawing.* He teaches painting and life drawing at his own school, the Ryder Studio, in Santa Fe.

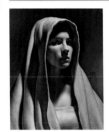

Pia p. 36

The portrait was inspired by the beautiful, mysterious handmaidens of Queen Amidala of Naboo. Pia is meant to express quiet reserve, presence, compassion, and attention. I painted her from life over a period of six months, from November 2008 to May 2009.

Carl Samson

American figurative painter Carl Samson is a Grand Prize winner at the National Portrait Competition. He was one of five American painters invited to work with the Union of Russian Artists in Moscow. Samson has also lectured and demonstrated at the Metropolitan Museum of Art. His groundbreaking full-length nude, *Triumph of Truth,* received the Phil Desind Award for most outstanding representational painting at the Butler Institute of American Art's annual Midyear exhibition. He is represented by GandyGallery.com and Wessel House Gallery, Cincinnati.

Padmé Resplendent with Naboo Mandala p. 82

When I first saw images of Natalie Portman dressed in her burgundy cut-velvet robe from *Revenge of the Sith,* I was at once taken with the possibility of juxtaposing her lovely profile and gown against the brilliance of gold leaf. It occurred to me that, from a modern perspective, visual and narrative parallels could be drawn between Padmé Amidala, as Queen of Naboo and mother of Luke Skywalker, and the great icon images of Byzantium and later historical periods. Since I have also admired the visually pleasing combination of naturalism and decoratively incised gold leaf exhibited in many late nineteenth- and early twentieth-century paintings, I chose to depict Padmé in a similar way. Though, in place of the typical circular halo, I have incised the mandala, or orbital path, of her native planet, Naboo.

Liam Sharp

Liam Sharp is an artist and writer from the United Kingdom. Born in 1968 in Derby, Liam won an art scholarship to St. Andrews preparatory school in Eastbourne at the age of eleven. He has produced work for some of the biggest titles in comics—from *The Incredible Hulk* to *The Death Dealer, X-Men,* and *Gears of War*—as well as founding his own publishing company, Mam Tor. He has also produced work for advertising campaigns, created concept designs for several movies, and is a critically acclaimed novelist. Sharp lives in Derby with his wife, three children, and their cat.

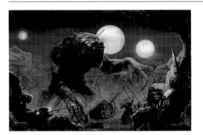

Rancor Hunters pp. 88–89

I always loved the rancor in *Return of the Jedi*—it had that King Kong thing going on, a trapped beast far from home. So when I was asked to contribute a concept and painting to this book, the first thing that sprung into my mind was the rancor. That got me thinking: Where did it come from? How did Jabba the Hutt get to own one, and who traded in these beasts? It wasn't long before a *Moby-Dick*–like scenario presented itself, and from there on in, the whole project went like a dream, just a pleasure start to finish.

I feel sad for the rancor, but at least now, when I watch the movie with my kids, I know exactly how it got to be there and where it came from.

Dolfi Stoki

Born in Zimbabwe, Dolfi Stoki was trained as a walking guide specialist. This unusual vocation gave Stoki the privilege of working in some of the most remote and untouched regions in Africa. Stoki paints full time today, the magic of the African bushveld being his main inspiration. His artwork can be found in many private collections around the world.

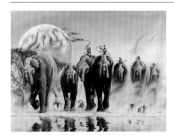

Mosi-oa-Tunye (The Smoke That Thunders) pp. 104–105
The idea of conflict between technology and nature was a tremendous factor in composing this painting. The huge beasts were modeled off the imperial walkers, or AT-ATs, seen in the Battle of Hoth sequence. Nature-wise, I was looking at creating something really massive and dominating, and then balancing that with two of the most beloved characters of the *Star Wars* saga: R2-D2 and C-3PO. The juxtaposition of these two forces leaves the painting open to many interpretations.

William Stout

William Stout was born in Salt Lake City, Utah, in 1949. At seventeen he won a scholarship to the Chouinard Art Institute (California Institute of the Arts), where he obtained his BA. In 1971 he began to assist Russ Manning on the *Tarzan of the Apes* Sunday and daily newspaper comic strips and on Eisner Award–winning graphic novels. Stout joined Harvey Kurtzman and Will Elder on *Little Annie Fanny* for *Playboy* in 1972.

Stout has worked on more than thirty feature films, including both *Conan* films, *First Blood*, and *The Hitcher*. *Return of the Living Dead* made Stout the youngest production designer in film history. He production-designed *Masters of the Universe* and designed John McTiernan's *A Princess of Mars* film project. He recently completed the designs for *The Muppets Wizard of Oz*, then did key designs for Guillermo del Toro's horror classic *Pan's Labyrinth*. His latest film work was for Christopher Nolan's *The Prestige* and Frank Darabont's *Stephen King's The Mist*.

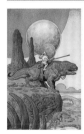

Searching for Anomalies (Stormtrooper and Dewback) p. 53
I was inspired by the "first" *Star Wars* art: Ron Cobb's painting of a rider on a lizardlike creature in an alien desert, a work in director John Milius's collection. John showed this work to his friend George Lucas. It was obviously inspirational. The fossil skull weathering away on the side of the gully is that of a prehistoric dewback. It's my way of connecting my early love for and longtime association with *Star Wars* and George (I created the art for the first commercial *Star Wars* merchandising, twenty-two Coca-Cola cups for Burger King) to a field in which I am well known nowadays: accurate reconstructions of prehistoric life.

Raymond Swanland

Raymond Swanland started his professional career and received his artistic education as a conceptual designer at the video-game company Oddworld Inhabitants. After eight years of working in many artistic capacities, from character design to marketing illustration to cinematic art direction, Swanland moved on to a freelance career pursuing other avenues of storytelling. Since 2004 he has branched out broadly to create illustrations and designs for book covers, comics, album covers, advertising, and film.

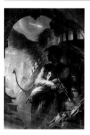

Shadows of Tatooine p. 21
From my earliest experience with the *Star Wars* universe, I was struck by the reality of the fantastic worlds before me. They were futuristic, but ancient and tangible at the same time. As I would take in the imagery and details of the exotic galactic locales, I imagined the feeling of the first human explorers who went to uncharted corners of our own planet, and the incredible stories they brought back. When I set out to create a piece of art to reflect my feelings about *Star Wars*, I imagined myself as a wayfaring artist determined to show the people back home the wonder and danger of distant lands . . . with just a healthy dose of romanticism layered in to reflect my own sense of childlike awe.

Dan Thompson

Dan Thompson was born in Alexandria, Virginia, and graduated from the Corcoran School of Art. He earned his MFA from the Graduate School of Figurative Art, New York Academy of Art. Thompson won Best of Show in the American Society of Portrait Artists' International Portrait Competition. Thompson cofounded the Grand Central Academy of Art and the Janus Collaborative School of Art. He has taught widely, including at Parsons The New School for Design and the Art Students League.

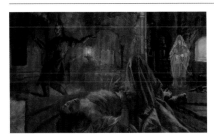

Sith Annunciation pp. 132–133
This painting is inspired by a sequence in Episode I. Shmi Skywalker, in response to Qui-Gon Jinn's inquiry about the talented child that she had given birth to (Anakin), says, "There was no father . . . I can't explain what happened." Further reading led me to a theory that Anakin was conceived by midi-chlorians, which the wisdom of the Sith Master Darth Plagueis could have manipulated. In this painting, Plagueis's former apprentice, Darth Sidious, uses his own apprentice and messenger, Darth Maul, to cast the light of a Sith Holocron upon the sleeping form of a younger Shmi.

David Tutwiler

Renowned for his firsthand knowledge of trains and railroads, David Tutwiler is considered to be one of the leading experts of railroad art in the United States today. Tutwiler's commission clients have included the Pepsi-Cola Company, *National Geographic*, and the National Railway Historical Society. His works have been shown in museums throughout the United States and his paintings are represented in numerous public, private, and corporate collections worldwide. Tutwiler is a member of the Steam Railway Historical Society, the American Society of Marine Artists, and a signature member of the Oil Painters of America. He is a winner of numerous awards, including a bronze medal from the National Park Academy for the Arts, the Marguerite Pearson Gold Medal Award, and the New York Guild of Boston Artists Award for Traditional Painting.

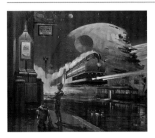

Droids p. 62
The evolution of a work of art is very evident in this final portrayal of the famous *Star Wars* droids, awaiting transport aboard a levitating in-universe train. The final interpretation was fine-tuned and directed through multiple stages by George Lucas, with the patient assistance and communications aid of the Lucasfilm executive editor J. W. Rinzler.

Liné Tutwiler

Following the tradition of Romantic Realism, Liné Tutwiler depicts landscapes, street scenes, and homes that represent the beauty, grandeur, and aesthetic diversity of America. Liné's commission clients have included the MBNA Bank of New England and Gordon's of Gloucester. Her work has also appeared in *Palette Talk* magazine and she is a sought-after instructor for workshops in New England and northern Indiana. In 2009 Tutwiler launched a new ongoing series of paintings entitled *Comfort Classics*. She is a winner of numerous awards.

Yoda Archway on Naboo p. 125
A handmaiden observes the courtyard below from the Yoda archway. Soft sunlight and shadows play on the walls and flowers, while the carving of Yoda overlooks it all.

Scott Waddell

Scott Waddell aspires to be a history painter. Growing up, his interests varied among painting, writing, and filmmaking, all connected by the desire to tell a human narrative. Now, as an adult, he funnels all of that drive into classical oil painting, spending the last several years painting nineteenth-century whaling scenes. Recently Waddell has been looking farther back in history to parts of antiquity that have long piqued his interest. This *Star Wars* project was a chance for him to explore a world that was a part of his childhood, a world in some ways as real in his imagination as any history he desires to paint.

Diptych pp. 100–101

I decided to portray a Jedi and a Sith as archetypes for good and evil. I thought it would be interesting if their poses were similar and they bore ostensibly similar expressions on their faces—hopefully, subtleties will reveal the Sith as amorphous and wretched while the Jedi shows as benevolent and a defender of good and truth. It seemed like a good idea to present them as a diptych. I put the Sith on the left and the Jedi on the right to imply a type of sequence wherein great good, by necessity, comes out of great evil.

Christian Waggoner

A third-generation portrait artist, Christian Waggoner has been drawn to the *Star Wars* series since its inception. His eye for detail and his work with reflective surfaces have garnered the attention of collectors both private and corporate. He currently resides in Atlanta, where he continues to develop his realism and abstract works.

Worlds Collide p. 79

A personal perspective that combines the style of my *Star Wars* print series and the original work that caught the attention of Lucasfilm.

Anthony J. Waichulis

Anthony J. Waichulis hails from rural Pennsylvania and has established an international reputation for his trompe l'oeil paintings. Dozens of highly successful exhibits and publications across the United States have refined his endeavors, and his work has taken top awards in both national and international competitions. In 2006 Waichulis became the first trompe l'oeil painter to be granted Living Master status by the Art Renewal Center.

Young Leia p. 83

This portrait of a young Leia Organa is coupled with a letter or journal entry that may have been written by any one of Leia's early caretakers or perhaps even her adoptive mother. The letter, written in the Galactic Basic (Aurebesh), translates: "She continues to speak of the dreams that haunt her. Alone and scared, surrounded by oceans of sand. I fear that these dreams may one day lead to questions—questions that we may one day have to answer. . . . She remains safe in our charge." This implies that even though Luke and Leia are light-years apart, they are still closely linked through their innate abilities with the Force—perhaps amplified by the fact that they are twins. With a little investigation, the concept of twins can be seen reverberating throughout the piece.

Patricia Watwood

Patricia Watwood is an artist in the emerging school of New York classicists, a group committed to creating beautiful representational paintings that add our contemporary experience to the painting tradition. Watwood studied painting at the Water Street Atelier under Jacob Collins, and at Ted Seth Jacobs's atelier in France. She earned her MFA from the New York Academy of Art. Watwood has exhibited in many group and solo shows in the United States and abroad. She lives in Brooklyn, New York.

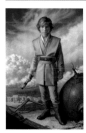

Anakin, Padawan p. 41

I have envisioned this painting as a formal portrait of the boy Anakin a couple of years into his training as a Padawan. During his first mission, he tests the mettle of his new training by bringing down a spider droid. I find this luminal stage of Anakin's life very poignant. He is a boy and a soldier, beautiful and fierce, honorable and angry. He contains at this moment all the potential of innocence, as well as the darkness he will eventually embrace.

Evan Wilson

Evan Wilson was born in Tuscaloosa, Alabama, in 1953. He studied at the North Carolina School of the Arts and the Maryland Institute, College of Art. In 1978, he was the recipient of a Greenshield's Foundation grant to study in Florence, Italy. His paintings imbue everyday reality with a heightened sense of elegance and grace. An artist from the Realist tradition, his works capture the present as they acknowledge the past. His numerous honors include the Alabama Arts Award from the University of Alabama and the William Bouguereau Award from the Art Renewal Center. His paintings are in many private and public collections, including the Huntsville Museum of Art, the Warner Museum of American Art, and the Greenville County Museum in South Carolina.

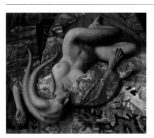

Sleeping Aayla p. 112

My concept for *Sleeping Aayla* has its origins in several hundred years of art, but particularly celebrates the Orientalist movement of Western painters like Whistler and Sargent, who became infatuated with depicting Japanese kimonos in their paintings. In my painting, I wanted to give the viewer a candid and fresh look at a *Star Wars* character. Unlike her powerful image depicted in comics and film, my Aayla is seen in a private and vulnerable moment, as she might look while resting between galactic battles. My love of tradition and the enduring beauty of the figure have their roots in and draw their influences from many sources, including artists of the past and present, which affirms my belief that art is not created in a vacuum and that the way to move ahead is by studying what has come before.

Randall Wilson

Based in Australia, Randall Wilson is a self-taught artist. He has been painting professionally for thirteen years, having previously served in the Royal Australia Navy for six years. He has a keen interest in warships, both modern and past, and particularly loves battleships. Randall is also a keen model-ship enthusiast and has made some incredible naval models over the years.

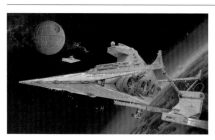

Star Destroyer in for Repairs pp. 30–31

174

Will Wilson

Will Wilson was born and raised in Baltimore. He received his art training from the Schuler School of Fine Art and the New York Academy of Art. Wilson is represented by the John Pence Gallery in San Francisco, where he currently lives with his wife, Kyra, and their two cats, Chauncey and Sazerac.

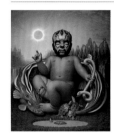

Dawn of Maul p. 80

Due to his powerful and lasting presence, I was drawn to the idea of painting and framing Darth Maul as an icon in the rich tradition of sacred paintings of the Byzantine Empire. We recognize Maul's home planet of Iridonia by its rocky canyons, acid pools, and temperate waterfalls. The enfant terrible sits among a cadre of supporters who have been charmed by his hypnotic spell. In his left hand he confidently wields a writhing two-headed serpent, which represents his eventual mastery of the deadly two-sided lightsaber. Also hidden in his Buddha-like pose is a subtle foretelling of Darth Maul's death by bifurcation. In the sky, we witness a total eclipse of the sun, and on closer examination we discover that it is the infamous Death Star that shrouds the light; even the clouds in the sky rebel against this eerie phenomenon. The iconic imagery is complete as the young Maul, with right hand raised, signs the universal symbol for love; his index finger connects to a sunbeam and his penetrating gaze connects to ours. In this frozen moment, light and darkness, innocence and knowledge, good and evil become one force.

Ryan Wood

Ryan Wood is a concept artist/illustrator who studied illustration at Utah State University. He has worked on various projects with Disney, Nickelodeon, Blizzard Entertainment, Lucasarts, and THQ. He currently resides in the Salt Lake City area.

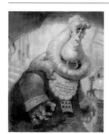

Die Wanna Wanga p. 28

Jamie Wyeth

A celebrated contemporary realist painter, Jamie Wyeth is a third-generation artist and member of the famed American artistic dynasty. Though many of his works reflect the eternal beauty of the Maine and Pennsylvania landscapes or the enduring dignity of domestic animals and wildlife, others are intensely of their time, depicting important individuals and cultural events in the late twentieth and early twenty-first centuries. Among these are portraits of political and entertainment figures, including presidents John F. Kennedy and Jimmy Carter, Rudolf Nureyev, Andy Warhol, and Arnold Schwarzenegger; charcoal drawings that documented the unfolding drama of the Senate Watergate hearings; pictorial reporting of NASA space launches, and, most recently, a series of paintings depicting the seven deadly sins.

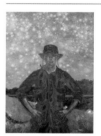

Night Vision p. 111

Night Vision was painted in 1982 to commemorate the twentieth anniversary of the dedication of the Vietnam Memorial in Washingon, DC. (*Editorial note*: The Vietnam War and its coverage in the media was key in forming George Lucas's vision of the Empire and the Rebels in the first *Star Wars* film.)

FOR LUCASFILM LTD.
Executive Editor: J. W. Rinzler
Art Director: Troy Alders
Image Archives: Tina Mills, Shahana Alam, and Stacey Leong
Product Development: Stacy Cheregotis
Director of Publishing: Carol Roeder

FOR ABRAMS
Editor: Eric Klopfer
Project Manager: Eric Himmel
Designer: Neil Egan, with Francis Coy
Art Director: Michelle Ishay
Production Manager: Jules Thomson

Library of Congress Cataloging-in-Publication Data

Star wars art : visions / [foreword by George Lucas ; introduction by J.W. Rinzler].
 p. cm.
 ISBN 978-0-8109-9589-5 (alk. paper) – ISBN 978-0-8109-9678-6 (limited edition)
 1. Star wars (Motion picture) I. Lucas, George, 1944- II. Rinzler, J.W.
 PN1997.S65943S78 2010
 791.43'72—dc22
 2010011516

CASE FRONT: Arantzazu Martínez. Preliminary sketch for *Rancor*.
CASE BACK: Michael Grimaldi. Preliminary sketch for *Incident at Mos Eisley Spaceport*.

Printed and bound in Hong Kong, China
10 9 8 7 6 5 4 3 2 1

Abrams books are available at special discounts when purchased in quantity for premiums and promotions as well as fundraising or educational use. Special editions can also be created to specification. For details, contact specialmarkets@abramsbooks.com or the address below.

THE ART OF BOOKS SINCE 1949
115 West 18th Street
New York, NY 10011
www.abramsbooks.com
www.starwars.com

ACKNOWLEDGMENTS

Lucasfilm would like to thank: Robert P. Brown at the Big Horn Gallery (bighorngalleries.com); Richard R. Gandy at the Gandy Gallery (classicalrealism.com); David Higgins at Cranston Fine Arts (directart.co.uk/mall/default.php); and John Pence at the John Pence Gallery (johnpence.com) for their efforts and expert advice in recruiting several of the wonderful artists in *Star Wars Art: Visions*.

And a grateful nod toward the families, wives, agents, friends, and representatives of the artists, including: Tom Appel, Michelle Bailey, Les Barany, Sheila Berry, Marlys Carter, Adrienne Colan, Patti Dietz, Mary Beth Dolan, Irene Grinnell, Mahlon Kraft, Louis K. Meisel, Christine Mills, Dana Morgan, Jill Pfeiffer, Sabrina du Pont-Langenegger, T. J. Ross, Roger Servick, Richard Solomon, Heather Taylor, Carol Tinkelman, and Scott Usher.

A big thanks to our colleagues at Lucasfilm: David Anderman, Jane Bay, Kyra Bowling, Leland Chee, Jo Donaldson, Laela French, Sheila Gibson, Lynne Hale, Pablo Hidalgo, Chris Holm, Howard Roffman, Anne Merrifield, Jann Moorehead, and Chris Spitale.

Our sincere thanks to the gang at Acme Archives: Sean McLain, Chris Jackson, and Kirk Smith.

And once more our gratitude goes out to all the artists from all over the world who gave their time and art to this project.

Acme Archives would like to thank: Chris Jackson, Kirk Smith, Lisa McLain, Charlie Sainz, Jeff Cox, Louis Solis, Bennett Dean McCall, James Monosmith, Edgar Gonzalez, Rob Ralls, Annick Biaudet, and Bonnie Eck, as well as the endless energy and countless hours that J. W. Rinzler has put into this project.